GREAT ARTISTS
EXPLAINED

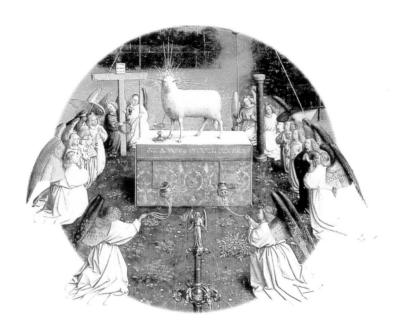

Detail from
The Ghent Altarpiece
See page 14

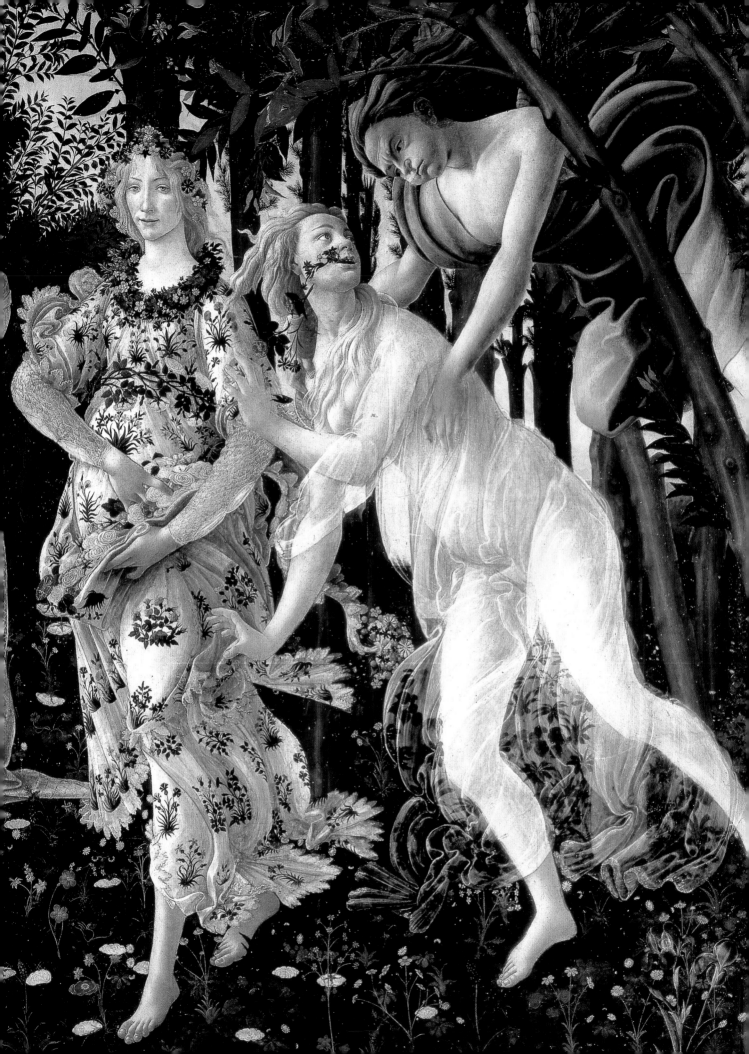

GREAT ARTISTS
EXPLAINED

ROBERT CUMMING

Detail from
*An Election
Entertainment*
See page 54

Detail from
Primavera
See page 22

Previously published as *Annotated Guides: Great Artists*

Detail from
Portinari Altarpiece
See page 16

LONDON, NEW YORK,
MELBOURNE, MUNICH, AND DELHI

Project editor Damien Moore
Art editor and DTP designer Claire Pegrum
Assistant editor Diana Walles

Senior editor Louise Candlish
Senior art editor Tracy Hambleton Miles
US editor Ray Rogers
Senior managing editor Sean Moore
Deputy art director Tina Vaughan
Production controller Kate Hayward
Picture researcher Jo Walton

Detail from
Jeanne Hébuterne
See page 106

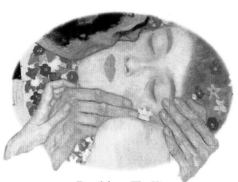

Detail from **The Kiss**
See page 94

First published in the United States in 1998
This revised edition published in 2007 by
DK Publishing
375 Hudson Street, New York, New York 10014

07 08 09 10 10 9 8 7 6 5 4 3 2 1
GD091 – 05/07

DK books are available at special discounts when purchased in bulk for sales promotions,
premiums, fundraising, or educational use. For details, contact:
DK Publishing Special Markets
375 Hudson Street, New York, New York 10014
SpecialSales@dk.com

A catalog record of this book is available from the Library of
Congress.

ISBN: 978-0-7566-2870-3

Proofing by Wyndeham Pre-Press, UK
Colour reproduction by DK India, India & GRB, Italy
Printed and bound by Toppan Printing Co Ltd, China

Discover more at
www.dk.com

Detail from
Self-portrait with Saskia
See page 48

Detail from
**Charles V at
Mühlberg**
See page 34

Dying Slave
See page 28

CONTENTS

Detail from
*The Infanta Margarita
in a Pink Dress*
See page 46

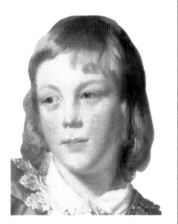

Detail from
Thomas Lister
See page 56

Detail from
Peace and War
See page 40

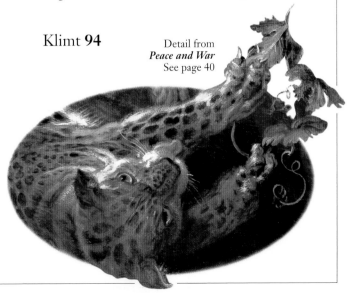

WHAT MAKES A GREAT ARTIST?

The type of personality that flourishes as a painter at any given time is the product of many different factors. There must be skill, determination, and inspiration, but these essential qualities are never enough in themselves. It is a simple truth that most artists reflect their own times but no more, whereas the outstanding artist has the ability to capture the imagination of future generations and say something of direct relevance to them. It is a rare occurrence and is possible only if the artist is working out of the deepest personal conviction with a wish to reveal something more than skill and with the intention to do more than impress or please an individual patron or a specific audience. The timelessness and universality of the work of a great artist exists because he or she has something exceptional to say, and because for such artists painting is not an end in itself but a means of trying to reach a fundamental human truth.

Leonardo
Leonardo da Vinci produced very few paintings, but he profoundly influenced the perception of the status of the artist, arguing that he should be treated as the social equal of princes rather than as a humble, if gifted, craftsman.

During the last 500 years the role and motivation of the painter have changed enormously. Today, we tend to see the contemporary artist as a free spirit who often consciously seeks to adopt a different lifestyle and set of values, sometimes in a manner that is deliberately provocative. For artists of the early Renaissance, such as Masaccio (p. 12) or Piero della Francesca (p. 16), the reverse was true. They did not need to be outside society in order to innovate and create. Van Gogh (p. 90) would not have found a role as a painter in the 17th century—he would have been a hellfire preacher. Rubens (p. 40), if alive today, would be an international diplomat and troubleshooter, not an artist.

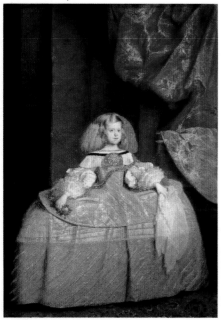

Velásquez
Velásquez's life was inextricably linked with the Spanish royal court, and he was ambitious to hold high office. He believed devoutly in the divine right of kings, and his official duties extended far beyond those normally associated with painting.

From Craftsman to Philosopher There are two major turning points in the development of the role of the artist: the first during the High Renaissance, and the second in the early 19th century. Early Renaissance artists, such as van Eyck (p. 14) and Bellini (p. 20), were considered to be craftsmen, and their activities were supported and regulated by a guild system. At the beginning of the 16th century, however, Leonardo da Vinci (p. 24) successfully argued that the artist should have a different status and should be treated as the intellectual and social equal of the highest in the social strata. Artists such as Raphael (p. 32), Michelangelo (p. 28), and Titian (p. 34) shared his aspirations, as did ambitious Northern artists, such as Dürer (p. 26). Between them, these great artists established a role model and an ambition that endured well into the 19th century—and it still exists today.

Courtiers and Commerce Before the 19th century it was a rare occurrence to find a rebellious artist, such as Caravaggio (p. 38), who deliberately defied convention. On the contrary, many prominent 17th-century artists—for example Rubens and Velásquez (p. 46)—acted as diplomat and courtier and lived a very full public life. Equally, there were those of a different temperament, such as Poussin (p. 44), who worked much more privately but still within well-defined rules. In the newly founded Dutch Republic, painters with commercial motivations, such as Ter Borch (p. 50) and the young Rembrandt (p. 48), chose to supply the prosperous middle classes with the type of paintings and portraits that their new lifestyle and wealth demanded.

The Professional and the Romantic
The French Revolution of 1789 was a great watershed and ushered in profound political and social changes. The privileged world of

Turner
The early 19th century was one of the major turning points in the development of the artist's role. In all the arts, the creative spirit sought a new freedom of expression and intensity of personal experience. Many of the Romantics were willing to risk their lives

monarchy and aristocracy that had supported notable artists such as Fragonard (p. 58) and Reynolds (p. 56) was now on the wane. As happens at all periods of major change, the arts began to attract new personalities who previously would have ignored an artistic life. There was a new sense of liberty in the air, and the Romantic spirit exploited this freedom to express individual emotions and to paint about personal experiences. This was equally true for painters such as Turner (p. 66), Delacroix (p. 72), and Friedrich (p. 64) as it was for poets, writers, and musicians, and it led to a period of extraordinary creative energy: works were produced that have remained at the heart of popular appreciation of the arts.

The Radical and the Loner The classical tradition, with its admiration for antiquity and disciplined professional training, continued to flourish alongside Romanticism, most notably in the genius of Ingres (p. 70) and, less significantly, in the work of prolific but dull painters who clung to the academic tradition. But the newly found freedom of the Romantics led to the emergence of the true radical in the second half of the 19th century. Thus, painters as diverse as Courbet (p. 74), Klimt (p. 94), and Cézanne (p. 82) sought

diligently to develop new, genuinely original styles of painting that would continue to respect tradition but, more importantly, would reflect modern sensibility. Klimt, for example, wanted to bring about a union of painting and craftsmanship that had disappeared with the High Renaissance. Other artists, such as Whistler (p. 80), openly defied convention and boldly challenged their critics. Outsiders such as van Gogh and Gauguin (p. 88), who were unable to cope with the demands and complexities of the new, crowded industrial society, turned to painting as an escape and solace. Through their art, they endeavored to find the spiritual fulfillment that modern society was unable to offer them.

The Avant-Garde At the beginning of the 20th century there was a fundamental reexamination and exploration of many of the assumptions in the arts, science, and technology that had been established since the Renaissance. Many of the rules by which we define, describe, and explain our world were established. Modern masters, such as Picasso (p. 102), Matisse (p. 98), Kandinsky (p. 96), and Klee (p. 100), were attracted to the arts not by thought of commercial gain or social status but by the opportunity to experiment and rewrite the rule book. Like Einstein, Freud, Stravinsky, or even

Cézanne

Cézanne never needed to sell his paintings in order to survive, so he could ignore the demands of fashion. Lacking the skills that a strict academic training demanded, however, he had no alternative but to go back to nature and record only what he saw and experienced without the guidance (or restriction) of preconceived rules. His experiments and innovations were revolutionary.

the pioneer aviators who first dared to fly, the modern artists were aware that they were venturing into the unknown. Nevertheless, the daring and heroic modern artists succeeded in their quest, and the model of radical innovation that they established as a new ideal persisted into the midcentury with the emergence of progressive artists such as Pollock (p. 108). It remains to be seen whether those high-profile artists of today, who so successfully attract media attention, are as radical and as shocking as they frequently claim to be, or whether they are in fact merely working to a new formula (effectively a new type of academic art). Of course, it has always been easier to identify the great artists of the past who have passed through the exacting test of time, and whose work still speaks with conviction and meaning, than to predict which of so many much-heralded contemporaries will still merit a mention 50 or 100 years from now.

in order to savor life to the fullest, and, indeed, many of them died young. Turner lived a full life (he died at the age of 76), but the desire for fresh and even dangerous experiences never left him. In his early work, he built on the tradition of the Italian and Dutch masters, and the radical innovations in his later work often baffled the critics and his fellow artists.

Kandinsky

Kandinsky was the first abstract painter and one of the pioneers of a new type of art that sought to be in accord with the sensibilities and discoveries of the early 20th century. Like his fellow innovators in the arts, sciences, and technology, he was motivated principally by a desire for discovery and knowledge rather than commercial gain.

ARTISTS, PATRONS, & COLLECTORS

Few artists are able to work exclusively on their own without thought as to whether they will find favor with patrons or collectors. Cézanne (p. 82) was one of the rare exceptions: he had a private income and was so single-minded that he had little need for the company of other people. By the same rule, there are few artists now numbered among the great names who were completely ignored by patrons and collectors in their own lifetime, only to find fame and influence

after their death. Notable examples of such rare neglect are Constable (p. 68), who sold few paintings other than to friends, and van Gogh (p. 90), who sold only one painting in the whole of his short lifetime. Both of these artists are now among the most revered names, and their paintings sell for extraordinary sums of money. Far more common is the artist who is eagerly sought after during his or her lifetime, subsequently to be consigned to relative obscurity by the judgment of time.

The equation that links artist, patron, collector, and dealer or institution is fascinating and unpredictable. As is the case with all human relationships, the outcome depends on that indefinable personal chemistry that may be uplifting and rewarding but that can just as easily be painful and frustrating. Either of these circumstances can cause the artist to dig deeper into his or her spiritual and technical resources to find a degree of inspiration that the creative mind and eye rarely are rarely able to find in isolation.

Princes and Popes In the early Renaissance, the patronage of one of the noble courts or the Church was the essential framework within which an artist was obliged to operate, and the influence of a creative and imaginative patron was immense. The three Limbourg Brothers (p. 10), for example, were effectively employees of the Duke of Burgundy. Leonardo da Vinci (p. 24) worked for many different patrons, not just as a painter,

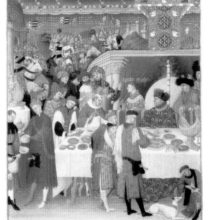

The Limbourg Brothers
The support of a powerful lay patron or the Church was essential for early Renaissance artists. The Limbourg Brothers were fortunate in coming to the notice of the Duke of Burgundy.

but also as architect, inventor, engineer, and philosopher, and in this he was following a well-established pattern. Great monarchs, such as Charles V or Louis XIV, used art—the work of the past as well as of the best contemporary artists—to increase their prestige and credibility of political power. Likewise, the papacy and the Church employed art to spread the Christian message and to promote its worldly power and influence. Without such patrons, the greatest artists of the Renaissance and the 17th century would not, and could not, have created their supreme masterpieces. But there was also a private side to such support. When patrons wanted quieter and more intellectual

pleasures, they turned to artists such as Giorgione (p. 30), Brueghel (p. 36), or Poussin (p. 42) and established with them a more intimate relationship that provided the impetus for fresh thinking as well as the actual commissioning of works.

Academies Before the 17th century, most painters learned their trade through a rigorous apprenticeship with an established artist and, if successful, went on to gain recognition in their own right. In turn, many of these artists set up successful workshops or studios and played an active role in training the next generation of aspiring painters. When this system declined, however, the academies grew to fill the gap, establishing a forum where novice artists could train, show their work, and receive official recognition. Successful academies encouraged high-quality work and were a means of connecting artists and collectors, but at the same time they established rules that, at their worst, could stifle creativity. In the 19th century, artists such as Courbet (p. 74) and Manet (p. 76) were spurred on to highly original work by reacting

Raphael
Raphael spent most of his working life in the service of the Church. Profound Christian faith and inspired commissions from the popes, who sought to deepen the authority of the Church through art, were catalysts for his greatest achievements.

Poussin
Poussin worked principally for private patrons and collectors, but his influence was profound. The intellectual rigor that he brought to his work, and his disciplined control of design, line, and color, became the cornerstone of the French academic system, and his art was a model of inspiration for generations of French artists.

Sargent
Sargent was the favored portrait painter of the aristocracy and nouveaux riches of the late 19th century. He consciously built on the example of the old masters and the famous 18th-century portraitists, and he pleased his clients by bringing a fresh vision and easy modern manner to a well-established tradition.

and, with their strict historical perspective, had no interest in showing contemporary art. Thus, from the mid-19th century onward, there developed different attitudes toward the art of the past and contemporary art. Without intending to, this division allowed the avant-garde to emerge—a small group of pioneering artists who had no place in (and received no acknowledgement from) the official art world and whose only support was the private dealer and collector. These were the circumstances that faced the true pioneers of modern art, such as Picasso, Matisse, and Kandinsky (p. 96). The isolation of the avant-garde artist began to end when the Museum of Modern Art was founded in New York in 1929. The avant-garde now had an official and institutional "home." From this modest origin, museums of contemporary art have become significant institutions throughout the world, wielding great power, supporting a select band of artists through purchase and exhibition, and effectively fulfilling many of the same functions as the old academies. The politics of official patronage and art collecting at the end of the 20th century are curiously similar to those of the end of the 19th—only the "look" of the art is different.

against the dictates of the French academic system. Today, the once-powerful academies have little real influence in the kaleidoscope of art politics.

Collectors Collecting the work of living artists for private commercial reasons as well as for pleasure first blossomed in 17th-century Holland, but it was the 18th and early 19th centuries that saw the flowering of a golden age for the private collector. Then, many great masterpieces of antiquity, the Renaissance, and the 17th century were taken from their original settings and sold to foreign art collectors. This created a new type of competition for artists: contemporary painters such as Reynolds (p. 56) and Canaletto (p. 52) realized that their work would need to live up to comparisons that would inevitably be made between them and the major artists of the past, as well as with the artists of their own day. They accepted the challenge and drew inspiration from it.

Dealers The modern picture dealer came to the fore in the 19th century, when many of the famous firms that are still in existence today were founded. As the artist found greater freedom to express a private vision, rather than one that was shared with, or demanded by, a patron or institution, so the dealer became a very necessary intermediary between the painter and collector. Indeed, without the courage of a few adventurous dealers and collectors, the Impressionists and the great masters of the Modern movement, such as Picasso (p. 102), Matisse (p. 98), Modigliani (p. 106), and Pollock (p. 108), would have faced extreme difficulty surviving economically and would have lacked an indispensable source of encouragement.

Museums National galleries were first founded in the 19th century for the express purpose of showing the great masterpieces of art of the past in an imposing setting. Their founders had a moral and political purpose

Picasso
In his early years, Picasso had little support and found favor with only a few adventurous dealers and collectors. However, by the end of his life, when he, with others, had succeeded in rewriting the rules of painting and sculpture, his work became eagerly sought after by institutions as well as private individuals.

LIMBOURG BROTHERS (DIED 1416)

THE **LIMBOURG BROTHERS** lived and worked during one of the periods of great upheaval and change that have molded European art and history: the old attitudes and ideas that shaped and informed the medieval mind were giving way to the new expectations that would find their fullest flowering in the Renaissance. It is thought that there were three brothers—Paul, Herman, and Jean—but details about them are sparse. They were born in the Netherlands, where their father was a wood carver. Through the influence of an uncle, who was a painter, they were sent to train in Paris, and it is likely that Paul visited Italy at some stage. Like all artistic craftsmen in the medieval world, the brothers worked together as a team to produce many different works: illuminated manuscripts, silverware, enamels, and decorations for churches and mansions. Fortunately, their exceptional talents came to the attention of the great patron of the time: Jean, Duc de Berry.

Self-portrait?
It has been suggested that the brothers depicted themselves among the guests: the fine-featured figure with a gray hat is thought to be Paul.

LES TRES RICHES HEURES
These two illustrations are taken from the Book of Hours, *Les Très Riches Heures du Duc de Berry*—a masterpiece of manuscript illumination begun for the Duc de Berry in about 1408. The illustration on the left represents January, which was a traditional period for exchanging gifts; the painting on the right represents June and shows a group of peasants laboring on the duke's land.

ELABORATE TAPESTRY ●
The scene shows a winter banquet held by the duke. The walls of the banqueting hall are hung with an elaborate tapestry depicting a battle scene. The details were probably painted using a magnifying glass and fine brushes, some of which contained only a few bristles.

The Limbourg Brothers sowed the seeds of ideas and interests that would grow significantly in northern European art: landscape, portraiture, storytelling and observation of everyday life (genre), and an obsession with recording fine detail.

Attention to Detail
The paintings show a remarkable attention to detail observed at first hand—the two small dogs eating on the table provide a notable example.

LAVISH BANQUET ●
The damask-covered table is lavishly laid out with food on gold plates. To the left of the duke is a massive gold saltcellar in the shape of a boat. Salt was an expensive commodity that was vital for the preservation of food, and an elaborate saltcellar was a status symbol. Its prominence in the composition suggests that it may well have been designed by one of the Limbourg Brothers.

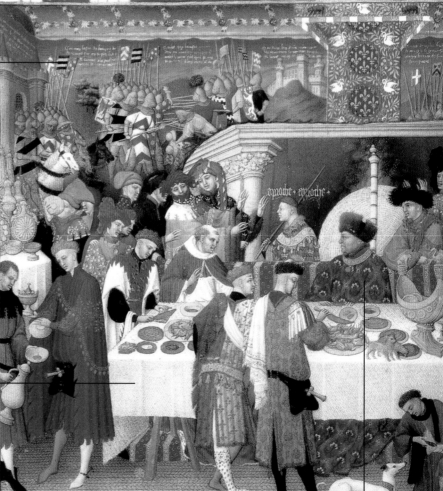

Limbourg Brothers; *Les Très Riches Heures du Duc de Berry: January*; c. 1415; 11½ x 8 in (29 x 20 cm); gouache on vellum; Musée Condé, Chantilly

DUC DE BERRY ●
The duke is shown in profile, his head framed by a wicker fire screen. Behind him, his chamberlain welcomes each guest with the words *"Aproche + Aproche"* inscribed in gold lettering above his head.

THE ARTIST'S STATUS

Artists such as the Limbourg Brothers occupied a position that was somewhere between the elegant and courtly world of the princely family and the laborer's world of toil. They would have traveled with the duke's court as it moved from one magnificent chateau to another: attendants at the feasts, observers of both the peasant and princely worlds, but belonging to neither. They were entirely dependent for their livelihood and welfare on the approval and patronage of either the aristocracy or the Church.

Hôtel de Nesle
In the background is a detailed depiction of the duke's residence in Paris: the Hôtel de Nesle. Below the castle walls is a diminished River Seine, bordered by pollarded willow trees. The castle no longer exists.

TECHNIQUE
The brothers painted the illustrations in gouache (opaque watercolor) on vellum (animal skin). Gold laid on blue is characteristic of their work.

SIGNS OF THE ZODIAC
Above each scene is the correct sign of the zodiac for the month. The sun god in his chariot is based on the image on a medal that was owned by the Duc de Berry, which showed the Emperor Heraclius returning the True Cross to Jerusalem.

Both pictures have a strong and instinctive sense of design, which is helped by the experimental perspective. Figures, trees, objects, and buildings are arranged in neat and decisive blocks and then placed so that nothing hides or competes with anything else. There is a satisfying and complete unity and harmony of composition.

DOMINANT CHURCH
The medieval Church dominated all society, encouraging piety through prominent visual aids such as architecture, stained glass, wall decorations, ornamented caskets, and the detailed illustrations and decorative lettering and borders (illuminations) in manuscripts.

The interest in naturalism is a new feature for this sort of work in Northern Europe and may be the result of Paul's visit to Italy. The brothers would also have been able to look at work by French and Italian masters in the Duc de Berry's library.

ATTENTION TO DETAIL
The willows at the river bank and smoke rising from one of the chimneys are examples of the new interest in close and fresh scrutiny of the real world that was a catalyst in undermining the medieval emphasis on obedience to received ideas.

> *Truly, art is embedded in nature; he who can extract it, has it*
> ALBRECHT DÜRER

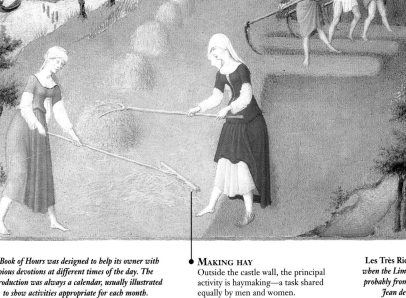

Limbourg Brothers; *Les Très Riches Heures du Duc de Berry: June;* c. 1415; 11½ x 8 in (29 x 20 cm); gouache on vellum; Musée Condé, Chantilly

1400–1420

1400 Chaucer dies. Richard II of England murdered. England and France at war (Hundred Years' War).

1405 Death of Tamerlane the Great of Mongolia.

1406 Venice colonizes Padua; Florence colonizes Pisa.

1407 Civil War in France.

1415 Henry V of England defeats the French at Agincourt.

1417 End of the Great Schism in the Church (rival popes).

1419 Alliance between Henry V and Philip, duke of Burgundy.

A Book of Hours was designed to help its owner with pious devotions at different times of the day. The introduction was always a calendar, usually illustrated to show activities appropriate for each month.

MAKING HAY
Outside the castle wall, the principal activity is haymaking—a task shared equally by men and women.

Les Très Riches Heures was unfinished when the Limbourg Brothers died in 1416, probably from plague. It was completed by Jean de Colombe in the 1480s.

MASACCIO (1401–1428)

TOMMASO MASACCIO INITIATED A PROFOUND CHANGE in European art, and even in his own day it was recognized that he had achieved something extraordinary. Yet, surprisingly, we know very little about his life. He was born in Arezzo, near Florence, the son of a young notary. Nothing is known about his training, but he was admired and studied Giotto's paintings in the Church of Santa Croce in Florence. He made astonishingly rapid progress, and the new vision and freedom expressed in his work was an important part of the intellectual wind of change that swept through Florence. He changed painting by rejecting the elegant Gothic style and concentrating on giving his figures the illusion of weight and bulk within a coherent three-dimensional space. The series of frescoes that he created with Masolino in the Brancacci Chapel (after 1425) was to have a deep impact on artists such as Leonardo da Vinci (p. 24). However, Masaccio did not complete the fresco cycle: in 1428 he went to Rome, where—at the age of 27—he died so suddenly that it was rumored he had been poisoned.

Tommaso Giovanni di Mone Masaccio

THE TRINITY

The painting shows the Christian Holy Trinity of God the Father, Son, and Holy Spirit. Masaccio's interpretation shows how medieval ideas are starting to give way to new ways of seeing and thinking.

Masaccio was a nickname. The artist's original name was Tommaso Guidi. Vasari maintained that Masaccio was obsessed with his art and impractical in everyday affairs, hence the nickname, which is usually interpreted as "Clumsy Tom."

VASARI'S "LIVES"

Giorgio Vasari (1511–1574) was an Italian artist and architect best remembered for his great biographical work *The Lives of the Artists,* which is the principal source of information about Masaccio. Like Masaccio, Vasari was born in Florence, and he proposed that Florentine artists were superior to all others. Michelangelo (p. 28), whom Vasari idolized, was the only living artist included in the first edition of his book in 1550.

The strict hierarchy from God the Father at the top, down to the donors who are placed outside the holy group (implying they have no role other than to obey), represents the traditional medieval attitude. The standing figures are the Virgin Mary and St. John.

CLASSICAL ARCHITECTURE

The architectural setting, based on a study of the classical buildings of Rome, shows the new interest in antiquity.

FORESHORTENING

Masaccio's mastery of foreshortening is evident in this painting. Vasari described the architecture as "a barrel vault drawn in perspective, divided into squares with rosettes that diminish and which are foreshortened so well that there seems to be a hole in the wall."

Over a century before Masaccio, Giotto (1266–1337) had pioneered a more natural type of art, but it had not found much following with other painters. Giotto did not know about scientific perspective or modeling with light and, compared with Masaccio's work, his world is fictitious and idealized. Nevertheless, Masaccio built strongly on Giotto's example.

HOLY TRINITY

The dove represents the Holy Spirit. Masaccio's modern interpretation of the Trinity makes the great mystery more humanly accessible in a world where intellectual and emotional relationships were changing rapidly.

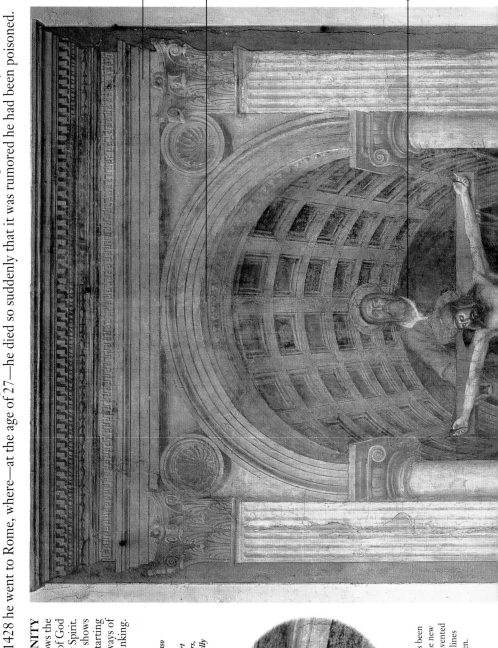

Rules of Perspective

The illusion of a vaulted ceiling has been precisely calculated according to the new mathematical rules of perspective invented by Brunelleschi—the incised grid lines under the plaster can still be seen.

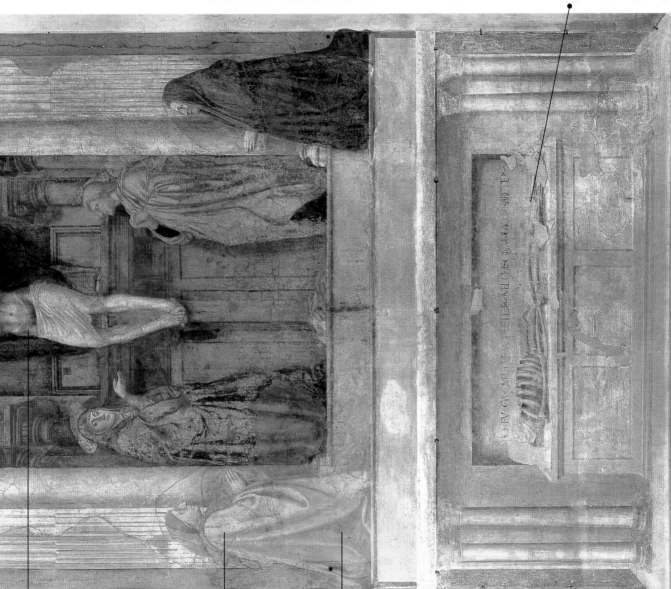

KEY WORKS

- **Adoration of the Magi;** 1426; *Picture Gallery, Dahlem,* Berlin
- **Madonna and Child;** 1426; *National Gallery,* London
- **Tribute Money;** c. 1427; *Brancacci Chapel,* Florence
- **The Expulsion of Adam and Eve from Paradise;** c. 1427; *Brancacci Chapel,* Florence

Serious Madonna

Masaccio championed a new and vivid realism. A serious Virgin Mary looks down and gestures with her right hand to intercede between the human supplicant and the divine presence.

THE PRESENCE OF DEATH

The perspective scheme presupposes that the altarpiece will be seen by someone kneeling before it, eye level with the skeleton. The viewer is thus reminded of his or her own mortality. The Latin words inscribed directly above the skeleton mean, "I was that which you are. You will be that which I am."

Tommaso Masaccio; *The Trinity;* 1425; 264 x 124 in (670 x 315 cm); fresco; Santa Maria Novella, Florence

NEW OPTIMISM

God the Father supports the dead body of Christ as if to raise Him up, emphasizing the idea of resurrection and rebirth. This new optimism contrasts strikingly with the old, gloomy dominance of death.

❝ *It was Masaccio who perceived that the best painters followed nature as closely as possible (since painting is simply the imitation of all living things of nature …)* **❞**
VASARI

LIFELIKE DONORS

The altarpiece was commissioned by the Lenzi family, and the kneeling figures are probably Lorenzo Lenzi and his wife. Although they are placed lower in the hierarchy, the artist paints the donors on the same scale as the other figures. Their lifelike presence expresses the Renaissance view of man's position at the center of the world around him.

SOFT MODELING

Masaccio has modeled the donor's robes with light to create solidity and weight rather than defining their shape with a flat outline. Gestures and facial expressions are also closely observed.

In 1422, Masaccio became a member of the Florentine painter's guild, which controlled and regulated the activities of painters. Although he helped to develop a new intellectual atmosphere, artists were still ranked with craftsmen at this time.

1420–1430

1420 Brunelleschi designs dome of Florence Cathedral.

1422 England's Henry V dies.

1425 Alain Chartier: *La Belle Dame sans Merci.*

1426 Venice at war with Milan.

1427 Peak of Aztec Empire, Mexico.

1429 Joan of Arc liberates Orléans.

1430 Creation of Order of the Golden Fleece by Philip the Good.

VAN EYCK (DIED 1441)

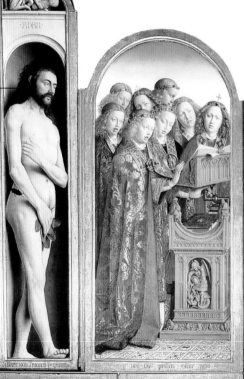

THE **GHENT ALTARPIECE** was the most renowned of all early Flemish paintings. It was the work of two brothers, although the extent of their respective participation is not easy to unravel. Little is known about the elder brother, Hubert, but Jan's life is well documented. He was born near Maastricht, and after his apprenticeship he entered the service of the Count of Holland. In 1425, he became Court Painter to Philip the Good, duke of Burgundy (1396–1467). He was highly esteemed by his patron, and Philip entrusted him with secret diplomatic missions to Spain and Portugal at the time of the duke's proposed marriage to the Infanta Isabella. In the scale, breadth of vision, realism, and technique of his work, he helped to establish a new style of painting that shaped all of northern European art and made a great impact on Italian art.

Jan van Eyck

THE GHENT ALTARPIECE

Rich and complex in subject matter, and outstanding in technical skill and innovation, the Ghent Altarpiece is one of the supreme masterpieces of Christian art. It has had a stormy history: nearly destroyed by the Calvinists in 1566, it was dismantled in 1816 (when some of the panels were sold) and damaged by fire in 1822. The altarpiece was finally reassembled in 1920.

UPPER ROW
The upper row (from outer to inner panels) shows Adam and Eve, musical angels, the Virgin Mary and John the Baptist, and God the Father. Van Eyck has portrayed the naked figures of Adam and Eve with an unprecedented realism. No attempt has been made to idealize the figures.

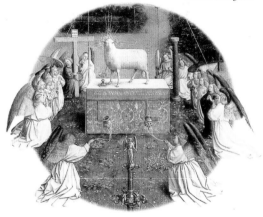

Adoration of the Lamb
The principal panel shows the Adoration of the Lamb. The Lamb, symbolic of Jesus Christ and the resurrection, is placed between the Fountain of Life, a symbol of redemption, and the dove of the Holy Spirit.

❝ His eye was at one and the same time a microscope and a telescope ❞
ERWIN PANOFSKY

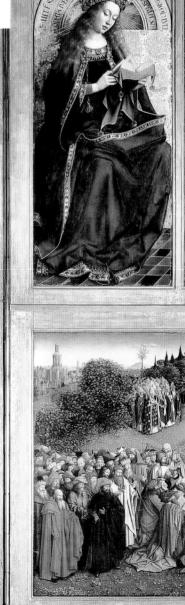

UNIFYING HORIZON
The bottom panels, although containing many dozens of figures in different groups, are unified in design by the horizon line with its protruding towers and trees. The upper panels are unified by the poses of the figures who turn in toward the center.

THE BLESSED
The lower-left side panels show the Just Judges (outer) and the Warriors of Christ (inner). The lower-right panels show Holy Hermits (outer) and Holy Pilgrims (inner).

KEY WORKS

• **The Painter's Wife**; 1433; *Musée Communale des Beaux Arts*, Bruges

• **The Arnolfini Marriage**; 1434; *National Gallery*, London

• **The Madonna with Canon van der Paele**; 1434–36; *Musée Communale des Beaux Arts*, Bruges

SUBJECTS AND SYMBOLS

Biblical and mythological subjects and symbols were a universal artistic language widely understood throughout Europe, indicating the deeply rooted influence of Classical civilization and the power of the Catholic Church. Although great masters such as Jan van Eyck were moved by their own spiritual convictions and personal experiences and imposed their own style and emphasis, subject matter and its moral content were a greater priority in art than personal aesthetic experience. The change from these priorities to an art emphasizing essentially personal emotion and symbolism occurred in the Romantic movement of the early 19th century (p. 64).

The altarpiece is a polyptych. Although large in size overall, it is composed of many relatively small panels. The meticulous techniques of northern painting were best suited to small-scale work. By creating a polyptych, the virtues of small-scale detail and impressive overall size are combined. The outer wings are hinged to enclose the central panels, and 12 additional panels decorate the other side of these doors.

Exotic Trees
Van Eyck has included palm trees, pomegranates, and orange trees, painted in faithful detail. The work must, therefore, date from after his diplomatic visits to Spain and Portugal in 1427 and 1428.

NEW REALISM
Van Eyck introduced a type of realism that had not been seen before. Unlike Masaccio (p. 12), who had a scientific knowledge of perspective and anatomy, he relied entirely on observation, recording detail and the fall of light and shadow with the greatest fidelity.

DOUBLE MEANING
Read along a vertical central axis, the central figure can be seen as God the Father, below whom is the Holy Spirit and the Lamb of God. Read along the horizontal axis, the figure can be seen as Christ in glory, placed between the Virgin and John the Baptist.

CAIN AND ABEL
In the lunette above Eve, the killing of Abel by Cain is depicted; above Adam is the offering of Cain and Abel. Van Eyck has used shades of gray to imitate bas-relief.

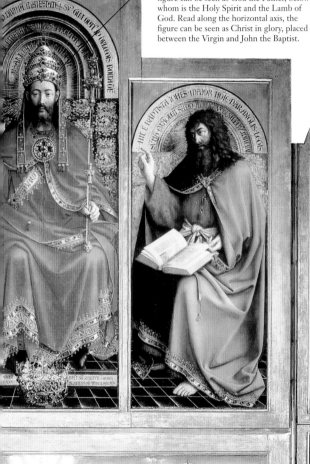

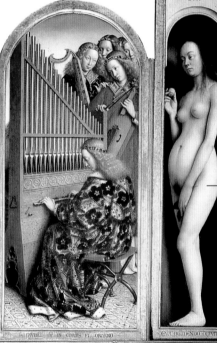

In 1823 an inscription was found on the back of the painting, made after the work was completed: "The painter Hubrecht van Eyck, than whom none was greater, began this work, which his brother Jan, who was second to him in art, completed at the behest of Jodoc Vijdt, and which he invites you by this verse to contemplate on 6 May 1432." It is thought that Jan repainted the altarpiece, which Hubert had designed and worked on until his death in 1426.

OIL PAINTING
A pioneer of oil painting, van Eyck manipulated the new medium with a skill that has rarely been surpassed. Oil paint is very flexible, allowing the artist to develop subtle gradations of light and shade, rich saturated colors, and brilliant highlights.

Dürer (p. 26) went to see the altarpiece in 1521 and pronounced it "stupendous." Van Eyck's meticulous style later influenced the German Romantics (p. 64). But the Dutch 17th-century masters, with their interest in landscape and anecdotal detail, are the real successors of his style.

Jan van Eyck; *The Ghent Altarpiece*; 1432; 138 x 181 in (350 x 461 cm); oil on panel; St. Bavo Cathedral, Ghent

1430–1450

1431 Joan of Arc burned at Rouen.

1433 Donatello: *David.*

1434 Exiled Cosimo de' Medici returns to control Florence.

1438 Inca dynasty founded in Peru.

1439 Turks annex Serbia.

1440 Platonic Academy founded in Florence.

1445 Diaz discovers Cape Verde.

1450 Pope Nicholas V authorizes the Portuguese to "enslave the enemies of Christ" in Africa.

Hugo van der Goes

PORTINARI ALTARPIECE

Tommaso Portinari, an Italian residing in Bruges and an agent for the renowned Medici family (p. 22), commissioned the artist to paint this majestic work. It was to take pride of place in the Portinari Chapel in the Church of the Hospital of Santa Maria Novella in Florence.

MONUMENTAL SAINTS •
The enormous dimensions of the painting were specified by Portinari, who wanted an altarpiece of the size commonly found in Italian churches. The saints are lifesize.

This work had a dramatic impact when it was first seen in Florence. Italian painters were immediately impressed by the naturalistic handling of detail and the colors that resulted from the use of oil paint. Both aspects were incorporated into Italian art soon afterward.

1450–1470

1451 Glasgow University founded.

1452 Ghiberti completes *Gates of Paradise*, Florence Cathedral.

1453 Turks take Constantinople. End of Hundred Years' War. Gutenberg Bible printed.

1455 Start of the Wars of the Roses in England.

1456 Turks capture Athens.

1460 Death of Scotland's James II.

1469 Lorenzo de' Medici rules Republic of Florence.

1470 Portuguese explorers reach Africa's Gold Coast.

VAN DER GOES (DIED 1482)

Hugo van der Goes is an artist of undoubted greatness about whom very little is known. His reputation rests solely on one of the supreme masterpieces of the late 15th century—the *Portinari Altarpiece*. No other work is directly authenticated as being created by his hand, although there are a few other works attributed to him, based on comparisons of style and the little documentary evidence that exists. He is known to have been working in Ghent in 1467, where he painted civic decorations for public events such as the weddings of Philip the Good and Charles the Bold. In 1475, Van der Goes became dean of the painters' guild in Ghent; however, he spent the last seven years of his life as a lay brother in a monastery near Brussels where he was something of a celebrity and received visits from the Hapsburg Archduke Maximilian. His reasons for settling in the monastery are not known. He might, of course, have entered for religious purposes, or possibly because he knew he was mentally unstable—he experienced bouts of acute depression. In 1481, he suffered a severe mental breakdown and died the following year.

Van der Goes and his patron would have discussed the altarpiece in detail before negotiating a cost and a deadline for completion. The choice of subject, symbolism, size, and pigments would have been agreed in advance and specified in a firm contract.

PORTINARI'S PATRON
Van der Goes uses symbols that were understood throughout Europe. Notably, each member of the Portinari family is shown under the protection of his or her patron saint. St. Thomas is identifiable by his spear, St. Anthony by his bell.

SYMBOLIC ANGELS
The 15 angels have been interpreted as a reference to the 15 Joys of the Angels.

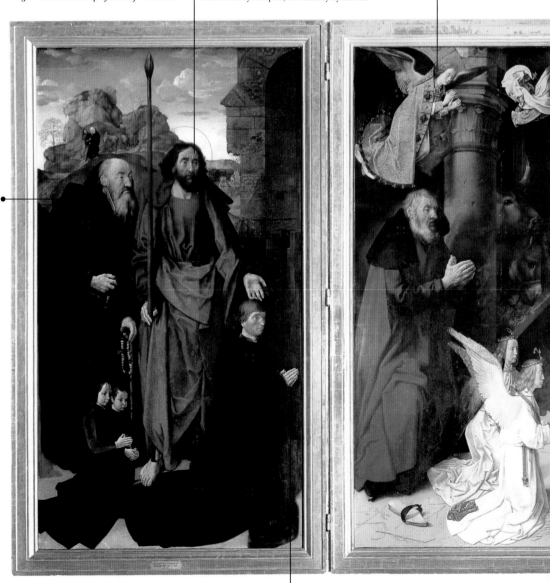

FATHER AND SONS •
Tommaso Portinari is shown kneeling in prayer; behind him are his two sons: Antonio (far left), born in 1472, and Pigello, born in 1474. Pigello has been squashed in as a late addition, suggesting that the work was already well advanced at the date of his birth. Three other children were born between 1476 and 1479.

Lorenzo de' Medici failed to keep control of his overseas operations. Portinari made reckless loans that incurred huge losses. As a result, the Medici Bank in Bruges was closed.

Hugo van der Goes;
Portinari Altarpiece;
c. 1475; 100 x 55 in
(254 x 140 cm); oil on
panel; Uffizi, Florence

Symbolic Flowers
The still life in the foreground is one of the finest details in the painting. The earthenware vase is identifiable as an albarello (possibly from Spain). The scarlet lily symbolizes the blood and passion of Christ, while the white irises symbolize the purity of the Virgin.

● COMPOSITE SUBJECT
The central panel illustrates how artistic ideas were being exchanged between the Netherlands and Italy at this time. The central image with the Virgin and Christ child is a variation on a theme commonly found in Netherlandish art. The image of the adoring shepherds is commonly found in Italian art. Their combination in this way is unprecedented. The Christ child lying naked on the earth is a typical feature of Northern art.

The Magi
The winter landscape in the right-hand panel shows the Three Magi. Italian paintings rarely depict a time of year or a location so specifically.

Northern artists were more interested in objects and their symbolism than in scientific perspective. There is no rational explanation for the strange variations in scale of the figures in the Portinari Altarpiece—van der Goes may have simply struggled to organize a composition on such an unfamiliar large scale.

THE NETHERLANDS
The Netherlands was a center for successful trade, shipping, and banking, and artists were attracted from elsewhere to work in flourishing cities such as Antwerp, Ghent, and Bruges. But the Netherlands was also a perpetual battleground for the political and military rivalries of the major European powers. As a result, many works of art, documents, and even libraries were destroyed, especially in the turmoil of the Reformation. Compared with what was produced, few examples of Netherlandish painting survive, and information about the artists is meager.

● PORTRAIT FACES
All the faces have the quality of portraits taken from life. The men look troubled; the women have fashionably high foreheads and pale faces.

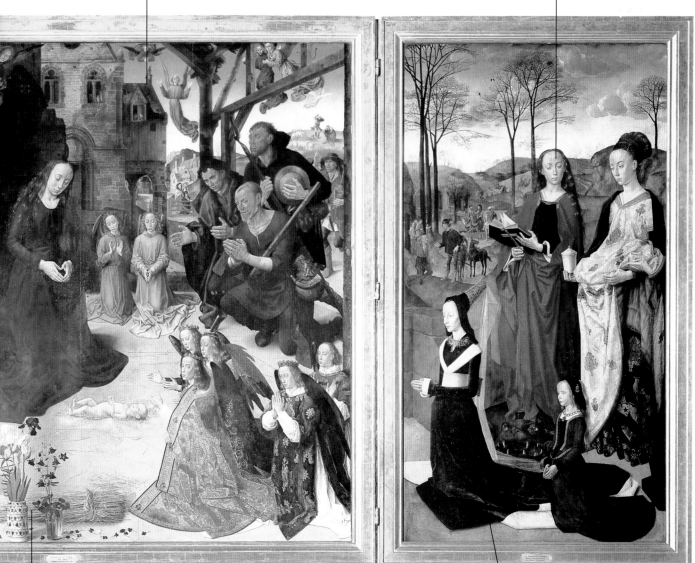

● SYMBOLIC REFERENCES
The sheaf of grain is a reference to Bethlehem; the purple columbine represents the Virgin's sorrow; the red carnations may symbolize the Trinity; and the discarded shoe signifies holy ground.

Anxiety about his art may have contributed to van der Goes' mental instability, which led him to attempt suicide on at least one occasion. A rather unsympathetic account of the artist's illness was written by Gaspar Ofhuys, a fellow monk at the priory. It suggests that the fits took the form of religious mania—the most revered artist of his day was doubtless troubled by guilt for the sin of pride.

MARIA PORTINARI
The kneeling women are Portinari's wife Maria and their daughter Margaret. The dragon between them is an attribute of St. Margaret, who stands next to Mary Magdalene holding the ointment pot.

PIERO (C. 1410-1492)

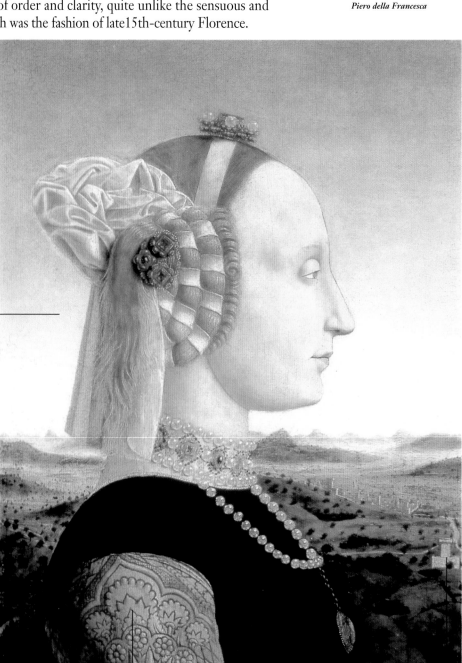

ONE OF THE MOST REVERED ARTISTS of the early Renaissance, Piero was born in a small Italian town, Borgo San Sepolcro (now Sansepolcro), to which he remained deeply attached—at one point acting as a city advisor. His father died when he was young, and he is recorded as working in Florence with Domenico Veneziano (died 1461) in the 1430s. Although he studied the great pioneers of the day, such as Masaccio (p. 12) and Donatello (c. 1386–1466), Piero remained an independent master with an individual mind; he worked outside Florence, receiving commissions for religious works and portraits in Rome, Ferrara, Rimini, and Urbino. Piero's art is one of order and clarity, quite unlike the sensuous and intellectual art of Botticelli (p. 22), which was the fashion of late15th-century Florence.

Piero della Francesca

Like many artists and craftsmen, he lived an uneventful provincial life and died relatively unknown.

BATTISTA SFORZA

In keeping with his character and the role of the artist at the time, Piero's portraits of the Duke and Duchess of Urbino are restrained and respectful. The Duchess was intelligent, well-educated, and influential; she governed Urbino when her husband Federigo was away on one of his frequent military campaigns.

Urbino was the most successful Renaissance state. Its population of 150,000 was ruled over by Federigo da Montefeltro (1422–82), a professional soldier who often held the balance of power in Italy. As a result, his citizens enjoyed low taxes, peace, and stability. Urbino was the birthplace of the great architect Bramante (1444–1514), whom Piero may have given lessons in perspective.

LIGHT

Piero's handling of light is supremely delicate and based on close observation, falling convincingly and naturally from the right. He also used light to create the illusion of depth, using shadow and dark, warm colors in the foreground, changing to pale colors in the distance.

Landscape Background

Piero's inclusion of a landscape background was a new innovation in Italian art—the idea originated in Flemish painting. Piero would have seen works by Rogier van der Weyden when he was working at Ferrara in 1450.

KEY WORKS

• **The Madonna of Mercy;** 1445; *Pinacoteca Communale,* Sansepolcro

• **The Baptism of Christ;** c. 1450; *National Gallery,* London

• **The Story of the True Cross;** c. 1452–57; *San Francesco,* Arezzo

• **Resurrection of Christ;** c. 1453; *Pinacoteca Communale,* Sansepolcro

Piero della Francesca; *Battista Sforza;* 1472; 18½ x 13 in (47 x 33 cm); tempera on wood; **Uffizi, Florence**

BATTISTA'S COSTUME
Battista's brocade sleeve carries a design in gold thread that shows stylized pine cones, thistles, and pomegranates—symbols of fertility and immortality.

BORGO SAN SEPOLCRO
The town behind Battista is not Urbino, but Borgo San Sepolcro, Piero's birthplace.

PIERO AT THE COURT OF URBINO

Piero visited the humanist court of Federigo at Urbino on several occasions between 1469 and 1472. He stayed with Raphael's father, who was a painter at the court. It was at Urbino that Piero discussed perspective and mathematics with the great architect Alberti (1401–72). His portraits of the Duke and Duchess of Urbino may well have been painted in 1472. This was the year of Federigo's famous victory at Volterra, of the birth of his son and heir Guidobaldo, and of the death of his beloved wife Battista—her portrait may be commemorative.

Federigo's Nose
Federigo's curiously shaped nose was the result of an injury sustained in a tournament in 1450. He was taking part in a joust, and, to please a lady friend, he kept the visor of his armor open. His opponent's lance caught his unprotected nose and broke the bridge. His right eye was also badly mutilated.

The portraits were painted as a diptych: two panels hinged together in the middle. On the reverse side, and visible when the diptych is closed, are painted panels showing (and describing in words) The Triumph of Federigo *and* The Triumph of Battista.

Piero died in 1492, one of the most significant dates in European history because of Columbus's voyage to the New World, which established the truth of the theory that the earth was spherical.

● PROFILE POSE
Piero shows Federigo's left profile so that his damaged eye cannot be seen (see above right). The flat profile pose is typical of the period. It acknowledges the influence of the portraits found on Roman coins.

FEDERIGO DA MONTEFELTRO

The most celebrated of the Dukes of Urbino (he ruled from 1444–82), Federigo was the model Renaissance Prince. Sober, upright, and deeply religious, he was fearless and successful on the battlefield, but he was also a scholar with a deep appreciation of the arts. He enjoyed and encouraged the company of poets and painters, and he ran a boarding school for princes and scholars.

Federigo's palace at Urbino was one of the finest examples of early Renaissance architecture and housed the Duke's magnificent paneled library of illuminated manuscripts (he did not allow printed books in it). His collection of art treasures was pillaged and dispersed in 1502 by Cesare Borgia, captain-general of the papacy.

● WARTS AND ALL
Although the pose is contrived, the portrait is realistic and detailed—showing the influence of Flemish painting (p. 18). Piero thrived on careful observation of the world around him and was never afraid to experiment.

❝ *Painting consists of three principal parts— drawing, proportion, and coloring* ❞
PIERO

● PERSPECTIVE
Piero made a close study of perspective, undertaking rigorous mathematical research and publishing a treatise, which he dedicated to Federigo. The landscape here does not use mathematical perspective and does not depict an actual place, but it has been suggested that the curious little hills diminish with distance as they would if placed on a curved surface. This suggests that Piero was aware of the latest theories proposing that the world was round and the surface of the earth curved.

Piero della Francesca; *Federigo da Montefeltro*; c. 1472; 18½ x 13 in (47 x 33 cm); tempera on wood; Uffizi, Florence

● ELEVATED VIEWPOINT
The viewpoint asks us to assume that the Duke is seated on a loggia, but Piero provides no firm evidence such as a wall or chair back. Leonardo da Vinci (p. 24) revolutionized portraiture by introducing a more natural three-quarter pose.

Piero is said to have lost his sight in old age. It was when his eyesight began to fail that he concentrated on his studies of mathematics and geometry. He died a celebrity, but unmarried and without children.

1470–1480

1470 First French printing press.

1472 First printed edition of *The Divine Comedy* by Dante.

1473 Sistine Chapel added to Vatican Palace by Pope Sixtus IV.

1474 William Caxton prints first book in English.

1478 Murder of Giuliano de' Medici, sparking two decades of political strife in Florence.

1479 Union of Aragon and Castile creates the Spanish state.

BELLINI (c. 1430–1516)

GIOVANNI BELLINI LIVED DURING THE PERIOD when the Venetian Empire was the greatest trading power in the world and when Venice itself was the crossroads of Europe. Born into a distinguished family of painters, he was a quiet, industrious man, a slow worker, a family man, and a devout Christian. He learned his craft from his father, Jacopo (c. 1400–71), and was also influenced by his brother-in-law, the famed Mantegna (c. 1431–1506). Bellini was the greatest of the Venetian *Madonnieri*, or Madonna painters, creating altarpieces of exceptional imagination and versatility. He was also skilled in painting portraits and mythologies, which he often integrated with exquisite landscape details. The foremost teacher of his generation, Bellini had a decisive influence on his famous pupils Giorgione (p. 30) and Titian (p. 34). He also had an important influence on the great Northern artist Dürer (p. 26), who made a point of visiting the aged Bellini in 1506, declaring that he was still "the best in Venice."

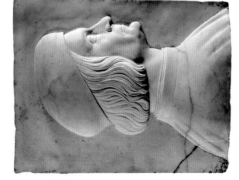

Giovanni Bellini

SAN GIOBBE ALTARPIECE

The altarpiece shows the Madonna and Child enthroned, surrounded by saints—a Venetian specialty known as a *Sacra Conversazione*. It is one of the artist's greatest works and his largest extant painting. Radiating serenity and assurance, the details spell out the depth of Bellini's Christian devotion and his pride in the Venetian Republic.

VAULTED CEILING

The design of the vaulted ceiling has been calculated with a full knowledge of the recently established laws of scientific perspective and architectural design by Mantegna and Piero (p. 16).

INSCRIPTION

The inscription *Ave Virginei Flos Intemerate Pudoris* reads, "Hail undefiled flower of virgin modesty"—a reference to the Virgin Birth. The Virgin was invoked as a protectress of Venice, which, by tradition, was founded on March 25, 421—the Feast of the Annunciation. The altarpiece thus cleverly celebrates the purity of the Virgin and the founding of Venice itself.

ARCHITECTURAL SETTING

The architecture in the painting replicates that of the church. Bellini deliberately set out to create the illusion that the church setting of the picture was an extension of the church itself and that his life-size figures were present in reality.

PERSPECTIVE SETTING

The vaulted ceiling is visible due to the low horizon line in the perspective setting. The artist has positioned the horizon line precisely on a level with the top of the plinth on which the angels are seated.

Bellini's loyalty to Venice was reciprocated by the award of honors from the Republic. In 1483, he was appointed official State Painter and exempted from taxes normally paid by artists to the painters' guild. With his elder brother Gentile (c. 1429–1507), he undertook decorations for the Doge's Palace, depicting triumphal events in Venetian history. Started in 1494, he worked intermittently on the project for 35 years. The paintings were destroyed by fire in 1577.

LAUREL

The laurel leaves suspended above the Virgin Mary symbolize purity—a further reference to the Virgin Birth alluded to in the inscription below. Laurel leaves have also symbolize victory, and here the Virgin appears victorious on her royal throne as the Queen of Heaven.

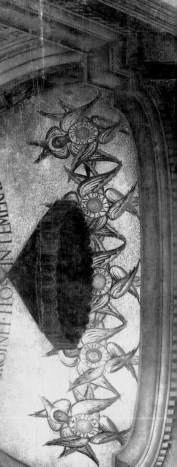

"Since our eyes are educated from childhood on the objects which we see around us, a Venetian painter is bound to see the world as a brighter and gayer place than the rest of us"

GOETHE

Oil Painting Technique

The illusion of light is created by Bellini's subtle and skilled use of oil paint, using a limited palette of warm colors and weaving them together through carefully controlled half tones. He was one of the first artists to master the techniques of oil painting, probably learning the skill from Antonello da Messina, who was in Venice in 1475–76. Antonello in his turn learned the technique from Northern artists such as van Eyck (p. 14).

HOLY FIGURE

The figure who is bound and pierced with arrows is St. Sebastian. He was a popular Renaissance saint and, like St. Job, was often invoked as a protector against plague that frequently ravaged Venice—the result of overcrowding and polluted canals. There was a severe epidemic in 1478, shortly before this work was commissioned.

LA SERENISSIMA

Known as *La Serenissima*—"the most Serene Republic"—the city of Venice was the seat of government for one of the most powerful empires in the world. The Venetian Empire controlled lands in northern Italy and colonies throughout the commercial crossroads of the world and ruled the sea through her powerful navy. Trade from the Far East and China, North Africa, Spain, and the Netherlands all passed through Venice. The decline of the Venetian Empire began after the discovery of new sea routes to the East and the exploration of the New World.

Isabella d'Este, one of the prominent collectors of the time, commissioned a work from Bellini, but he missed the agreed deadline for completion and made so many excuses for his delays that she finally took him to court. However, when he eventually did complete the commission, she was so pleased that she paid him a bonus.

MOTHER AND CHILD

The Madonna and Child face toward the source of the warm golden light, which illuminates the picture from the right. The artist seems to suggest that they are drawing strength from the light—a sort of spiritual sunbathing. Bellini saw light and landscape as a source of divine inspiration.

THE PATRON SAINT

St. Job is nearest to the throne. Often invoked as a protector against the plague (he himself had undergone great physical and mental suffering), he was the patron saint of the hospital that commissioned this painting. Behind St. Job stand the bearded St. John the Baptist and St. Francis of Assisi, who is recognizable by the stigmata wounds on the palms of his hands.

Giovanni Bellini; *San Giobbe Altarpiece;* c. 1480; 185½ x 101½ in (471 x 258 cm); oil on canvas; Accademia, Venice

DEVOTED ANGELS

St. Job was a patron saint of music. Bellini has shown two of the three musical angels looking up devotedly toward the saint.

The setting of the altarpiece is similar to that of Masaccio's Trinity (p. 12). Although Bellini did not see Masaccio's painting, he may have known about it. The mood is very different, however— Bellini emphasizes light rather than darkness, life rather than death.

Sensual Angel

The angels seated at the feet of the Virgin play musical instruments, inviting us to imagine the gentle music that should accompany the work. Venice has always been a city of sensual and visual pleasure rather than intellectual pursuits, and Bellini's altarpiece reflects this character.

ARTIST'S SIGNATURE

Bellini has signed the work by placing his name like a carved inscription on the cartellino fixed to the base of the throne.

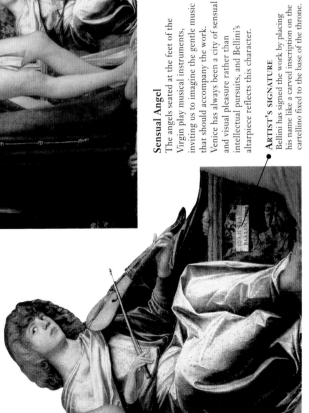

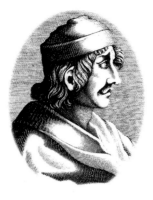

Sandro Botticelli

❝ *Florence was the nest... of the arts, as Athens was of the sciences* ❞
VASARI

BOTTICELLI (1444-1510)

SANDRO BOTTICELLI WAS THE PRINCIPAL PAINTER in Florence in the second half of the 15th century. His refined and feminine style was outside the mainstream of Florentine art, but it found favor with the Florentine intelligentsia in the troubled times in which they lived. Little is known about his early life. Temperamentally, he seems to have been highly strung and inclined to laziness and practical joking. His principal patrons were the Medici dynasty, for whom he created altarpieces, portraits, allegories, and banners. His masterpieces were his large mythological paintings, which promoted a particular type of divinely inspired beauty, combined with complex literary references. After his death, Botticelli's work sank into obscurity, but his reputation revived in the 19th century when artists in search of aesthetic experience were inspired by his portrayal of a dreamlike, otherworldly existence.

KEY WORKS

- **Young Man with a Medal;** c. 1475; *Uffizi*, Florence
- **Adoration of the Magi;** 1482; *National Gallery*, Washington, DC
- **The Birth of Venus;** c. 1484; *Uffizi*, Florence

PRIMAVERA

Primavera shows the garden of Venus, the goddess of love. The painting was probably commissioned by Lorenzo di Pierfrancesco de' Medici (1463–1503) to hang in a room adjoining the wedding chamber of his townhouse in Florence.

MERCURY

Mercury, the messenger of the gods, is shown wearing his winged boots. He was the son of the nymph Maia, whose name was given to the month of May— the month in which Pierfrancesco de' Medici married Semiramide d'Appiano in 1482. Mercury uses his caduceus—a wand entwined with snakes—to hold back the clouds so that nothing can blight the eternal spring of Venus' garden.

ATTENDANTS OF VENUS

Botticelli perfected a style in which crisp line was paramount. The intertwined hands, intricate drapery folds, and flowing hair of the Three Graces display his skill to the fullest. Their pointed faces, long necks, sloping shoulders, and curving bellies embody the ideal of feminine beauty in Renaissance Florence.

Stylized Flowers

Flora's gown is appropriately decorated with flowers that are slightly raised to imitate embroidery. Botticelli was fascinated by decoration and stylized pattern. Other examples in this painting are the "halo" of foliage that is silhouetted against the sky around Venus, the carpet of flowers, and the pattern formed by the golden orbs of fruit and the rich green leaves.

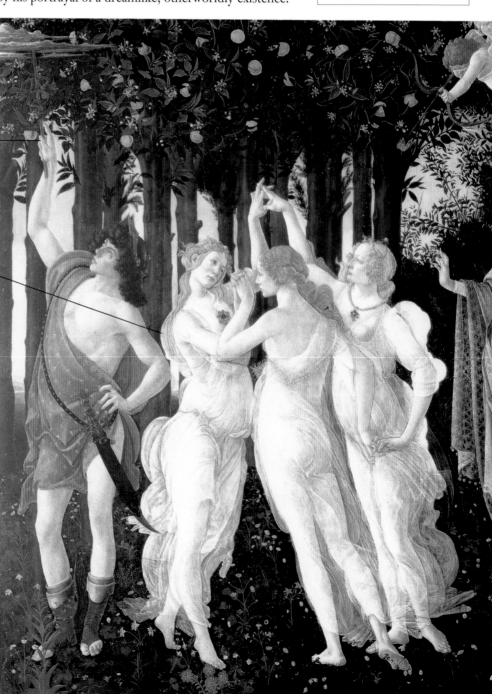

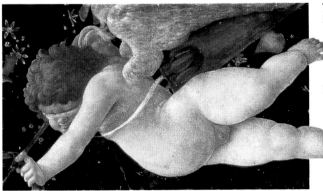

The God of Love
Botticelli's pot-bellied and mischievous Cupid, the god of love, contrasts with the solemn and slender figures below. He is characteristically blindfolded (love is blind) and is close to his mother, Venus. He aims an arrow, burning with the flames of love, at one of the Three Graces—in mischief, or as a subtle compliment to Pierfrancesco's bride? It is tempting to see Botticelli, the practical joker, quietly at work.

● **GODDESS OF LOVE**
Venus presides over the scene with her right hand raised as if in blessing. Significantly, she is shown wearing the characteristic headdress of a Florentine married woman— another reference to the nuptial theme of the painting.

Botticelli's real name was Alessandro di Mariano Filipepi. He and his brothers were given the nickname Botticelli, which means "little barrels" in Italian, after their elder brother, who was a successful businessman dealing in barrels of merchandise. The nickname almost certainly alluded to his wealth rather than his stature.

Botticelli was adept at playing a game enjoyed by many early Renaissance artists—that of making clever cross-references through a play of words and images. Thus the flames on Venus' and Mercury's robes may refer to St. Laurence, who was burned (a reference to the name Lorenzo); the round golden fruit are reminiscent of the golden orbs on the Medici family crest; and Mercury is shown holding a caduceus, the symbol of doctors (the name Medici means "doctors").

● **WEST WIND**
This blue winged figure is one of Botticelli's most imaginative inventions. It is the ghostly Zephyrus, god of the West Wind and herald of Venus. He is pursuing his lover, Chloris.

Like all Renaissance artists, Botticelli ran a workshop. Known as "an academy for idlers," the name suggests that Botticelli may, himself, have been a lazy man.

● **FLORA**
Flora, the goddess of flowers, is the principal figure who balances the right-hand side of the painting. She tiptoes across the meadow of flowers as the embodiment of beauty, strewing blossoms around her. She provides a further reference of the joy of marriage and is a symbol of Florence, the "City of Flowers."

● **CHLORIS AND ZEPHYRUS**
Behind Flora, Botticelli shows her courtship with Zephyrus. When Zephyrus fell in love with Chloris, he pursued the startled nymph and took her as his bride, transforming her into the goddess Flora. Botticelli ingeniously, if somewhat artificially, shows how Flora emerged from the courtship.

Sandro Botticelli; *Primavera;*
c. 1480; 80 x 123½ in (203 x 314 cm);
tempera on panel; Uffizi, Florence

LEONARDO (1452–1519)

THE MOST EXTRAORDINARY GENIUS of the Renaissance, Leonardo stood outside the mainstream. He was much more than an artist and architect—his restless mind and insatiable curiosity led him to make important discoveries and innovations in disciplines as diverse as engineering, anatomy, aeronautics, art theory, music, and theater design. He was born in Vinci, near Florence, the illegitimate son of a notary at a time when illegitimacy was a serious stigma. This may have been a factor that led him to become detached from others. He trained in Florence with Andrea del Verrochio (c. 1435–88), a talented painter and sculptor with a large workshop, but much of his life was spent working at the courts of foreign dukes and princes who at times were at war with Florence. The ruling family of Florence, the Medici (p. 22), ignored him entirely. After 1483, he worked for Ludovico Sforzas, Duke of Milan, but returned to Florence after the French invasion of Milan in 1499. Between 1500 and 1516, Leonardo produced many of his most famous paintings. He spent his last years in the service of the French monarchy and died near Amboise in the Loire Valley.

Leonardo da Vinci

"Curiosity and the desire for beauty—these are the two elementary forces in Leonardo's genius; curiosity often in conflict with the desire for beauty, but generating, in union with it, a type of subtle and curious grace"

WALTER PATER

THE VIRGIN OF THE ROCKS

The origins of this famous painting are obscure. It was commissioned as an altarpiece by the Confraternity of the Immaculate Conception in San Francesco, Milan. However, there is an earlier version of this work, now in the Louvre in Paris, which suggests that the artist sold his original painting to the French king rather than delivering it to the Confraternity as required by his contract. He probably created this second version in order to fulfill his contractual obligation.

The subject matter is obscure and unconventional. Leonardo shared neither the typical Renaissance belief in Christian devotion nor the admiration for antiquity. His inspiration came from nature, and this is reflected here.

IDEAL BEAUTY

The face of the Virgin, with her young, well-balanced features, heavy eyelids, and pointed chin, represents Leonardo's notion of ideal beauty, a type that he introduced in many paintings, most notably in the Mona Lisa.

Leonardo's Notebooks

Throughout his life, Leonardo filled many notebooks with copious notes and sketches in which he explored his private thoughts about art and science, recorded his observations of natural phenomena, and drew diagrams for scientific and mechanical projects.

Leonardo da Vinci; *Water*; c. 1508; 8 x 6 in (20 x 15 cm); pen and ink drawing; Royal Collection, Windsor

Leonardo's notes are written in his famous "mirror writing," which travels from right to left. Left-handedness was considered "sinister" and was a cause of Leonardo's sense of isolation from other people.

ROCKY BACKGROUND

Rocky formations and water were a lifelong fascination for Leonardo. His birthplace, Vinci, overlooks the River Arno where it enters a rock gorge. His first datable work is a drawing of an Arno landscape (1473), which already shows his interest in the structure of the Earth.

Leonardo's mind was both practical and theoretical: as well as observing what things looked like, he wanted to know how they worked and what they meant. He was interested in the relationship between science and art, the definition of beauty, and the status of the artist.

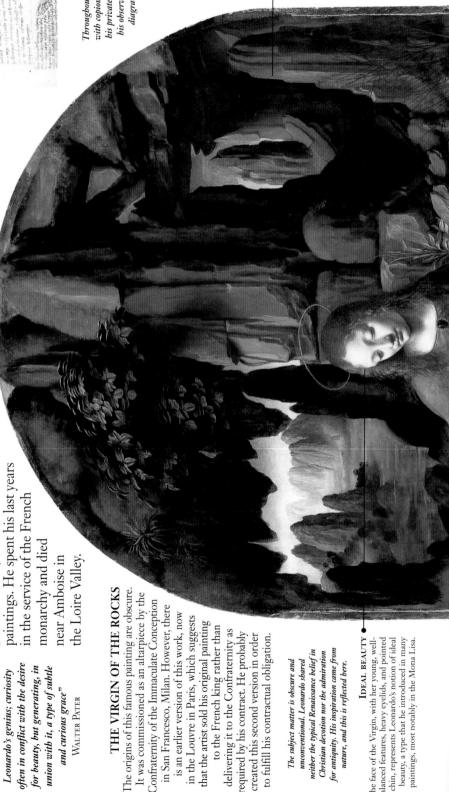

SFUMATO

The artist's mastery of light and shadow is evident in the face of the angel: the gentle luster in the eyes, the delicate highlights in each curl of hair, the soft shadows. Leonardo introduced the technique of *sfumato*—the soft, "smoky" handling of paint and outline that makes forms merge into one another. The effect produced greater realism and enhanced the mood of a painting.

Leonardo was notoriously unreliable when it came to fulfilling commissions and left many works unfinished. He grew bored with the physical task of painting once he had solved the intellectual problems of content and composition.

UNFINISHED

Some areas of the painting are not finished, such as the left hand of the angel placed on the back of Christ.

KEY WORKS

- **Annunciation**; 1472–74; *Uffizi*, Florence
- **The Adoration of the Magi;** 1481; *Uffizi*, Florence
- **Last Supper;** 1495–97; *Santa Maria delle Grazie*, Milan
- **Mona Lisa;** 1503–06; *Musée du Louvre*, Paris

Leonardo was interested in exploring underlying human motivations as well as scientific causes. Today, we would call such an interest psychology. Leonardo referred to it as "the motions of the mind."

FRANÇOIS I AND LEONARDO

François I (1494–1547) secured the foundations of the French monarchy and its future leadership of the arts. He had a lifelong admiration for Italian politics and culture, which led him to invade Italy. A good scholar, he acquired classical antiquities and major works by the leading Italian artists (including Leonardo's *Mona Lisa*). He contrived the marriage of his son Henry to Catherine de' Medici, employed Italian military engineers and courtiers, and promoted the adoption of Italian manners at court. Thus, it is no surprise that he recognized the genius of Leonardo and persuaded him to reside in France. According to legend, Leonardo died in the King's arms.

ST. JOHN

The halos and the reed cross carried by St. John did not appear on the original painting. They were added by a later hand.

EXPRESSIVE HANDS

The Virgin's right hand rests protectively on the shoulder of the infant Baptist, while her foreshortened left hand hovers above the head of her son. Leonardo has employed these gestures to help unify the grouping and, at the same time, create a mood of tenderness and mystery.

Leonardo da Vinci; *The Virgin of the Rocks*; 1508; 75 x 47¼ in (190 x 120 cm); oil on panel; **National Gallery, London**

1510–1520

1511 French driven out of Italy.

1513 Giovanni de' Medici elected as Pope Leo X.

1514 Portugal starts to trade with China by sea.

1515 François I crowned King of France. France invades Italy.

1517 Martin Luther questions Papal infallibility.

1518 Spanish discover Mexico.

1519 Ferdinand Magellan sets out to circumnavigate the globe.

FAMILY GROUP

Leonardo has adapted the conventional family group of Virgin, Christ child, and St. John by adding an angel whose presence remains unexplained.

FOREGROUND

The foreground is unfinished. In the earlier version in the Louvre, Leonardo included water in this area.

Leonardo was so successful in raising the status of the artist from skilled craftsman to world-famous virtuoso that even in his own lifetime collectors went to great lengths to acquire a work—however small—made by his hand. This altarpiece was bought by the Scottish painter Gavin Hamilton in 1785, while he was residing in Italy. He brought it back to London and sold it to Lord Lansdowne. It was acquired by the National Gallery in 1880.

Leonardo used hand gestures and facial expressions to express the inner emotions of his figures. He wrote, "A good painter is to paint two things, namely man and the working of man's mind. The first is easy, the second difficult, for it is to be represented through the gestures and movements of the limbs."

Close Observation

The curls in the hair are closely related to Leonardo's drawings of flowing water (top right). In his notebooks, he remarks how the shapes formed by flowing water resemble the curls in hair; and that there are similarities between the spiral movement of water and the spiral growth of some plants.

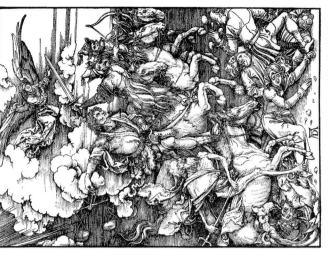

DÜRER (1471–1528)

Born in Nuremberg, Germany, Dürer was the son of a goldsmith and initially trained in his father's workshop. His earliest influences were the medieval traditions of northern Europe: fine craftsmanship, strong imagery, and the Gothic heritage. However, his precocious talent, combined with his curiosity, ambition, and desire to travel, led him to break with those traditions. His visits to Italy were to have a decisive influence on his life. There, he discovered the new methods of observation and the new artistic styles and techniques of the Italian Renaissance, and was particularly impressed by the paintings of Bellini (p. 20). He was also inspired by the elevated status of artists in Italy and was determined to raise the status of art in the North. After his return to Germany, Dürer intensified his studies of geometry and mathematics, seeking the company of scholars rather than that of his fellow artisans. He became the main channel through which Italian ideas flowed to the North, and his influence reverberated throughout Europe. However, he produced relatively few paintings himself, devoting most of his energy to printmaking—an art in which he was supremely gifted.

Albrecht Dürer

❝ *Here (in Italy), I am a gentleman; at home I am a parasite* ❞
ALBRECHT DÜRER

SELF-PORTRAIT
In this painting, Dürer is elegantly dressed in a self-conscious desire to portray himself as a gentleman, not an artisan. The work was part of a strategy to raise the status of the artist and shows that he has absorbed the latest Italian ideas.

Dürer was inspired by the argument of Leonardo da Vinci (p. 24) that originality and inventiveness effectively meant more than diligence and craftsmanship. Such ideas were unheard of in Germany.

FACIAL FEATURES
Although he dresses himself up (the expensive doeskin gloves are a Nuremberg speciality), Dürer records his facial features with dispassionate accuracy. The numerous self-portraits testify to his obsession with his own appearance.

CAP AND GLOVES
The artist's cap is the height of fashion, and his costume, with its fine embroidered border, is supremely elegant. Dürer was a proud man who never doubted his talents or their value to posterity.

Dürer lived in troubled times: Martin Luther (1483–1546) challenged the power of the Catholic Church and laid the foundations of a religious and political schism that haunted European affairs to this day. It is likely that Dürer himself converted to the Protestant cause.

The Apocalypse
One of Dürer's best-known works is the series of 14 woodcuts of scenes from the Apocalypse that was issued as a book with the relevant biblical text. Instantly popular, it struck a chord with the troubled mood of the day and had a profound influence on Italian artists.

Albrecht Dürer: *Four Horsemen of the Apocalypse;* c. 1498; 15⅜ x 11 in (39 x 28 cm); woodcut; The Metropolitan Museum of Art, New York

The Apocalypse, the last book of the New Testament, predicts the Second Coming of Christ and the end of the world. In the lower left-hand corner of the above engraving, the jaws of Hell devour a bishop—a symbolic reference to the corruption in the Catholic Church.

MOUNTAIN LANDSCAPE
To reach Venice from his native Nuremberg, Dürer crossed the Alps, and the mountain scenery made an enormous impression on him. He recorded it in drawings and watercolors, which would then have been used to create the view seen through the window.

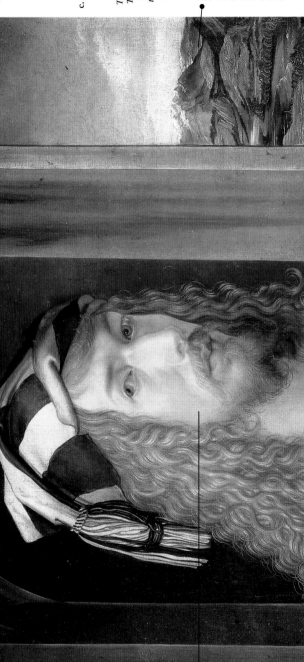

Woodcuts are made by cutting into a block of wood to leave ridges that will print as black lines. Simple Renaissance problems of woodcuts, which were the standard means of illustrating printed books, left large white spaces that were then colored by hand. Dürer introduced new and sophisticated expression: he filled the spaces with lines and hatching to create light and shade, and he employed swirling rhythms and tense, complex lines.

INSCRIPTION

The inscription under the window reads "1498. This I painted after my own image. I was 26 years old." The monogram with the initials AD appears in nearly all Dürer's work.

KEY WORKS

- **Adam and Eve;** 1504; *British Museum*, London
- **Feast of the Rose-garlands;** 1506; *National Gallery*, Prague
- **Madonna of the Siskin;** 1506; *Staatliche Museen*, Berlin
- **St. Jerome in his Study;** 1514; *British Museum*, London
- **Four Apostles;** 1526; *Alte Pinakothek*, Munich

It was traditional for young German craftsmen to spend a few years traveling upon completion of their apprenticeship, but most traveled in northern Europe rather than to Italy. Dürer's first ambition was to go to Colmar, near Strasbourg, to visit Germany's leading painter and engraver Martin Schongauer, but he died in 1492, and Dürer never met him.

Love of Detail

The painstaking treatment of the curls of the artist's hair shows the artist's fascination with detail, while in giving them the appearance of engraving on gold he reveals the legacy of the training in his father's workshop. His supreme printmaking was also assisted by his knowledge of the goldsmith's work.

In the late 1490s, Dürer was preoccupied with engravings and woodcuts. However, much as printmaking has been admired, it has always occupied an inferior status to painting. For this reason, gifted printmakers such as Dürer, Rembrandt (p. 43), and Whistler (p. 80) have felt the need to prove themselves first and foremost as painters.

ITALIAN STYLE

The half-length format was often used by Dürer. The relaxed pose with the arms resting on a sill, the head turned on the body, and the window in the background show that he has adopted the latest ideas in Venetian portraiture. On the other hand, however, the refusal to idealize his face and features, the meticulous observation of detail, and the angular—rather than smoothly rounded—style all demonstrate that he has not abandoned his Northern roots.

Dürer had a lifelong interest in art theory and studied the problems of perspective and proportion. He published a Treatise on Measurement in 1525, and his Four Books on Human Proportion were published posthumously in 1528.

This painting belonged to King Charles I of England, who was a notable connoisseur and collector (p. 40). He received the work as a gift from Lord Arundel who, in turn, had been presented with it by the Town Council of Nuremberg. After Charles' execution the picture was bought by Philip IV of Spain.

Albrecht Dürer; *Self-portrait*; 1498; 20½ x 16¼in (52 x 41 cm); oil on canvas; Museo del Prado, Madrid

THE REFORMATION

In the early 16th century, the Catholic Church was rife with corruption to which a German priest, Martin Luther, protested in a series of theses. Although they were originally intended as reforms within the existing Church order, Luther's ideas ultimately led to the division of Western Christendom and the formation of the new Protestant Church. Dürer, who was profoundly influenced by Luther's ideas, supported the reforming quest for spiritual truth. However, he was repelled by the excesses of violence instigated by the Reformation.

MICHELANGELO (1475-1564)

SCULPTOR, PAINTER, ARCHITECT, AND POET of genius, Michelangelo exerted a profound influence in his own long lifetime (he lived to be 89), and his work directly affected every generation of artists until the 20th century. He was born near Florence, the son of a minor official with noble lineage, and he showed his talent at an early age. He was apprenticed to the painter Ghirlandaio and learned much from his studies of the frescos of Giotto and Masaccio (p. 12), but, deeply influenced by Donatello (c. 1386–1466), his first love was always for three-dimensional form. His reputation was established by his sculpture, notably his *Pieta* in Rome (1498) and his *David* in Florence (1501–04), both created before he was 30 years old. He was a devout Christian, and his commitment to his religion is one of the inspirations in his art. He was also a passionate admirer of antiquity, and the influence of classical sculpture touches every corner of his work. In painting, his overwhelming achievement is to be found in the Sistine Chapel in Rome. He worked on the ceiling for four years between 1508 and 1512, when he was in his mid-30s (*The Last Judgement* was begun in 1534). Michelangelo spent most of his working life in Rome—the last two decades as Architect-in-Chief of the new St. Peter's—creating some of his finest and most moving sculpture and poetry.

Michelangelo Buonarroti

66 *One does not achieve inner discipline until one reaches the extremes of art and life* **99**
MICHELANGELO

THE LAST JUDGEMENT
The proposal for this extraordinary project came from the Medici pope, Clement VII (1478–1534). Initially, Michelangelo was unenthusiastic, but he warmed to the idea.

The painting is conceived on a monumental scale. There are over 400 individual figures, and the pose of each is different. There are deliberate strange discrepancies in the scale of the figures, and the space is unworldly and ambiguous. The mood is somber, and even the faces of those who have achieved salvation are pensive and troubled. Joy is noticeable only for its absence.

INNER CIRCLE
Surrounding Christ are saints, prophets, and patriarchs who seem perplexed and terrified by Christ. By His right side, the Virgin Mary, who traditionally intercedes on behalf of sinners, seems to cower unnoticed.

LATER ADDITIONS
The scenes in the lunettes show the instruments of Christ's Passion. They were added (obliterating an earlier work by Perugino) when he realized his design had to fill the whole wall.

During the period in which Michelangelo painted this work, the Roman Catholic Church was gripped by uncertainty. Michelangelo himself was very much affected by this mood: whereas his Sistine Chapel ceiling radiates confidence and harmony, here is nothing but disharmony, violent movement, and grim questioning.

Michelangelo; *Dying Slave*; 1513; 89 in (226 cm); Musée du Louvre, Paris

Dying Slave
The so-called *Dying Slave* was one of several statues created in 1513–15 for the tomb of Pope Julius II, a project that occupied Michelangelo for nearly 40 years and was never completed. The sensuous pose and idealized beauty show the artist free from the spiritual torment of his later years.

Argumentative and belligerent, Michelangelo found relationships with others difficult. He was homosexual and tortured by guilt. He did not establish happy relationships and probably chose to remain celibate. As he grew older, his consciousness of man's state of sin, and his own failings, increased.

WRATHFUL CHRIST
Christ does not sit in majesty and judgement but presses forward with boundless energy, seeming to raise up the good with his right hand and dismiss the damned with his left. Michelangelo's unusual interpretation of the subject breaks firmly with tradition.

Michelangelo; *The Last Judgement*; 1536–41; 48 x 44 ft (14.6 x 13.4 m); fresco; Sistine Chapel, Rome

MALE NUDE

The variety of poses shows the artist's supreme understanding of the male body (which he had dissected in the course of his studies). Each of the figures is conceived as three dimensional and could be realized as a piece of sculpture.

THE DAMNED

Michelangelo uses traditional symbols creatively—for example, St. Catherine puts her wheel to good use to repel the damned who attempt to rise heavenward. Devils are also on hand to drag the damned downward.

The fresco took over five years to complete, longer than it took to paint the Sistine Chapel ceiling. It covered an earlier fresco by Perugino. Windows had to be blocked up, and the effect of the commission altered both the lighting and the interpretation of the other works in the Chapel.

1530–1550

1531 Halley's Comet appears.

1534 Jesuit Order founded.

1536 Church of England founded.

1540 Circulation of the blood discovered.

1545 First botanical garden at Padua. Council of Trent.

1547 Nostradamus's first predictions.

KEY WORKS

- **David;** 1501–04; *Galleria dell' Accademia*, Florence

- **The Fall and Expulsion;** 1509–10; *Sistine Chapel*, Rome

- **The Creation of Adam;** 1510; *Sistine Chapel*, Rome

- **Madonna and Child;** 1520; *Casa Buonoti*, Florence

MINOS

The figure bound by a snake is Minos, an inhabitant of the underworld—a conscious reference to classical antiquity and to Dante's *Inferno*. It is said to be a portrait of Biagio da Cesena, the papal Master of Ceremonies, who was an outspoken critic of the artist's work.

Books of Lives

Two angels hold books in which are written the names of the damned and the saved. They show the lists to those who are included. The book with the names of the damned is noticeably larger.

CHARON

Charon, who ferries the damned across the River Styx, is especially terrifying. He uses his oar to beat his doomed passengers. It is a reference to Dante's *Inferno* and a reminder of medieval ideas concerning death and sin (see p. 12).

Grotesque Self-portrait

St. Bartholomew holds his attribute, a flayed skin, and dangles it over the abyss. The distorted face is traditionally said to be a self-portrait of the artist. Michelangelo depicts himself excluded from Paradise—an indication of his spiritual torment at this period.

PAPAL COMMISSIONS

From 1505 Michelangelo was constantly employed by the papacy, although the relationship was often stormy. The massive tomb for Pope Julius II and the architectural and sculptural projects for San Lorenzo in Florence were never completed. Later, he supervised the designs for the reconstruction of St. Peter's. The fresco paintings in the Sistine Chapel are the only commissions that Michelangelo originated and completed for the popes.

Many hostile critics described the work as obscene. When Pope Paul IV suggested that Michelangelo should "tidy up" the work (meaning paint over exposed genitals), the artist replied, "tell the Pope that this is a small thing... in the meantime he should tidy up the world, for pictures are readily tidied up...". The Council of Trent decided to amend the frescoes and ordered drapery to be added to the nudes.

RISING DEAD

On the left-hand side of the painting, the dead are awakened by the trumpets of seven angels. They rise up from their graves and ascend heavenward—some struggling, some aided by others, some apparently self-propelled.

29

GIORGIONE (C. 1477-1510)

ETAILS ABOUT GIORGIONE'S LIFE are as elusive as the meanings of his paintings. Even in his own short lifetime, however, he was recognized as a genius who radically changed ideas about the nature of painting and the status of the artist. Born in Castelfranco, near Venice, he studied in Bellini's workshop (p. 20). It is said that he came from a humble background but was highly intelligent, musical, and attractive to women. He met Leonardo da Vinci (p. 24) in 1500 and was influenced by his views on the role of the artist and his ideas on beauty. Giorgione worked principally for private patrons who had sophisticated intellectual interests and wished for small paintings with a poetic or philosophical content. It seems Giorgione shared their interests and was accepted as an equal. He was also interested in exploring new techniques of oil painting, which allowed a heightened level of luminosity and softness. The artist's early death deprived Venetian art of the full flowering of one its greatest masters.

Giorgio Barbarelli

EROTIC THEME
The erotic nature of the image suggests that it may have been commissioned to hang in a private bed chamber.

SLEEPING VENUS
Universally known as the *Dresden Venus*, this was an image of exceptional originality—there were no precedents in the art of classical antiquity. The work demonstrates the artist's interest in an new ideal of beauty, where the evocation of poetic mood takes precedence over intellectual content.

Sleeping Goddess
The reclining nude became one of the most popular images in European painting. Giorgione shows the naked figure asleep under a rock, her eyes closed, lost in her dreams and unaware that she is observed. Almost all subsequent versions of the theme show the figure awake. In his *Olympia*, Manet (pp. 76–77) notably portrayed a "Venus" offering sexual favors.

LEONARDO'S INFLUENCE
The soft shading and rounded forms of Venus's body show the influence of Leonardo da Vinci, as does the treatment of the folds in the drapery. The *Dresden Venus* was painted in the same decade as the *Mona Lisa*—both images were much copied and imitated from the outset.

Because of Venice's fortunate geographical position as a world center for art and trade, Giorgione came into contact with a very wide range of influences from Europe and the East. Several collections in Venice contained work by important Netherlandish artists; Giorgione would have seen many prints, notable those of Dürer (p. 26). Giorgione's Venus suggests as much the languorous beauty of the Turkish odalisque as the divine beauty of the Goddess of Love.

KEY WORKS

• **La Tempesta;** 1505–10; *Accademia*, Venice

• **Laura;** 1506; *Kunsthistorisches Museum,* Vienna

• **The Three Philosophers;** c. 1509; *Kunsthistorisches Museum,* Vienna

MASTERY OF OIL PAINT
The carefully modeled shadows and highlights of the rich cloth on which Venus lies demonstrate Giorgione's mastery of the new techniques of oil painting.

Giorgione proposed a new and sensual interest in the beauty of the human form. The early Renaissance ideal—as seen in Botticelli's Primavera (p. 22)—depends on specific intellectual connections, but Giorgione deliberately breaks away from this approach. He creates an ideal of beauty designed to appeal directly to the senses rather than the mind.

Finishing Touches
The painting was reputedly left unfinished at Giorgione's death, and it is generally accepted that Titian (p. 34) was commissioned to complete the landscape. The "layered" recession of the landscape and the distant blue hills are characteristic of Titian's early style. His rival's early death left Titian's star firmly in the ascendant.

DRESDEN

In the 18th century Dresden became one of the great artistic centers of Europe. The Electors of Saxony formed a notable picture collection that included many Italian masterpieces, including Raphael's *Sistine Madonna* (p. 32) and Giorgione's *Venus*, which was one of the earliest acquisitions. Dresden became a place of pilgrimage for young artists and intellectuals, and by the end of the 18th century there was a flourishing Academy, which attracted artists such as Friedrich (p. 64). Dresden was heavily bombed in World War II, and some of the paintings were lost. However, since the reunification of Germany in 1990, the famous Picture Gallery has been restored.

Legend has it that Giorgione employed Titian to work with him on a prestigious commission decorating the facade of the headquarters of one of the German merchant companies in Venice. The established master Giorgione was congratulated on a figure of Judith, which he was told was the best thing he had painted for a long time. In fact, the figure was painted by Titian. Giorgione did not speak to Titian again.

DESERTED TOWN
The deserted town in the background enhances the mysterious mood of the painting. It is a motif that recurs in Giorgione's famous work *La Tempesta*.

In October 1510, Isabella d'Este, who was one of the most passionate collectors of the Renaissance, wrote to her agent in Venice asking him to acquire a work by Giorgione—a sure indication of the eminence of his reputation. The agent replied that he could not fulfill the request because Giorgione had recently died of the plague.

> **❝ *He filled with admiration every heart, so much alive seemed Nature in his art* ❞**
> Boschini

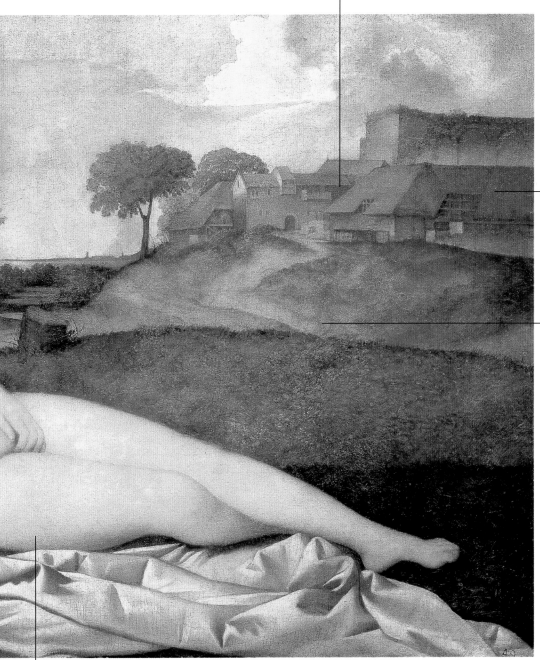

LANDSCAPE BACKGROUND
An interest in landscape was a feature of Venetian painting, which led to the pure landscape painting of the 17th and 18th centuries. In particular, Venetian art created a vision of a harmonious union between figures and landscape (in Florentine painting, landscapes were always of secondary interest to figures and faces).

LOST CUPID
There is evidence from X-rays and from records of restoration in the 19th century that Giorgione originally included, or thought of including, a figure of Cupid on the right-hand side of the picture. At some point the figure was painted out.

Giorgione; *Sleeping Venus*; 1508–10; 42½ x 69 in (108.5 x 175 cm); oil on canvas; Gemäldegalerie, Dresden

1500–1510

1500 Venetians print music with moveable type. Portugal claims Brazil.

1503 The Republic of Venice signs peace treaty with the Turks. The election of Pope Julius II.

1506 Antique statue *The Laocoon* unearthed in Rome. Columbus dies.

1507 America named after Amerigo Vespucci. Machiavelli: *The Prince*.

1509 Constantinople destroyed by earthquake. France and the Papacy declare war on Venice.

c. 1510 Leonardo: *Mona Lisa*.

GENTLE CURVES
The gently undulating outline of the body enhances the sensation of heavy-eyed sleep and encourages the eye to cast a caressing gaze over the figure.

There were many sources of lucrative patronage in Venice, both from the State and the Church. In general Giorgione seems to have ignored them, perhaps because their artistic taste was too conservative, preferring to work for a small group of private patrons who commissioned small paintings that reflected their poetic and musical interests.

Experimental Sketches

The sketches show Raphael experimenting freely with possible poses of a mother and child. The page is not directly related to the Sistine Madonna, but there would have been similar sketches, which sadly are now lost. Heads, hands, and draperies interested him particularly.

Raphael: *Studies of the Virgin and Child; c. 1510; 10 x 7¼in (25.5 x 18.5 cm); pen and ink; British Museum, London*

From his experimental sketches, Raphael went on to work out a finished design for the picture, perhaps trying several versions until he found the right one. He would then proceed to a full-sized cartoon, which would be used to create the outlines on the canvas for the finished picture.

RAPHAEL (1483–1520)

ALTHOUGH RAPHAEL LIVED A CHARMED LIFE, he died tragically from fever on his 37th birthday. He was born into cultured surroundings in Urbino, where his father worked for the Duke (p. 16), and was apprenticed to Perugino (c. 1445–1523)—one of Italy's leading painters. In 1504, Raphael was in Florence at a time of great creativity, and he was able to study works by Giotto, Masaccio (p. 12), and Michelangelo (p. 28). All accounts tell of Raphael's beautiful appearance, his graceful manner, and his gentlemanly conduct. He was to become a favorite of Pope Julius II, who first summoned him to Rome in 1508 to decorate the papal apartments. The project inspired Raphael to produce works of genius, and from then on all his activities were commissioned by the papacy. His natural ease endeared him to the papal officials and to women (Raphael was renowned for his many love affairs). His mature style set a standard of perfection for European art until the end of the 19th century and was the example for all artists who aspired to develop a classical style.

Raffaello Sanzio

❝ The divine genius of Raphael reached a height that no one else will surpass or equal ❞
GOETHE

THE SISTINE MADONNA
This altarpiece was Raphael's final major work on a theme that was particularly dear to him—the Madonna and Child. Much of his early work in Florence centered on this theme, which he reworked with constant variation and invention.

Like all of Raphael's work, this painting has a seemingly effortless grace, which belies the careful planning and attention to detail involved in its creation.

EFFECTIVE POSE
Raphael was noted for his skill in working out a pose that expressed the intention and movement of the figure and harmonized with the emotion shown in the face. Here, the Christ child is not the active, precocious infant portrayed by Leonardo (p. 23). His expression is questioning and wary, and this mood is echoed in His posture.

ST. SIXTUS
St. Sixtus (Pope Sixtus II, who was martyred in 258 CE) intercedes between the worshiper, who would be kneeling before the altar, and the Virgin Mary.

The work was commissioned as an altarpiece for the chapel of the convent of St. Sixtus in Piacenza. Julius II, when still a Cardinal, had made a contribution to the original building fund for the chapel, which housed the supposed relics of St. Sixtus and St. Barbara.

CELESTIAL VISION
The curtains give the impression that they have just been swept back to reveal a heavenly vision of the Madonna and Child floating on a celestial cloud.

FLOWING VEIL
The Madonna envelops the Christ child in a protective circle formed by her left arm, His right arm, and her flowing veil.

VIRGIN AND CHILD
The Madonna and Child show the sweetness of expression and the graceful fluid pose for which Raphael has always been famed. The Virgin holds the Christ child with confidence and maternal gentleness, and He nestles her side in response.

1520 Luther excommunicated. Chocolate introduced in Europe from Mexico.

1521 First silk manufactured in France. Belgrade falls to Turks.

1524 Peasants Revolt in Germany.

1525 French driven out of Italy.

1526 First European settlement in the US (in South Carolina).

1527 Sack of Rome by Charles V.

1530 Charles V crowned Holy Roman Emperor.

St. Barbara

St. Barbara's pose is modest and demure, and it accords with the expression on her face with its lowered eyes. She is the patron saint of victories—appropriate for the political and military victory that Julius II had just won (see below).

Leonardo almost certainly inspired Raphael to discover the power and practicality of drawings when, as a young man, he worked in Florence. Raphael used drawings to bring a new freedom of ideas, composition, and poses to painting.

Raphael; *The Sistine Madonna;* 1513; 106 x 79 in (269.5 x 201 cm); oil on canvas; Gemäldegalerie, Dresden

In June 1512, Pope Julius II won a crucial victory over dissenting states, and there were major celebrations in Rome. At the same time, Piacenza announced that she would voluntarily show allegiance to the Papacy. As an acknowledgment, Julius II commissioned this work as a gift to the convent.

Key Works

- **The Alba Madonna;** c. 1510; *National Gallery,* Washington, D.C.
- **The School of Athens;** 1510–11; *Stanza della Segnatura, Vatican Museums,* Rome
- **Galatea;** 1513; *Villa Farnesina,* Rome
- **The Transfiguration;** 1520; *Vatican Museums,* Rome

Foreshortened hand

The right hand and arm are a dramatic and skillful example of foreshortening. Michelangelo was skilled at inventing unusual poses, and Raphael may have been responding competitively to his great rival.

Papal robes

St. Sixtus wears a cape decorated with acorns, which are the emblem of the della Rovere family—the family of Julius II.

In the 18th century, this altarpiece was sold to the Elector of Saxony, who built up a famous picture collection in Dresden, Germany. Today, not a single altarpiece by Raphael can be seen in its original setting. Most have been seriously damaged by unwise cleaning and restoration. Fortunately, this painting is still remarkably well preserved.

Pope's tiara

A papal tiara is placed on an illusionistic shelf between the heavenly vision and the viewer.

Raphael's method of proceeding from sketches to the finished work became the standard studio practice and basis of the academic tradition until the end of the 19th century. This method allowed the use of studio assistants to work on the finished design, once it had been worked out by the artist. Michelangelo worked quite differently, and in isolation. He was critical of Raphael's work, and there was no love lost between them.

Cherubim

Two angels appear to have escaped from the Heavenly Host in the background. These winged infants have more in common with mythological putti than the Church's cherubim. Their presence and expression adds a touch of human lightheartedness to the work.

Simplified forms

The weight and texture of the saint's cape is brilliantly conveyed. The form is simplified into a few elegantly sweeping folds.

All of Raphael's work shows his superb draftsmanship—his ability to control line with complete assurance and mastery. Drawing was considered a superior skill to the handling of color, the argument being that line was a more intellectual discipline and color essentially decorative.

Ghostly Angels

Barely visible in the hazy, light-filled background, Raphael has included a host of ghostly angels. This highly original imagery heightens the air of mystery in the painting.

Raphael in Rome

From the mid-15th century, successive popes shared an ambition to beautify Rome in order to make it worthy of its role as the center of Christianity and as the historic capital of the Roman Empire. The key figures in achieving this ambition were Julius II and his successor, Leo X. Both looked to Florentine artists to realize an art and architecture that would synthesize classical art and Christian belief. Raphael was called to Rome when he was 25 years old, so great was his reputation. For Julius II he executed the frescoes in the papal rooms of the Vatican, which are one of the greatest achievements of the High Renaissance. For Leo X he undertook an archeological survey of the ancient monuments of Rome.

Tiziano Vecellio

TITIAN (c. 1488-1576)

BORN INTO A HUMBLE FAMILY in the mountains north of Venice, Titian stands alone for the prestige he achieved in his own lifetime, and his subsequent reputation has proven unshakable. He was extremely shrewd, and through good judgement (as well as much good fortune) he became enormously wealthy and won the friendship of the most powerful rulers in Europe. He trained with Bellini (p. 20), and early on in his career many of his potential rivals, for example Giorgione (p. 30), had either died or gone to Rome. His early work displayed a magisterial authority, and he quickly assimilated all the pioneering achievements of the early Renaissance, infusing them with new life and handing on to subsequent generations a style and tradition that would shape the course of art for nearly four centuries. Titian excelled in the two areas most certain to please great rulers: decorative mythologies, which were fit to grace princely apartments, and portraiture. As a portraitist, he had an instinct for that subtle blend of flattery, idealism, and realism that became the hallmark of aristocratic portraiture.

CHARLES V AT MÜHLBERG

The Emperor Charles V commanded Titian to paint this portrait to celebrate one of his most important victories: the defeat of the Protestant League at the Battle of Mühlberg in 1547. The painting displays the artist's supreme skill as a portraitist. It also shows his exquisite feel for color and the rich expressive possibilities of oil paint.

ORDER OF THE GOLDEN FLEECE

Around his neck, the emperor wears the symbol of the Order of the Golden Fleece, of which he was the leader. One of the great Orders of Christendom, it was composed of 24 knights who vowed to join their sovereign in the defense of the Catholic faith. The knightly Order had more than ceremonial authority: Charles used the knights as a consultative assembly.

Titian first met Charles V at Bologna in 1533, when the Emperor ennobled the artist as a Count Palatine. After the Battle of Mühlberg, Charles summoned Titian to meet him at Augsburg, where he painted this portrait and those of other members of the royal household.

FACT AND FLATTERY

Titian deliberately uses no props or symbols. Charles V rides out alone to meet his enemy, richly attired, strong, and supremely confident. His eye looks straight ahead and his jaw is firm. In reality, Charles was aged 57 at the time and suffered badly from gout and asthma.

Painterly Style

The 1540s and 1550s was the period of Titian's greatest worldly achievement and saw the fullest flowering of his style. He delighted in light and textures, such as can be seen in the play of light over the magnificent suit of armor. Titian produced an art that appealed to the eye as much as the intellect.

Vasari (p. 28) wrote that Titian's late works "cannot be viewed from nearby, but appear perfect at a distance.… The method he used … makes pictures appear alive and painted with great art, but conceals the labor that has gone into them." Some critics, however, could not see that this painterly style was deliberate, complaining that he did not finish his work.

CEREMONIAL ARMOR

Charles V is portrayed wearing the armor and riding the horse that he used at the battle. The armor was decorative rather than protective, because the invention of guns had rendered it ineffective. But it was still worn for show, and the 16th century saw the art of the armorer reach unprecedented heights.

1550–1590

1551 Thomas More's *Utopia* translated into English.

1554 Philip II marries Queen Mary I of England.

1564 Michelangelo dies. Shakespeare born.

1565 St. Augustine, FL, founded.

1584 Walter Raleigh discovers Virginia.

1588 Defeat of the Spanish Armada.

Charles V rode into battle many times to secure his Empire and to protect the integrity of the Catholic Church. His external enemy was France; his political enemy was the Turks, whom he defeated in the 1530s. Too late, he turned his attention to the growing power of the Protestants in the north of Europe, which his victory at Mühlberg did not stop. In 1556, worn out by his traveling and political battles, he abdicated and retired to a monastery in Spain, taking his paintings by Titian with him. He once said that he valued a new painting by Titian as much as the acquisition of a new province.

THE EMPEROR'S FAVORITE

As the leader of the Hapsburg dynasty, Charles V ruled more of Europe than any leader since the time of the Roman Caesars, and until Napoleon (p. 62). The relationship between the Emperor and Titian was unusually close. Social etiquette would normally have imposed a distance between prince and painter, but the mutual respect that existed between these two men of the world comes through in the portraits. The story is told that on one occasion the Emperor picked up a paintbrush that Titian had dropped—an unprecedented act of intimacy for a monarch. Titian was awarded various decorations and pensions by the Emperor.

Titian's exact birth date is unknown, and he seems to have purported to be older than he was, claiming to have lived to be nearly 100. Best estimates suggest he was born in about 1488 and that he lived into his late 80s. He was happily married to a barber's daughter and had three children; one of his two sons was a notorious wastrel.

❝ *To tell the truth I do not like Raphael at all. It is in Venice that the finest things are to be found.... It is Titian who carries the day* **❞**

VELASQUEZ

KEY WORKS

• **The Assumption of the Virgin;** 1516–18; *Santa Maria dei Frari,* Venice

• **Man with a Glove;** c. 1520; *Musée du Louvre,* Paris

• **Venus of Urbino;** 1538; *Uffizi,* Florence

• **The Rape of Europa;** 1550–62; *Gardner Museum,* Boston

DRAWING AND COLOR
Venetian art always placed greater emphasis on color than on drawing. In 1545–46, shortly before this picture was painted, Titian went to Rome where he met Michelangelo. Both artists were polite but cautious. After he had seen Titian's work, Michelangelo remarked that his coloring was excellent but it was a pity that he could not draw.

Atmospheric Background
The loosely painted landscape with foothills, and the atmospheric sky, are typical of Titian's style, and add warmth and decorative appeal. He is not attempting to paint the actual landscape of the battle but to produce a setting that will suit the mood of the picture.

EQUESTRIAN PORTRAIT
Portraying the monarch seated upon his horse—the equivalent of a Roman or early Renaissance equestrian statue—was novel in painting, and this work initiated an entirely new genre in the art of portraiture. The work shows how Titian remained inventive in his approach to composition and progressive in his style, even when he was firmly established as the greatest Venetian painter of his time.

Many of Titian's finest works were painted for Charles and his son Philip II, who succeeded his father as king of Spain. A superb collection remains in Madrid. They were much admired and studied by Rubens (p. 40) and Velázquez (p. 46). Titian also influenced the portraiture of Reynolds (p. 56) and Gainsborough in 18th-century England.

Titian; *Charles V at Mühlberg;* 1548; 131 x 110 in (332 x 279 cm); oil on canvas; Museo del Prado, Madrid

BRUEGHEL (1568-1625)

Jan Brueghel

FOLLOWING IN THE FOOTSTEPS of his father and elder brother, who were both successful artists, Jan Brueghel became a major painter in his own right. His father, Pieter Brueghel the elder, was celebrated for his mastery of landscape and peasant subjects. He died shortly after his second son was born, so Jan received lessons in watercolor painting from his maternal grandmother. He lived most of his life in Antwerp but traveled widely, rising to prominence as court painter for the Archduke Albert and Infanta Isabella, who were the Spanish rulers of the Netherlands. He was a close friend of Rubens (p. 40), with whom he traveled and worked. He married twice: his first wife Isabella, the daughter of an engraver, died in childbirth in 1603, after four years of marriage. In 1605, he married Catherina van Marienberghe, and fathered eight children by her. He developed a very fine decorative style, which earned him the nickname "Velvet Brueghel," and had a particular skill with wooded landscapes and still life paintings of flowers, which were brilliantly colored. He and two of his children died in the cholera epidemic of 1625.

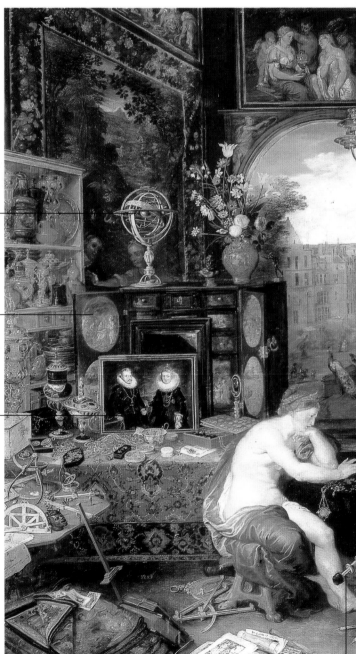

ALLEGORY OF SIGHT

This painting is one of a series that portrays the five senses: sight, hearing, smell, touch, and taste. In each painting, Venus is surrounded by objects representing the sense portrayed. Sight was the most significant for Brueghel, and this work is also an allegory of his own city and times.

AGE OF DISCOVERY

The armillary sphere, which shows the motion of the planets, is one of the many scientific instruments in the work. The astrolabe, which is shown close to Venus's foot, made long sea voyages possible. Such instruments were key features of Brueghel's rapidly changing world.

DECORATED CABINET

Antwerp, where Brueghel spent most of his life, was an important commercial and cultural center. It was noted for the production of fine decorated cabinets, which were prized throughout Europe. The tapestry behind the cabinet acknowledges the fame and skill of the Flemish weavers.

RULERS OF FLANDERS

The Archduke Albert and his wife Isabella mitigated the harsher aspects of the Inquisition and encouraged the arts. They accorded Brueghel special privileges and gave him access to their botanical and zoological gardens in Brussels to study rare plants and animals.

After his apprenticeship, Brueghel made the traditional tour that many artists regarded as an essential part of their training. He visited Rome and Prague—where Emperor Rudolf II had assembled the finest Cabinet of Curiosities in the world.

Detailed Flowers

The vase of flowers displays Brueghel's special skill as painter of flowers. Using a magnifying glass he reproduced them in the finest detail, sometimes including insects. He worked directly from nature without any preliminary drawings.

CABINET OF CURIOSITIES

One of the key features of 17th-century collecting was the "Cabinet of Curiosities." Collectors, who were excited by the voyages of discovery, valued objects for their strangeness and their rarity rather than their aesthetic appeal. Modest collectors would keep their curiosities in an elaborate cabinet. More lavish collectors would devote whole rooms to their collection of bones, shells, plants, antiquities, jewels, and other rarities. Brueghel's *Allegory of Sight* represents the ultimate cabinet of curiosities.

Jan Brueghel;
Allegory of Sight; **1618;**
25½ x 43 in (65 x 109 cm);
oil on panel; Museo del
Prado, Madrid

THE SCIENCE OF OPTICS

Close to Venus, Brueghel has portrayed scientific instruments that augment the sense of sight. By her foot is a telescope, which had recently been invented in the Netherlands. On the cabinet behind her is a magnifying glass on a stand.

KEY WORKS

- **Bouquet with Irises;** after 1599;
 Kunsthistorisches Museum, Vienna

- **Village Fair;** 1600;
 Royal Collection, Windsor

- **Latona and the Peasants;** 1601;
 Frankfurt Staedel, Frankfurt

- **Village on River Bank;** c. 1560;
 National Gallery, London

Symbolic Ape
The monkey examining a painting through
spectacles is an amusing allegory of the art of
painting, which is largely an art of copying.
The painting may be one Brueghel's seascapes.

*❝ The big artist does not sit
down monkeylike and copy ❞*
THOMAS EAKINS

*This painting is connected with two others that
were commissioned by the Magistrates of Antwerp
to present to Albert and Isabella when they made
an official visit to the city in 1618. Intended to
demonstrate the strengths and diversity of
Antwerp, the three works were a collaborative
venture between a number of leading painters.
Brueghel was in charge of the venture.*

1600–1610

1601 Kepler appointed astronomer
to Rudolf II of Germany.

1602 Dutch East India Company
founded.

1603 James I unites Scotland,
England, and Ireland as one
kingdom.

1605 Guy Fawkes attempts to blow
up English Houses of Parliament.

1608 Invention of the telescope.
Jamestown founded. Quebec
founded by Champlain.

1610 Hudson Bay discovered.

HAPSBURG DOUBLE EAGLE
The double eagle of the Hapsburgs
symbolizes the family's dominance of the
Netherlands and their control of
all the objects and activities in the room.

COLLABORATIVE VENTURE
The painting of the Madonna and
Child is a well-known work in which
Rubens painted the central figures and
Brueghel painted the garland of flowers.

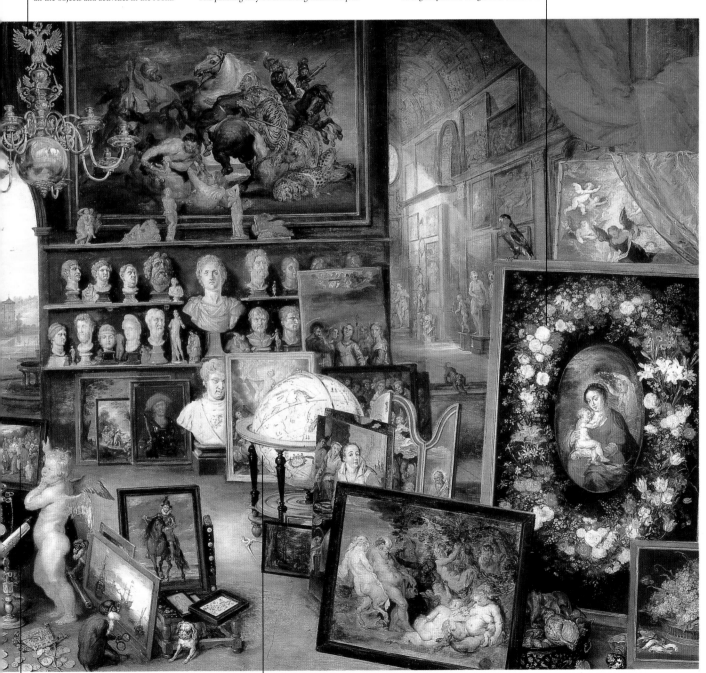

HEALING THE BLIND
Cupid shows Venus a painting depicting the biblical
story of Jesus healing the man who was blind from
birth. She appears to value the painting more highly
than the jewels that are placed before her on the table.

VOYAGES OF DISCOVERY
A huge globe stands in the center of the room. The
voyages of discovery to the Americas and the East
introduced Europe to many new plants, animals, and
treasures—for example, the parrot and the exotic shells.

*Brueghel became one of the most successful painters in Flanders.
He was dean of the artists' guild—The Guild of Saint Luke—and
he owned five houses. The Infanta Isabella and his first patron,
Cardinal Borromeo, were godparents to his youngest daughter.*

*Michelangelo Merisi
da Caravaggio*

CARAVAGGIO (1573-1610)

ONE OF THE FEW great artists to have a criminal record, Caravaggio was violent, loutish, and frequently under arrest. Nevertheless, in spite of his flawed temperament, he produced one of the most innovative and influential styles of the 17th century. Michelangelo Merisi took his name from the place of his birth, Caravaggio, near Bergamo in northern Italy. At 17 years of age, already alone in the world and with a small inheritance, he went to make his name in Rome. His money was soon spent, however, and he lived in poverty until he became attached to the household of Cardinal del Monte. Out of his prodigious talents and fiery personality there developed an art with a dramatic realism and theatrical lighting that was completely new—exciting to some, but deeply offensive to others. At the height of his success in 1606, he murdered a friend in a brawl over a petty wager. He fled to Naples, and died in exile at the age of 37.

BACCHUS

This image is an original and openly homoerotic representation of Bacchus, the god of wine. It was probably produced while Caravaggio was working for the influential Cardinal del Monte—a notable patron of the arts who commissioned the artist to produce a number of paintings of effeminate young men.

DECADENCE
The young god is openly dedicated to a life of physical sensuality (as was the artist himself), and he displays a deliberately wanton expression. There is no evidence that the artist shared his patron's sexual taste, but he has responded with enthusiasm to the pagan and decadent possibilities of the image.

ART OF CONTRASTS
Much of the best of Caravaggio's art plays with contrasts. Realistic detail contrasts with a theatrical pose. There is a contrast between the model's muscular right arm and his feminine face with its made-up eyebrows and curly black wig.

**Michelangelo Caravaggio;
Bacchus; c.1595; 37 x 33½ in
(94 x 85 cm); oil on canvas;
Uffizi, Florence**

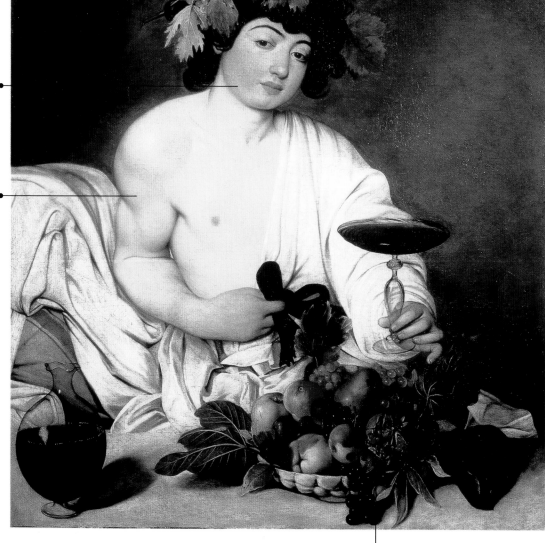

Open Invitation
Bacchus proffers an overfull glass of wine as if inviting us to join him in the pleasures of the flesh. His fingernails are dirty—a symbolic warning that the pursuit of pleasure comes at a price.

Caravaggio was a pioneer of still life painting, which began to emerge as a separate genre during the Renaissance. The basket-of-fruit motif appears in several of his early works.

SYMBOLIC STILL LIFE
The still life detail may be an allegory of the consequences of overindulgence and of the transience of youthful innocence. There is a wormhole in the apple, the pomegranate is overripe, and other fruit are bruised or rotten.

CARAVAGGIO'S INFLUENCE

In the early 17th century, Rome was an essential place to visit for ambitious young artists, who went to study the work of the great masters such as Michelangelo (p. 28) and Raphael (p. 32). However, it was the new dramatic lighting and obsessive realism of Caravaggio's art that caught the imagination of many painters, and when they returned home they spread the word about his style. Artists such as Gentileschi (p. 44) were among his disciples in Italy; in Spain, his influence is seen in Velásquez (p. 46); in Holland, it is most notable in Rembrandt's work (p. 48).

❝ His style is the chasm and total destruction of the most noble and skilled art of painting ❞
CARDINAL ALBANI

● **PLACID HORSE**
The docile horse and its attendant, both of whom are oblivious to what is happening, present a dramatic contrast to the taut body of Saul with its inner spiritual torment. By confining the the main dramatic incident to the lower-right quarter of the painting, Caravaggio paradoxically heightens its importance.

KEY WORKS

• **Judith Beheading Holofernes;** c. 1598; *Galeria National dell'Arte Antica*, Rome

• **Calling of St. Matthew;** 1599–1600; *S. Luigi dei Francesi*, Rome

• **Supper at Emmaus;** c. 1601; *National Gallery*, London

• **The Entombment;** 1602–04; *Vatican Museums*, Rome

Divine Light
St. Paul is temporarily blinded by a divine light. The way Caravaggio communicates the emotion as St. Paul realizes he is blind is intense and poignant.

THE CONVERSION OF ST. PAUL

The painting shows the moment of the conversion of Saul, a Roman soldier who persecuted early Christians. On the road to Damascus, a great light flashed from the sky and he heard Christ's voice saying, "Saul, Saul, why do you persecute me?" Changing his name to Paul, he became a devoted follower of Christ and was one of the founders of the early Church.

● **EVERYDAY REALISM**
The image of the attendant is a striking example of Caravaggio's new realism. He chose his models from the ordinary people he met on the streets of Rome. Although his art was in many ways closer to the "truth" than that of his contemporaries, many people—Church dignitaries and laymen alike—considered it offensive for the Church to display such coarse reality, preferring an art of idealism and unreality such as Raphael's.

In accord with his fiery personality, Caravaggio was a rapid worker. He rarely missed a deadline. He worked directly onto the canvas with little preliminary work and made alterations as he progressed. There are no drawings that can be positively identified as being made by the hand of Caravaggio.

● **EMOTIVE HANDS**
Caravaggio paid great attention to hands, which he always beautifully observed. He understood the emotion that can be conveyed through the movements and positioning of hands and arms.

In its actual setting in the Cerasi Chapel of Santa Maria del Popolo, the painting is hung on the right-hand side of an altarpiece by Annibale Carracci. In this setting, the work is not seen straight on (as it is here), but at an oblique angle from the right, so that the viewer seems to stand by the head of St. Paul and look along the length of his body.

Michelangelo Caravaggio; *The Conversion of St. Paul;* **1601; 90 x 69 in (230 x 175 cm) oil on canvas; Santa Maria del Popolo, Rome**

Like his art, Caravaggio was himself a man of contrasts. Capable of murderous behavior, he nonetheless studied and responded to the art of Leonardo da Vinci (p. 24) and Michelangelo. His religious paintings often display the deepest compassion and spiritual emotion.

● **FORESHORTENING**
One of the more sensational features of Caravaggio's realism is his foreshortening, which creates the illusion that part of the image is projecting from the surface of the canvas into the space occupied by the viewer. The pose of St. Paul is an effective example of this technique.

1590–1600

1590 Spenser: Faerie Queene.

1590–92 Four popes elected in quick succession.

1594 Henry IV crowned King of France at Chartres.

1595 Shakespeare: *A Midsummer Night's Dream.* Heels appear on shoes for first time.

1596 Galileo invents the thermometer.

1600 Shakespeare: *Hamlet.* Dutch invent the telescope. English East India Company founded.

Sir Peter Paul Rubens

> ❝ *I regard all the world as my country, and I believe I should be very welcome anywhere* ❞
> RUBENS

RUBENS (1577–1640)

HANDSOME, HEALTHY, AND HIGHLY TALENTED, Rubens was the most renowned painter in early 17th-century Europe. The son of a lawyer and court official, he received a good classical education and became a page in an aristocratic household. But he always wanted to be a painter, so he was sent to be trained with several mediocre artists in Antwerp. In 1600, he traveled to Italy, where his eyes were opened by his contact with the paintings of Michelangelo (p. 28) and Titian (p. 34) and the treasures of antiquity. On his return to Antwerp in 1608, he was immediately successful and ran a busy workshop to cope with the enormous demand for his paintings. His linguistic skills, his way with people, and his shrewd business sense impressed his many royal patrons, and he traveled extensively for them on important diplomatic missions. His last years were spent as a country gentleman at the Chateau de Steen, between Brussels and Malines, where he developed a pioneering interest in landscape painting.

Rubens' own successful and fulfilling lifestyle is reflected in the material blessings shown in Peace and War. *He was happily married, never lacked material comforts, and became very wealthy. In 1610, he bought land in Antwerp and built a palatial Italianate house from which he ran his studio.*

PEACE ●
The naked figure of Peace squirts milk from her breast to feed Plutus, the god of wealth. Rubens' preference, personal and artistic, was for ample female figures whose skin and hair glow with health.

PEACE AND WAR
This painting celebrates the blessings of peace, and Rubens uses his full command of painterly skills and scholarly knowledge—color, movement, drama, and symbolism—to convey his message. He completed the picture when he was in England on a diplomatic peacekeeping mission.

The Spanish Infanta Isabella, who was Regent of the Netherlands, sent Rubens to England in 1629–30 to negotiate a peace treaty. The painting is more than showy propaganda—Rubens was deeply committed to European peace and toleration. He presented the painting to Charles I of England, who knighted Rubens for his efforts.

FOLLOWERS OF BACCHUS ●
Although Bacchus, the God of Wine and Fertility, is not shown, two of his female followers are present, one carrying a basin full of golden cups and pearls, and the other dancing with a tambourine.

The most sought-after painter in Europe, Rubens excelled in the large-scale religious and mythological works that were the fashion with the Catholic monarchs and the Church.

ORCHESTRATED COLOR ●
Glowing color is orchestrated with eye-catching fluency. Complementaries are placed together to give colors heightened intensity.

Rubens was particularly influenced by the rich color and lively brushwork of the Venetian painters. He saw their work in Venice and in the Royal Collection in Madrid, with its magnificent examples of work by Titian (p. 34). He visited Spain in 1603 and again in 1628–29 (p. 46).

PEACE AND PLENTY ●
In front of Peace, a satyr holds out a horn of plenty as an offering to the three children on the right. A winged cupid invites them to eat fruit, and a leopard rolls over like a domesticated cat and playfully paws at the tendrils of a vine.

Peter Paul Rubens; *Peace and War*; c. 1629; 80 x 117 in (203.5 x 298 cm); oil on canvas; National Gallery, London

1620–1630

1621 Philip IV crowned King of Spain at the age of 15.

1625 Charles I crowned King of England, Scotland, and Ireland and marries Henrietta Maria of France.

1626 Dutch found New Amsterdam (later New York).

1627 Shah Jahan becomes Great Mogul of India. Barbados is colonized by British settlers.

1628 Taj Mahal built.

1630 Peace Treaty between England and France. Massachusetts Bay Colony founded. 500,000 Venetians die of bubonic plague.

WORKING METHODS

Rubens worked extremely rapidly, and he employed a large studio of assistants, some of whom (most notably van Dyck) became major names in their own right. Rubens worked out the basic idea in rapid, fluent sketches, which his assistants would use to work up the large-scale painting. Models would pose for the figures in a composition so that detailed drawings could be made from life. Rubens himself provided the finishing touches and final alterations. He was a prodigiously hard worker and was very demanding of his assistants. Patrons were perfectly satisfied to have a painting produced in this manner. The idea that the artist should paint every brushstroke of his work is relatively recent and not one that Rubens would have accepted.

• MINERVA
Minerva, the goddess of wisdom, uses her shield to hold back Mars, the armor-clad god of war. Behind Mars is one of the avenging furies.

• HYMEN
The older boy represents Hymen, the god of marriage, who places a wreath over the head of the older girl.

Hélène Fourment
In 1630 Rubens married Hélène Fourment, aged 16, who was the niece of his first wife, Isabella Brandt. The marriage was exceptionally happy and fruitful: there were five children, the last being fathered by Rubens one month before his death. This portrait shows Hélène with their second child, Frans, who was born in July 1633.

Peter Paul Rubens; *Hélène Fourment and her Son Frans;* c. 1634; 130 x 167½ in (330 x 425 cm); oil on canvas; Musée du Louvre, Paris

In 1609, at the age of 32, Rubens married the 17-year-old daughter of an Antwerp lawyer, Isabella Brandt. It was a very happy union, but Isabella died in 1626, probably from the plague, leaving two surviving sons, Albert and Nicolas. Rubens was overcome with grief and reacted by burying himself in his work.

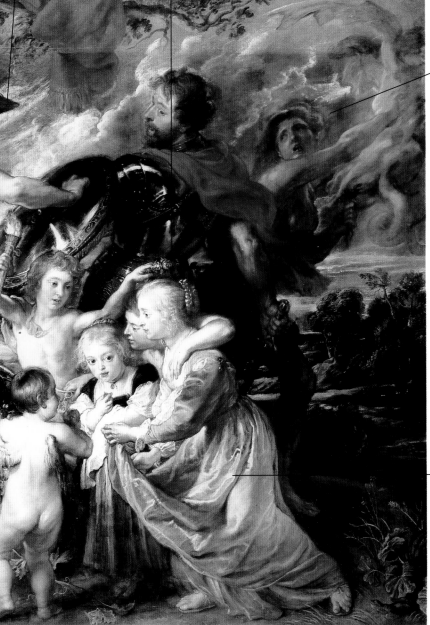

• TWO-PART COMPOSITION
The underlying design is a simple diagonal from bottom right to top left. Along and below the diagonal are the blessings of peace, brightly lit and glowing with rich color. Above the diagonal are the curses of war, portrayed with contrasting darkness. Rubens loved movement and visual drama, which he often created by using the rising diagonal.

Lifelike Leopard
The leopard is lovingly painted with extraordinary life and vitality, notably in the eyes and the texture of the fur. Rubens made studies of wild animals from life in the archduke's zoo in Brussels.

• FORTUNATE CHILDREN
Appropriately, it is the children who are shown to be the principal beneficiaries of Peace. The models for three of the children were the son and daughters of Rubens' host in London, Balthasar Gerbier.

KEY WORKS

• **Raising of the Cross;** 1610; *Antwerp Cathedral*, Antwerp

• **Marie de' Medici Cycle;** 1622; *Musée du Louvre*, Paris

• **Rainbow Landscape;** c. 1635; *Wallace Collection*, London

• **The Garden of Love;** 1638; *Museo del Prado*, Madrid

Nicolas Poussin

POUSSIN (1594-1665)

A PERSONALITY OF CONTRASTS, Poussin was both a sensual man and an austere intellectual who prized reason, order, and dispassion above all else. His art is a reconciliation and synthesis of these traits, and through it he set an example that was to become the standard for the long tradition of academic art that continued until the end of the 19th century. Although French by birth, Poussin spent most of his life in Rome, and it was there that he established his reputation. He studied classical art with a passionate zeal, and the subject matter of most of his work was based on stories from classical literature and the Bible. Initially, he attempted large-scale public commissions, but after a serious illness in 1629–30 he turned to small-scale works for a circle of private connoisseurs. Much of his work can be read as poetic debates on serious moral issues, or contemplations on life and death.

THE ARCADIAN SHEPHERDS

Painted in mid-career during a successful period of Poussin's life, *The Arcadian Shepherds* reveals his attraction both to sensual beauty and dispassionate reason. In poetic imagination, Arcadia was an earthly paradise where mundane cares were nonexistent. In this idyllic landscape, a group of young shepherds encounter a tomb and face the inevitability of death.

AUSTERE GEOMETRY
The landscape and the trees create a grid of horizontals and verticals that is repeated in the poses and gestures of the shepherds. This calculated geometry is characteristic of Poussin's work.

CALCULATED GESTURES
The shepherds are arranged around the central inscription in a circle, and their gestures and glances are designed to focus attention on this key feature.

Poussin is buried in Rome, and the image of this painting is carved into the tomb that was erected in his honor in 1828–32. His work had a particularly significant influence on David (p. 62) and Ingres (p. 70). Cézanne (p. 82) also expressed his debt to the artist, stating his intention "to do Poussin again, from nature."

SIGNIFICANT SHADOW
Although Arcadia was supposedly filled with love and happiness, a deep shadow, cast by the bearded shepherd, falls significantly on the inscription as he traces the letters with his finger.

1630–40

1630 Cardinal Richelieu assumes power in France.

1631 First public celebration of Thanksgiving. Eruption of Vesuvius.

1632 Galileo publishes work on terrestrial double motion.

1634 Milton: *Comus*.

1635 Academie Française founded.

1636 Rhode Island founded by Roger Williams. Harvard College founded. Black Death strikes London.

1640 *Bay Psalm Book* is first book printed in the US.

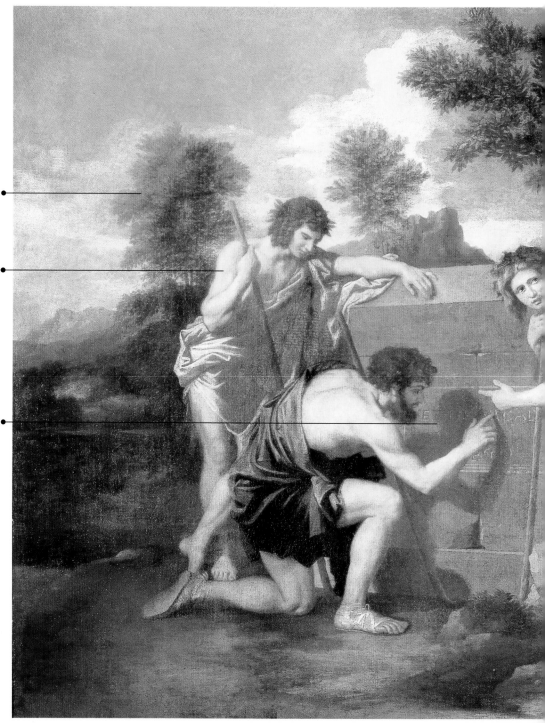

Et in Arcadia Ego

The message on the tomb is *Et in Arcadia Ego*, "Even in Arcadia, I, Death, am also present." The painting thus becomes the catalyst for an intellectual and poetic discussion on human mortality and the only certainty in life—death.

● **TRANQUIL RESPONSE**

The shepherds respond to their realization of the presence of death with a dignified calm, reflecting Poussin's own happy state of mind at this period. The response also reflects his admiration for the philosophy of the Stoics of Ancient Greece.

❝ *My nature leads me to seek out and cherish things that are well-ordered, shunning confusion which is contrary and menacing to me as dark shadows are to the light of day* ❞
POUSSIN

● **SENSUAL LIGHT**

The landscape is bathed in a warm and sensual evening light, which echoes the melancholy and contemplative mood of the picture. Poussin was a great admirer of the work of Titian (p. 34), and initially he strove to capture the rich colors and sensual light of the Venetian masters. Later in life, he deliberately purged such sensuality from his work.

THE FRENCH ACADEMY

The Royal Academy of Painting and Sculpture was founded in Paris in 1648. Under the direction of the French painter Charles Lebrun (1619–90), the Academy adopted many of Poussin's ideas of order and embraced his intellectual and moral priorities for art. It established a rigid system of compulsory instruction in practice and theory emphasizing Poussin's belief in the superiority of drawing, which he suggested appealed to the intellect, over color, which appealed to the senses.

In 1629, Poussin was nursed through a life-threatening illness by the family of Jacques Dughet, a French pastry cook living in Rome. On recovery, he married Jacques' daughter, Anne Marie. In 1630, Poussin painted **The Shepherds of Arcady**—*his original, darker, and more dramatic treatment of this subject.*

Ideal Beauty

Underlying all of Poussin's art is the search for an ideal beauty, which he believed would be revealed through an understanding of the laws of reason. The beautifully composed facial expressions of the shepherdess and her three companions, and their carefully organized and balanced poses, results in one of Poussin's most successful attempts at achieving his lofty aspiration.

Poussin arrived in Paris in 1624, having run away from his family home in Normandy. He lived in great poverty but was helped by the Italian poet Giovanni Battista Marino to travel to Rome. There, Poussin was patronized by Cassiano del Pozzo, Secretary to Cardinal Francesco Barberini, who had a remarkable library of drawings and engravings on themes relating to classical antiquity. Poussin was able to study these, and their influence on his work was immense.

● **ACTORS ON A STAGE**

The figures are placed in a narrow space like actors on a stage with a landscape backcloth. Poussin strove to capture in his art the classical unities of time, place, and action, which the great French dramatist Corneille (1606–84) also aspired to in contemporary literature.

Poussin worked slowly and with great deliberation. He first studied literary texts, then explored the resulting ideas with sketches in pen and wash. Next, he arranged small wax models on a boxlike stage. This led to new drawings using larger models, from which he began work on the painting itself.

Nicolas Poussin; *The Arcadian Shepherds*; c. 1638; 33½ x 47½ in (85 x 121 cm); oil on canvas; Musée du Louvre, Paris

GENTILESCHI (1593-1652)

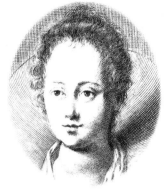

Artemisia Gentileschi

THE DAUGHTER OF THE CARAVAGGESQUE PAINTER Orazio Gentileschi (1563–39), Artemisia Gentileschi created powerful and expressive works that reflect events from her own dramatic life history. At the age of 19, she was allegedly raped in her home by her father's friend and colleague Agostino Tassi (c. 1580–1644), and she was tortured during the legal proceedings that ensued. In spite of (and perhaps partly because of) this traumatic event in her youth, Artemisia overcame the handicap of her gender and became one of the leading painters of her day. Following the trial of 1612, she was married to a minor Florentine artist, Pietro Stiattesi, and she left her native Rome for Florence. There, she was an immediate success and, with the support of the Medici family (p. 22), became the first female member of the Florentine Accademia del Disegno. She finally settled in Naples in 1630.

SUSANNA AND THE ELDERS
The theme of Artemisia's earliest signed painting foreshadows her own harrowing experience of the following year. The biblical heroine Susanna was condemned to death on a false testimony but was ultimately vindicated by Daniel's intervention.

CONSPIRATORS
Two elders, obsessed with Susanna's beauty, accost her at her bath, threatening to accuse her of adultery (a crime punishable by death) if she does not grant them sexual favors. Artemisia claimed that her own attacker conspired with the papal orderly Cosimo Quorli, and, like Susanna, Artemisia was publicly accused of promiscuity by the two men.

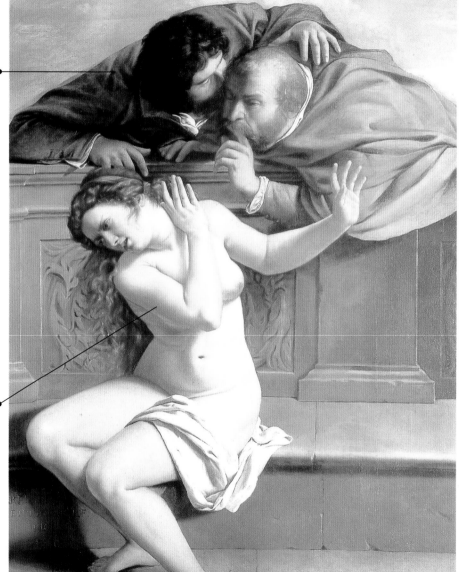

Unequivocal Expression
In many works the story of Susanna is used as an excuse to show the female nude, and the heroine herself is often shown encouraging her seducers. In contrast, Artemisia's Susanna displays unequivocal horror and disgust.

ARTISTIC INFLUENCES
Susanna's dramatic gesture is a reversal of the pose of Adam in Michelangelo's famous *Expulsion* scene in the Sistine Chapel, and the dramatically foreshortened hand of the dark-haired elder is taken from Caravaggio. However, Artemisia always smoothly integrated her artistic borrowings into highly original and very effective compositions.

Artemisia Gentileschi; *Susanna and the Elders*; 1610; 67 x 47½ in (170 x 121 cm); oil on canvas; Musée du Louvre, Paris

1610–1620

1610 Marie de' Medici becomes Regent of France for her nine-year-old son Louis XIII.

1613 Galileo: *Letters on the Solar Spots.*

1615 Cervantes: *Don Quixote.*

1618 Start of Thirty Years' War in Central Europe.

1619 Discovery of circulation of the blood.

1620 Mayflower sets sail with Pilgrim Fathers.

Agostino Tassi, whose testimony was rife with inconsistencies and blatant lies (he was openly ridiculed by the judge), served just eight months in prison.

INSCRIPTION
A prominent inscription illusionistically carved on the stone step reads ARTEMITIA / GENTILESCHI F. / 1610. The work is a remarkable technical accomplishment for so young an artist, and it is almost certain that Orazio assisted his daughter.

Although Artemisia's technique bears many similarities to that of her father, who was her only teacher, her paintings are stylistically very different. Her work grew increasingly dramatic and expressive, whereas her father's was always graceful and lyrical.

THE TORTURE OF THE SIBILLE

During the trial of 1612, Artemisia swore on oath that Tassi had violated her and then promised to marry her. In the presence of her alleged rapist, she was at one stage subjected to the torture of the *sibille*, whereby metal rings were placed around her fingers and tightened with a cord. At this traumatic point in the proceedings Artemisia is recorded to have insisted repeatedly, "it is true, it is true." Then, directly addressing her alleged assailant, she declared, "This is the ring that you give me, and these are your promises."

❝ *You will find the spirit of Caesar in this soul of a woman* ❞
ARTEMISIA GENTILESCHI

Symbolic Bracelet
The images on the bracelet on Judith's wrist correspond to well-known images of Diana, virgin goddess of the hunt and archetypal heroic woman. (Artemisia herself painted two images of Diana). The bracelet has been seen as a confident "signature" by an artist approaching the peak of her powers—the Greek name for Diana is Artemis.

DARK BACKGROUND ●
The black background heightens the dramatic tension and focuses attention on the action. As a woman, Artemisia had not been granted access to study perspective in the Roman Academy, so she did not include landscapes in her early works.

Ironically, Orazio Gentileschi had asked Agostino Tassi, who specialized in illusionistic architectural backgrounds, to give his daughter private lessons in perspective.

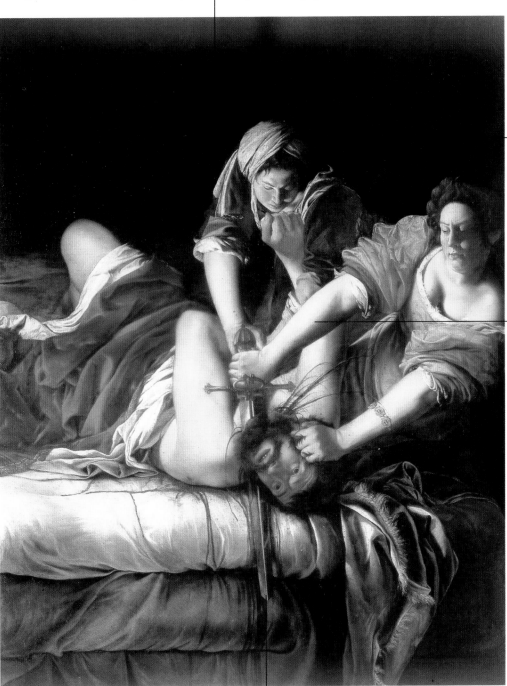

JUDITH BEHEADING HOLOFERNES
Artemisia painted this theme at least five times, a fact that indicates the personal importance it held for the artist. The horrific decapitation has been seen as Artemisia's revenge fantasy against her rapist.

● **ABRA**
In contrast to the conventional interpretation of the theme, where Judith's maidservant Abra is depicted as a passive crone and a foil to the active Judith, Artemisia has shown Abra as a youthful and vigorous young woman. Her participation in the execution, physically restraining the startled tyrant, makes the action more plausible.

The biblical heroine Judith saved her people by beheading the Assyrian general Holofernes, who had laid siege to her home town. The subject was popular during the Baroque era, which delighted in violent and erotic themes.

● **CARAVAGGESQUE POSTURE**
The parallel diagonals of Judith's arms, the gushing blood, and the angle of the sword (which gruesomely suggests a sawing rather than chopping action) were taken from Caravaggio's innovative treatment of the theme in a painting of 1598–99. Artemisia's debt to Caravaggio is also seen in the strong *chiaroscuro*, the realistic physiognomy, and the claustrophobic setting of the tent interior.

Artemisia is likely to have met Caravaggio while he was living in Rome, since he was a colleague of her father's and would occasionally visit Orazio's studio to borrow props. When Artemisia was ten, her father and Caravaggio were arrested as part of the "Via della Croce clique" on a charge of libel against the painter Giovanni Baglione (1571–1644).

Artemisia Gentileschi; *Judith Beheading Holofernes*; c. 1620; 78¼ x 64 in (200 x 163 cm); oil on canvas; Uffizi Gallery, Florence

KEY WORKS

• **Judith Slaying Holofernes;** 1612; *Museo di Capodimonte*, Naples

• **Lucretia;** c. 1621; *Palazzo Cattaneo-Adorna*, Genoa

• **Judith and her Maidservant;** c. 1625; *Institute of Arts*, Detroit

• **Self-portrait as the Allegory of Painting;** 1630; *Kensington Palace*, London

This work was completed by Artemisia at the end of her Florentine period and was probably commissioned by her principal patron, the Grand Duke Cosimo II. Her other illustrious patrons included Michelangelo Buonarroti the Younger, the Duke Francesco I d'Este in Modena, and Don Atonio Ruffo in Messina.

● **CRUCIFORM SWORD**
Artemisia has chosen not to depict the conventional saber, taken from the drunken general, but has shown a cruciform sword. In this way, she indicates that Judith's deed is an act of divine justice rather than a base act of human revenge.

Diego Velásquez

VELÁSQUEZ (1599–1660)

DIEGO VELÁSQUEZ'S CAREER was intimately bound up with the Court of Philip IV in his native Spain. He was born in Seville but, shortly after Philip was crowned, in 1621, traveled to Madrid to find favor at Court. The artist's first portrait of the young king so delighted Philip that he declared that henceforth only Velásquez should paint his portrait. His aloof personality appealed to the king, and the artist established an unusually close rapport with the monarch, which enabled him to become a trusted courtier with important political and administrative posts outside his role as court painter. His style changed considerably as he traveled in Italy and absorbed the influence of the Venetian masters. Although his output was small, Velásquez's influence has been enormous, and he is considered by many, including Manet (p. 76) and Picasso (p. 102), to be the greatest painter of all time.

THE WAWTERSELLER OF SEVILLE

This intensely detailed and realistic work was painted when Velásquez was barely 20 years old. The subject matter is characteristic of his early work, showing the humble occupants of a Spanish tavern.

WATERSELLER
Regardless of their status, Velásquez always managed to convey something of his sitters' inner nature. Here, he captures the old man's dignity.

CHIAROSCURO
The strong contrast of light and shade (*chiaroscuro*) and the powerful light source from the lower left corner of the painting are features of the artist's early style, showing the influence of Caravaggio (p. 38). The subtle, cool harmony of deep browns and blacks developed into a richer and warmer harmony in his later works.

Velásquez took this painting along with him on his journey to Madrid, where it helped him to establish his reputation. The young painter deliberately shows off all his skills in the painting, which was bought by the royal chaplain.

VIRTUOSO PAINTING
The illusion of the glass is a *tour de force*, and Velásquez makes it the unconscious focus of the painting. The hands of the young boy and the old waterseller grasp the stem, and both of them incline or face toward it.

Earthenware Texture
Around the glass, Velásquez weaves an intricate play of light and shade and a dazzling range of textures—for example, the delicate trails of water on the earthenware pot.

Diego Velásquez; *The Waterseller of Seville*; c. 1618; 42 x 32 in (106 x 82 cm); oil on canvas; Wellington Museum, London

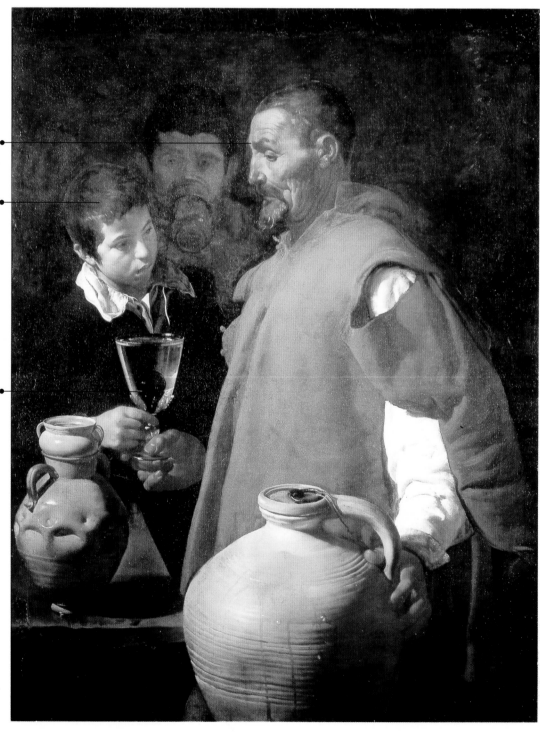

VELÁSQUEZ AT COURT

King Philip made Velásquez his "Usher of the Chamber" in 1627, the first of a series of appointments at Court, where he eventually achieved the highly prestigious position of "Chamberlain of the Palace" in 1652. His many duties included furnishing and decorating the royal apartments, and organizing public events and travels for the royal family. His exhausting public duties required by the marriage in June 1660 of Philip's daughter Maria Theresa to the young Louis XIV of France hastened Velásquez's death just two months later.

❝ Velásquez, when all is said and done, he's the best ❞
PABLO PICASSO

Velásquez acted as host to Rubens (p. 40) when the great Flemish artist visited Madrid on a diplomatic mission in 1628. Sharing similar tastes—most notably a great admiration for the Venetian masters—the two artists formed a close friendship.

● FLATTENED SPACE
As in most of Velásquez's work, the composition is simple and the space has little real depth.

KEY WORKS

- **The Surrender of Breda;** 1634–35; *Museo del Prado*, Madrid

- **The Rokeby Venus;** c. 1649; *National Gallery*, London

- **Pope Innocent X;** 1650; *Doria Pamphilj Gallery*, Rome

- **Las Meninas;** c. 1656; *Museo del Prado*, Madrid

The artist twice visited Italy. On his second visit, in 1648, he was commissioned to paint a portrait of Pope Innocent X. Significantly, the pope described the portrait as being "too truthful."

Exquisite Brushstrokes
Velásquez's style of painting became increasingly loose and fluid. This, in part, reflected his love of Venetian painting. However, it also reflects the rapid execution of his work necessitated by his increasingly demanding political duties.

THE INFANTA MARGARITA IN A PINK DRESS

This portrait was painted just before the death of the artist. The infanta—a child of Philip's second marriage—was just eight or nine years old. In his later years, the artist painted a number of portraits of the royal children, with whom he had a special bond.

● COLOR HARMONY
The lavish drapery and the infanta's sumptuous clothing allowed the artist to demonstrate his instinctive feel for color. The painting glows with harmonies of red and gold and contrasts of warm and cool shades.

At the end of his life, the artist still retained his position as the king's favorite. In 1659, the king bestowed the greatest honor on his court painter by making him a Knight of the Order of Santiago.

● THE EYES OF A CHILD
Margarita's expression is solemn. Her pose and attire portray the artificial formality of the Spanish Court with which she has had to come to terms. However, her eyes are full of vitality and suggest the lively child within.

Velásquez had a unique ability to combine potentially conflicting qualities—grandeur, intimacy, and realism. It is one of the features that make his portraits of the royal family so compelling.

● HANDS AND FACES
Velásquez considered hands to be as expressive as faces. In both of these paintings hands are posed as central points of interest, and the artist creates a deliberate, subtle interplay between them.

Diego Velásquez; *The Infanta Margarita in a Pink Dress*; c. 1654; 83½ x 58 in (212 x 147 cm); oil on canvas; Museo del Prado, Madrid

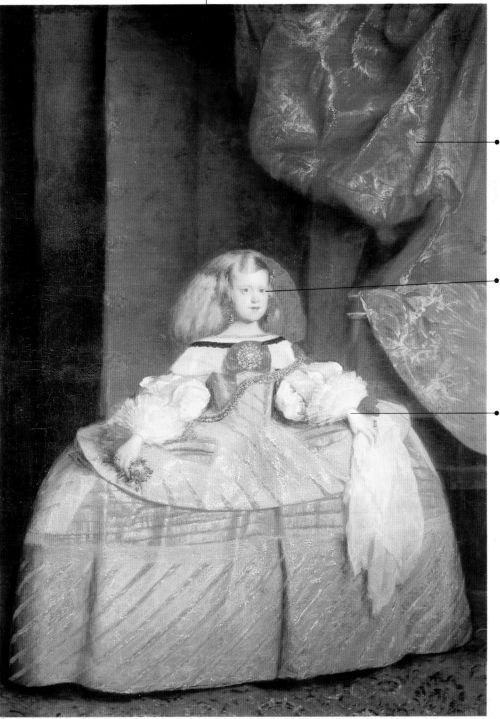

1640–1650

1641 First patent awarded in the American colonies.

1642 Montreal, Canada, is founded.

1643 Louis XIV becomes King of France at the age of five.

1644 End of Ming dynasty in China.

1648 End of Thirty Years' War. Holland gains independence.

1649 Charles I of England beheaded. The Toleration Act passed by the Maryland Assembly in the US.

Rembrandt van Rijn

REMBRANDT (1606–1669)

BORN IN PROSPEROUS CIRCUMSTANCES, the son of a miller, Rembrandt was well educated and enjoyed early recognition by painting family portraits of successful merchants. However, his life was overshadowed by personal tragedy. His wife Saskia died after only eight years of marriage, and three of their children died in infancy—only a son, Titus, survived. Rembrandt lived beyond his means and got into serious financial difficulty. Yet, because he sought to explore human emotions and fallibilities rather than proclaim high ideals, his troubled life increased rather than diminished the power of his art. Rembrandt is now considered to be the greatest Dutch master of the 17th century. The self-portraits, which he painted throughout his career, chart the changes in his life and art and express his tenacity in the face of adversity.

SELF-PORTRAIT WITH SASKIA

This portrait typifies the great energy of Rembrandt's early work and contains the physical action and dramatic expression that he liked during this period. It was painted shortly after his marriage in 1634, and he portrays himself as the happy *bon viveur*.

RAISED GLASS •
The artist raises his glass as if in celebration of his success and good fortune. He and Saskia engage us with eye contact as if inviting us to join them.

Few details are known about Rembrandt's early training, but he completed it with six months in the studio of Pieter Lastman (1583–1633), where he learned about the narrative techniques of Italian art and how to use facial expression and gesture.

SASKIA VAN UYLENBURCH •
Saskia came from a well-to-do family and so raised Rembrandt's social status. His marriage brought him new contacts and an increased reputation.

PEACOCK •
The table is adorned with a rich carpet and an exotic peacock—both indicating a privileged lifestyle. The peacock is also a symbol of pride.

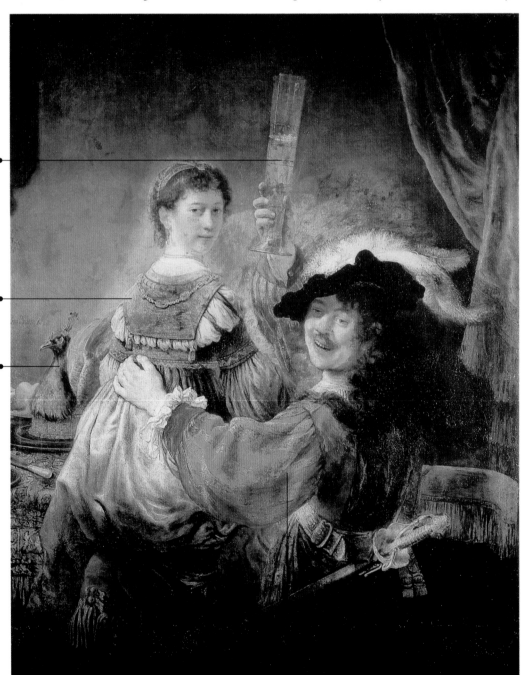

Loving Gesture
Rembrandt uses a simple but effective gesture to express his love and support for his young wife.

KEY WORKS

• **Self-portrait;** 1629; *Mauritshuis,* The Hague

• **The Night Watch;** 1642; *Rijksmuseum,* Amsterdam

• **The Jewish Bride;** c. 1665; *Rijksmuseum,* Amsterdam

Rembrandt van Rijn;
Self-portrait with Saskia;
c. 1636; 63½ x 51½ in (161 x 131 cm); oil on canvas; Gemäldegalerie, Dresden

AFFECTIONATE GESTURE •
Rembrandt puts his arm around Saskia. He painted several tender portraits of his wife and was very much in love. He was yet to experience the tragedy of her death in 1642.

• **FANCY DRESS**
Rembrandt enjoyed dressing up in fanciful costumes. Here he plays the swashbuckling cavalier, with a dramatic sweep of ostrich feathers in his hat and a sword displayed prominently at his side.

REMBRANDT'S BANKRUPTCY

With Saskia, Rembrandt moved into a large fashionable house and lived extravagantly. After his wife's death, the artist's reputation remained high but tastes changed, and he received fewer commissions. In 1657–58, his house and goods were auctioned to pay his debts, and he moved to a poorer district. He was protected from complete bankruptcy by his lover Hendrijke and his son Titus, who formed an art-dealing company that took on Rembrandt as an employee.

" Only Rembrandt and Delacroix could paint the face of Christ "
VAN GOGH

The portrait on this page was painted at the time of the death of Hendrijke Stoffels, who had become Rembrandt's mistress after entering his household as a servant in 1645. The artist was very fond of Hendrijke but was unable to marry her because of a clause in Saskia's will.

Pensive Mood
Rembrandt has painted his left eye entirely in shade, forcing us to look deep into his face to try to read his thoughts.

LOOSE HANDLING
The paint handling is very loose, and the colors are somber and rich. Rembrandt's interest in light and shade is still prominent, but he employs it to evoke a poetic mood rather than to heighten dramatic impact.

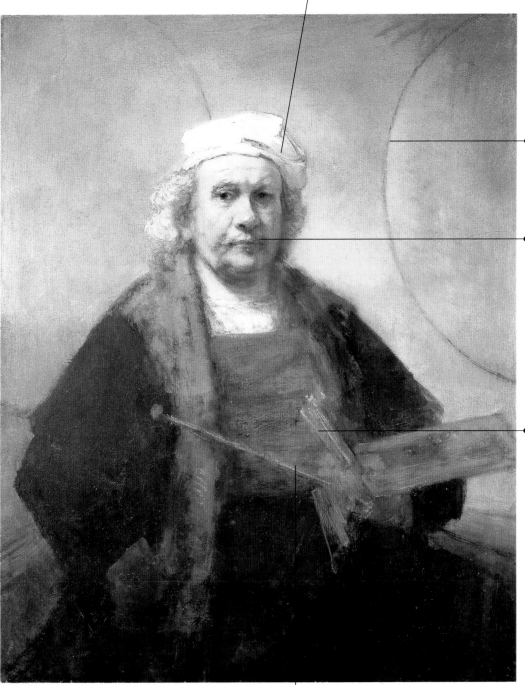

Rembrandt van Rijn
Self-portrait; c. 1665; 45 x 37 in (114 x 94 cm); oil on canvas; Iveagh Bequest, Kenwood, England

Rembrandt was well regarded in his own day, although he stood outside the mainstream of Dutch art. His contemporaries developed new secular subjects—landscape, still life, and genre painting—whereas Rembrandt's first love was Biblical history.

SELF-PORTRAIT

Rembrandt was nearly 60 years old when he painted this self-portrait—one of many that he completed in his last years. This version is particularly direct and uncompromising. He shows himself as he is—a painter.

CIRCLES
The circles in the background remain a mystery. A suggested explanation is that Rembrandt is alluding to the perfect circles supposedly drawn by Giotto as a demonstration of his artistic skill. However, this may simply be romantic legend.

MOUSTACHE
The moustache is scratched into the wet paint with the end of a brush. Rembrandt became increasingly free and inventive in his use of his materials.

The artist lived for another six years after painting this portrait. He was cared for by Titus until his son's death in 1668, and afterward by his daughter Cornelia (his child by Hendrijke Stoffels). Hendrijke died in 1663, two years before this portrait was completed. Rembrandt is buried beside her and Titus in Amsterdam.

THE ARTIST
Rembrandt portrays himself without any elaboration and with the tools of the trade—his palette, brushes, and mahlstick. His appearance is unkempt. Play-acting and exotic and fanciful costumes have been abandoned.

1660–1700

1665 Great Plague of London.

1666 Great Fire of London. Molière: *Le Misanthrope*.

1667 Milton: *Paradise Lost*.

1678 Bunyan: *Pilgrim's Progress*.

1679 Niagara Falls discovered.

1681 Pennsylvania granted to William Penn.

1683 Spain declares war on France.

1692 Massacre of Glencoe. Witch trials in Salem, Massachusetts.

1694 Bank of England founded.

UNFINISHED DETAILS
Rembrandt believed that an artist was entitled to leave parts of a painting unfinished if he "had achieved his purpose." Patrons, however, usually demanded a more precise and detailed style.

TER BORCH (1617–1681)

GERARD TER BORCH was a precocious artist—his earliest dated drawing is from 1625 when he was just eight. He was born into a well-to-do family, and he learned his craft from his father, who was a public official and a painter. He entered the Haarlem Guild in 1635, when Rembrandt (p. 48) was making his name in Amsterdam. Unusual for a Dutch artist, he traveled extensively, visiting England, Italy, France, Spain, and Germany. He lived to see the birth of the republic of the Netherlands, which finally won independence from Spain after a prolonged struggle. Independence was formally recognized by the Treaty of Münster, which was signed in 1648; Ter Borch was present at the signing in Germany and recorded the occasion with a small group portrait of all those who attended. His greatest artistic innovation was his development of a new type of portraiture: small full-length portraits, which were highly popular with the Dutch bourgeoisie. Out of these he developed his intimate anecdotal interior scenes, some of which rank among the finest masterpieces of 17th-century Dutch art. He left a lasting mark, not least on his talented compatriot Vermeer (1632–75), whom he met in 1653.

This painting became widely known in the 18th century in the form of an engraved copy entitled Parental Admonition, in which the coin in the soldier's hand (a vital clue to the artist's intended subject) was omitted. Goethe (1749–1832) wrote some verses about the picture having seen only the engraving—perpetuating the misinterpretation of the subject.

Gerard Ter Borch

KEY WORKS

• **Peace of Münster**; 1648; *National Gallery*, London

• **Boy Removing Fleas from his Dog**; c. 1658; *Alte Pinakothek*, Munich

• **Lady Peeling an Apple**; 1660; *Kunsthistorisches Museum*, Vienna

BED AND DRESSING TABLE
The four-poster bed and dressing table support the suggestion of a room in a brothel. Dutch society prided itself on its good order and practicality, recognizing the need for the brothel as well as family virtues.

Understated Eroticism
Ter Borch had a particular liking for long, slender necks. He invites us to linger on this beautiful feature. The fashion of the day dictated that wide collars should be worn to conceal the shoulders and breast as a matter of decorum. A 17th-century viewer would have been very aware that the girl portrayed was not wearing such a collar.

This painting was sold at auction in Paris in the 18th century. Dutch genre paintings were much admired in 18th-century France, influencing artists such as Fragonard (p. 58). Paintings with a constructive moral message, such as experience guiding youth, were particularly popular—hence the reinterpretation of the theme as "parental admonition."

PARENTAL ADMONITION
The original owner of this painting would have enjoyed the ambiguity of the subject matter, having recognized the clues indicating that it was probably a scene in a brothel. By the 18th century, these clues were no longer recognized and the work was given its current title and moral interpretation.

AVERTED EYES
It has been suggested that the soldier is proposing marriage. But, if so, why is the scene set in a bedroom, and why does the girl avert her eyes? Ter Borch probably encouraged such speculation—ambiguity is a common feature of 17th-century Dutch genre scenes.

SOLDIER

The soldier is evidently pleased and offers a coin in return for sexual favors. Ter Borch painted several pictures on the theme of the elegantly dressed military man turning his thoughts from war to love.

OLD WOMAN

The old woman, who sips her wine with such contrived delicacy and lowers her eyes in mock discretion, is the young woman's procuress. The pretentious way in which she is holding the glass of wine reveals her social ambitions.

John Evelyn, the English diarist (1620–1706), was amazed by the active art market in Holland and the demand for pictures such as **Parental Admonition**. *In 1641, he noted that such paintings were often bought as financial investments.*

Gerard Ter Borch;
Parental Admonition;
c. 1655; 27½ x 23½ in
(70 x 60 cm); oil on
canvas; Staatliche
Museen, Berlin

1650–1660

1650 Quaker movement founded.

1651 Dutch settle in South Africa.

1652 First US mint established in Boston.

1653 Cromwell becomes Lord Protector of the Commonwealth.

1654 Treaty of Westminster ends Anglo-Dutch War.

1657 Physicist Christiaan Huygens invents the pendulum clock.

1658 Red blood cells discovered by Dutchman Jan Swammerdam.

1660 Charles II restored to English throne. Pepys starts his diary.

Silks and Satins

Ter Borch is noted for his exquisite painting of silks and satins. He may well have been influenced by the ability and technique of Velásquez (p. 46).

STILL LIFE DETAIL

Ter Borch pays close attention to the still life objects. Dutch collectors appreciated works rich in domestic details. The tradition for paintings devoted exclusively to still life began in 17th-century Holland.

YOUNG GIRL

The girl's back is turned on the viewer, creating an air of mystery. Many of Ter Borch's paintings employ this sort of device, suggesting but never revealing secret thoughts. It is one of the qualities for which Vermeer is rightly celebrated.

HIGH SOCIETY

The artist introduced a new upright format showing "high-life" scenes. His own good upbringing made him familiar with this world. Early Dutch genre scenes showed "low-life" tavern scenes with unruly peasants.

SOBER PALETTE

Ter Borch's technique is extremely fine, and the simple composition, with carefully balanced warm tones, is characteristic. Whistler (p. 80) greatly admired these qualities and was influenced by them.

Genre scenes are small, unpretentious paintings illustrating an incident from everyday life, often with an amusing or moral message. They have always been popular with prosperous middle-class collectors.

" The Dutch painters were stay-at-home people— hence their originality "
CONSTABLE

Repainted Hand

There is evidence that the soldier's hand was repainted to eliminate the coin or turn it into a ring. The alteration of this single tiny detail radically changes the meaning of the picture. It was probably repainted in the 18th century.

NEW PICTURES FOR A NEW REPUBLIC

In the 17th century, Europe was dominated by Catholic monarchies who used art for their own glorification and for the reinforcement of their religion. The Netherlands stood apart and, after a long struggle to free herself from Spain, became an independent republic. The Netherlands prospered from commerce, banking, and trade, and surplus wealth was spent on luxury goods and art. To decorate their houses, people wanted small-scale pictures that would celebrate their new-found status. Thus landscapes, still lifes, and genre scenes portraying different aspects of their country and lifestyle came into vogue.

CANALETTO (1697–1768)

Giovanni Antonio Canale

FOR ABOUT **20** YEARS, Canaletto was one of the most successful artists in Europe. His views of Venice were much sought after, especially by the English Grand Tourists who flocked to Italy during the 18th century in search of education, adventure, and art. He was born in Venice and knew intimately the canals, the buildings, the people, and the history of the city that had once been the capital of the greatest empire in the world (p. 20). He learned his craft from his father, who was a theatrical-scene painter, and he drew on the traditions of Venetian art, especially its love of color, pageantry, and sensual pleasure. But Canaletto became almost too successful, and the great demand for his work caused him to lapse into a mechanical formula. Ultimately, fashion turned against him and his public grew tired of his work. He spent ten years in England trying to revive his fortunes, but in 1755 he returned to Venice, where he died poor, unmarried, and unnoticed.

❝ I place Velásquez on the same plane as Canaletto. The two men run side by side ❞
WHISTLER

THE MOLO ON ASCENSION DAY
Canaletto painted this view of Venice at the start of his career. It shows one of the great pageants of the Venetian calendar. Every year on Ascension Day the doge of Venice was rowed in his golden barge to the Lido, where, in a time-honored ritual, Venice was "married" to the Adriatic Sea. At the culmination of the ceremony the doge dropped a golden ring into the sea to symbolize the marriage.

Winged Lion
St. Mark is the patron saint of Venice. His symbol, a winged lion, is displayed prominently on a column in the Piazzetta. It can also be found on the Campanile and on the red flag of the doge's state barge.

HISTORIC BUILDINGS •
Three historic buildings frame the left-hand side of the picture: the three-storied mint (*Zecca*), which controlled the issue of Venetian currency; the two-storied library, which was built to Sansovino's design in 1540; and, towering behind them, the Campanile, which provided a landmark for ships arriving in Venice. Spectators can be seen in the loggia at the top of the Campanile.

LIGHT AND SHADE •
Although the composition is crowded with bustling activity, Canaletto theatrically arranged this scene so that the eye is drawn in an ordered way across a carefully worked out pattern of light and shade. The placing of the dark gondolas on the sunlit water provides a good example of this technique.

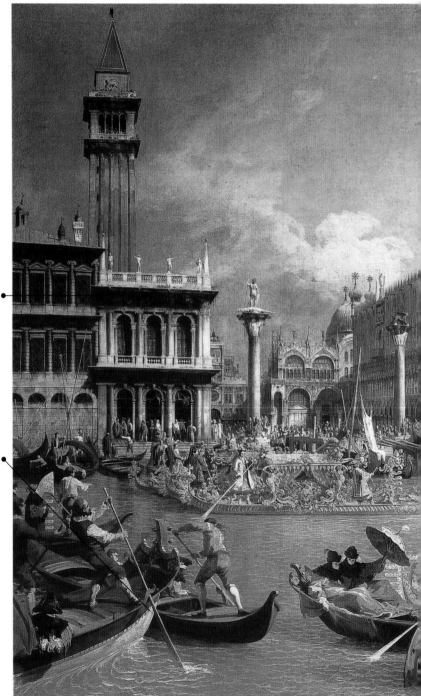

Canaletto; *The Molo on Ascension Day*; 1729–30; 71¼ x 102 in (182 x 259 cm); oil on canvas; Aldo Crespi Collection, Milan

Canaletto's art of visual delight rather than intellectual appeal suited the mood of the early 18th century. But the discovery of Roman remains at Herculaneum and Pompeii in the middle of the century changed the artistic agenda, and the serious Neoclassical style came into fashion. Canaletto did not adapt to this change in taste.

CANALETTO IN ENGLAND

The British Grand Tourists, who sought souvenirs of their travels, brought Canaletto great wealth. But the War of the Austrian Succession (1741–48) made traveling in Europe more difficult, and fewer Grand Tourists reached Italy. As a result, Canaletto made his first visit outside Italy to England to seek favor with his English patrons. However, he never recaptured the success of his earlier years, and the soft qualities of Northern light eluded him. Nevertheless, he had a strong influence on the developing school of English topographical watercolor painting, and his views of Venice still enrich many British stately homes.

• DOGE'S PALACE
The doge's palace was the seat of Government, but in Canaletto's day Venice's real political power had gone. The last doge signed away any remaining power to Napoleon on May 12, 1797.

When he returned to Venice from London, Canaletto applied for membership of the newly formed Venetian Academy but was initially rejected. His art did not aspire to the serious subjects and doctrinaire standards that were central to academic art and teaching.

Popular Festival
The lively detail of the doge's state barge and the fresh observation of figures drawn from life show Canaletto at his best. In later work such details become repetitive and unimaginative.

Although the scene is as convincing as a view from a window or balcony, it is, strictly speaking, a fiction, since there is no building from which this scene could have been observed from such a high viewpoint. Canaletto was very secretive about how he created these spectacular pictures. It is thought that he used a "camera obscura"—a machine that employed a combination of lenses and mirrors to project an image in light. He also made small freehand sketches in pencil of buildings and details. From his various sketches, and from memory, he would work out the design for the finished picture.

• SKY, LIGHT, AND WATER
One of the unique qualities of Venice is the magical union of sky, light, and water. Many artists have tried to capture this rare and changing beauty. Canaletto is one of the few to have succeeded. Turner (p. 66) greatly admired Canaletto's work and made several visits to Venice, captivated by the extraordinary quality of the city's light.

• RED FLAG
The flag repeats the image of the Lion of St. Mark (see opposite). Canaletto has used the bright red color of the flag at other strategic points on the canvas to help unify the composition and to lead the eye around the painting. This use of color is typical of Venetian painting.

Canaletto's success was developed by Joseph "Consul" Smith, an influential English diplomat who lived in Venice and helped the most prestigious Grand Tourists get the best out of their visit. He owned many paintings by Canaletto and actively promoted his work. In the 1760s Smith got into business difficulties and was forced to sell his collection. Many of his paintings were bought by King George III of Great Britain.

1700–1730

1701 Yale founded as Collegiate School.

1706 Benjamin Franklin born.

1707 United Kingdom of Great Britain created.

1714 George I (Elector of Hanover) crowned King of Great Britain.

1717 Handel: *Water Music.*

1718 New Orleans founded.

1721 Bach: *Brandenburg Concertos.*

1726 Jonathan Swift: *Gulliver's Travels.* Montevideo founded by Spanish.

• LIGHT AND COLOR
The clarity and precision of the light, the crisp shadows, and the precise anecdotal and architectural detail are typical of the style that so delighted Canaletto's foreign customers. There are only two of his works in Venice.

Canaletto's natural successor was his nephew Bernardo Bellotto (1720–80), who worked as his assistant. Bellotto left Venice in 1747, never to return, and made his career as a view painter in Dresden, Vienna, and Warsaw.

HOGARTH (1697–1764)

POPULARLY CALLED THE FATHER OF ENGLISH PAINTING, Hogarth was conscious that England had virtually no native artists of any stature, and he succeeded in paving the way for the eventual founding of the Royal Academy and the flowering of a strong English school. He was a Londoner, fiercely ambitious and highly patriotic, and strongly influenced by the theater and the satirical traditions of English literature. Hogarth knew at first hand the hardships of life and the

William Hogarth

follies of his fellow men—his father was a failed schoolmaster who went to the debtors' prison with his whole family when Hogarth was ten years old. Originally trained as an engraver, Hogarth was largely self-taught as a painter. He aspired to an art that would interest ordinary citizens rather than appeal to educated connoisseurs and critics, whom he despised. He achieved this ambition by creating a new type of painting, which could be reproduced as popular engravings. He won considerable success, but his later life was marred by ill health and political quarrels.

In the painting, a series of incidents are skillfully linked by the composition of the groups around the two tables. The inspiration for the work was the fight for the Oxford seat in the general election of 1754. The contest was between the Whigs (party of the new middle classes) and the Tories (party of the aristocracy and traditionalists).

AN ELECTION ENTERTAINMENT

The painting is one of a series of four, recording different aspects of a local election. It was Hogarth's last major work and arguably his finest achievement. It is typical of the artist's style in that it presents a scene that could be acted on stage. Each individual is given a specific role to play, which is conveyed by the character's facial expression, costume, and behavior. The series was reproduced as black and white engravings for popular sale.

The mayor
The mayor, who sits at the head of the table, has passed out after eating too many oysters. He is being bled—a process that was a "cure-all" treatment in Hogarth's day, when town barbers still doubled as surgeons.

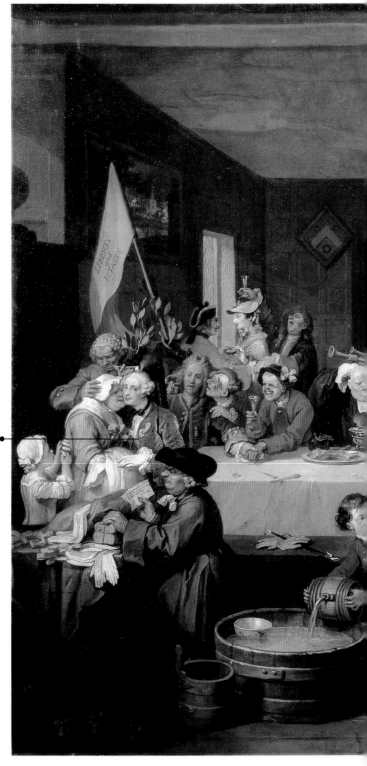

THE CANDIDATES
The entertainment is being paid for by the Whigs. They have two candidates: one is distracted by the attentions of an old woman, oblivious to the fact that her husband is setting fire to his wig and her daughter is stealing his ring. The second candidate behind him is being detained by a couple of drunks.

LIBERTY AND LOYALTY

Hogarth presents a fair if vivid picture of British society at the time. Britain was undergoing great change. Her society was robust and at times cruel, but it never lacked confidence—qualities that Hogarth displayed personally. Britain's system of parliamentary democracy was unique and in contrast to the absolute monarchies elsewhere in Europe. Britain had become a major world power and was creating an overseas empire, which at the time embraced the American colonies. Hogarth believed that Britain should also be on the world's artistic stage with her own painters. The slogan "Liberty and Loyalty" expresses the attitudes of Hogarth and his native country.

William Hogarth; *An Election Entertainment;* 1754; 48 x 50 in (101.5 x 127 cm); oil on canvas; Sir John Soane's Museum, London

Hogarth was an accomplished portraitist and was especially skilled at handling group portraits known as "conversation pieces." However, his portraits were as uncompromising as his other works—he never developed the ability to flatter.

One of Hogarth's great achievements was the introduction of a new genre—the modern moral subject. Prior to the Election Series, *Hogarth had completed* The Rake's Progress, The Harlot's Progress, *and* Marriage à la Mode. *In each series he illustrates human foibles, but he never moralizes, leaving the viewer to make a personal judgement.*

● **TORY PROCESSION**
At the window, a woman pours water over the Tories who parade down the street carrying banners and an effigy labelled "No Jews." The Tories (who polled the most votes) opposed the Whig legislation proposing that foreign Jews living in England should have the same rights as native-born English Jews.

❝ *My picture was my stage and men and women my actors who were by means of certain actions and expressions to exhibit a dumb show* **❞**
HOGARTH

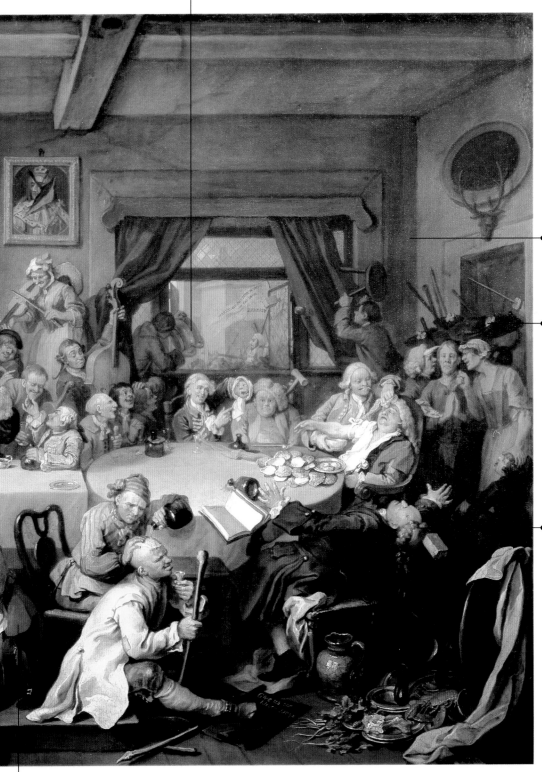

Although Hogarth made a considerable sum of money from his engravings, connoisseurs of the time did not take him seriously, and he had difficulty selling the actual paintings on which the engravings were based. He could not find a buyer for the Election Series, *so he decided to raffle it and asked his friend, the actor manager David Garrick, to help. Garrick bought the four paintings himself for just over £200.*

● **SIMPLE STYLE**
Hogarth's individual and unsophisticated style shows a conscious refusal to adopt the subjects and styles that characterize Italian and French art. He did attempt history painting, but the result was poor: too anecdotal and poorly composed.

● **ORANGE ORDER**
Several of the guests are wearing orange-colored favors, and the candidates themselves are seated under an orange flag displaying the slogan "Liberty and Loyalty." The Whigs were loyal to the Protestant succession from William of Orange (1650–1702), whereas the Tories hoped for the return of the Catholic Stuarts, who were exiled in France.

Hogarth was initially apprenticed as a silversmith—hence his interest in engraving. Ambitious to be a painter, he studied at Sir James Thornhill's free academy. He later eloped with the patron's daughter.

● **BRICK INJURY**
The collapsing man has been hit on the head by a brick, which has been thrown through the window. Another brick has broken the window.

Eleven Lost Days
A banner reads "Give us back our 11 days." In 1752, Britain adopted the Gregorian calendar. To enact the reform, Wednesday, September 3rd, was followed by Thursday, September 14th. Riots broke out because workers thought they had been cheated out of 11 days' wages.

● **THE FOLLIES OF DRUNKENNESS**
The boy mixes the drink that has already influenced the electors. Hogarth's work often dwells on foolish, drunken behavior. He also had a particular gift for capturing the character of children.

In 1735, Parliament passed a Copyright Act as a direct result of Hogarth's lobbying. Previously, any engraver could make reproductions of any painting without compensating the artist. The act protected the interests of painters, such as Hogarth, whose works had been pirated by profiteers.

REYNOLDS (1723–1792)

A TRUE PROFESSIONAL IN EVERY SENSE, Reynolds was artistically gifted, socially at ease, and had a firm grasp of the realities of running a business and manipulating art politics. His family was poor, but he was well educated—his father was headmaster at an English grammar school. From an early age he aspired to be a painter and to produce an art that had at its center a display of learning. He was apprenticed to the portraitist Thomas Hudson, and, in 1749, he went on an influential Grand Tour of Italy, absorbing the example of the Renaissance masters and the splendors of antique sculpture. On his return to England, he established a flourishing practice as a portrait painter in London, and by the age of 40 he had become rich and was accepted in the highest levels of society. As well as achieving his own personal ambitions, he used his talents to create for the first time a coherent artistic profession in England. He was a firm believer in standards and good organization and was a founder member and first president of the Royal Academy, which became the principal institution for exhibition of the work of established artists and for the training of the young. He helped to make British portraiture preeminent and endowed it with a new dignity.

Sir Joshua Reynolds

THOMAS LISTER

Thomas Lister, who later became Lord Ribblesdale, was the eldest son of a member of the British Parliament. He was 12 years old when this portrait was painted. The work exemplifies the grand manner that Reynolds introduced to portraiture and also shows the artist's sensitivity and his ability to capture the essence of this sitter's individuality.

Portraiture was one of the staple sources of income for an artist in the 18th century, but it was considered an inferior subject and less challenging than history painting. Reynolds captured the fashion of the day with his new style of portraiture, which introduced clever intellectual cross-references. He attempted several ambitious large-scale history paintings, but they were not successful.

A Child's Mind

Reynolds was renowned for his success with portraits of children. He was clearly able to make them relax and act naturally, and he had the knack of conveying a child's innocent combination of shyness and intensity of feeling.

❝*Considered as a painter of individuality in the human form and mind, I think him [Reynolds] the prince of portrait painters* ❞

RUSKIN

Reynolds had few friends among his fellow painters—he respected his rival Gainsborough but was not on close terms with him. He thought Gainsborough's work lacked intellectual depth. He was more at home with men of literature such as Samuel Johnson and Edmund Burke.

• INVENTIVE POSE

Reynolds was well known for the inventiveness of his poses—not just his learned borrowings from other famous works, but also the graceful movement, the seemingly natural turn of the head and body, and the expression of character through gestures of the hands and arms. Gainsborough exclaimed in admiration: "Damn the man, how various he is!"

• VAN DYCK DRESS

Master Thomas wears a brown satin suit embellished with a lace collar and cuffs, and brown ankle boots. The costume is highly fashionable and informal and is loosely based on that worn by the sitters in van Dyck's 17th-century portraits. It might have been Thomas Lister's own costume or a studio prop kept by Reynolds for his visitors to wear.

1751 French encyclopedia published. Linnaeus: *Philosophia Botanica*.

1752 Benjamin Franklin shows lightning is electricity.

1756 Black Hole of Calcutta. Seven Years' War begins in Europe. French and Indian War begins.

1757 British Museum founded.

1759 British capture Quebec. Voltaire: *Candide*.

1760 George III crowned King of Great Britain.

BACKGROUND DETAIL
Reynolds employed assistants to paint drapery and backgrounds. He may have employed the English artist Peter Toms to paint the background in this portrait.

MERCURIO.

Mercury
This antique statue of Mercury, the messenger of the gods, was considered by many art critics and connoisseurs to epitomize the concept of ideal beauty. Reynolds himself would have seen the statue on his visit to Italy when he was 26 years old, and he would have expected his audience to appreciate the flattering connection between the young, well-born English gentleman and the youthful god.

KEY WORKS

• **Commodore Keppel;** 1753–54; *Maritime Museum*, London

• **Dr. Johnson;** 1756; *National Portrait Gallery*, London

• **The Death of Dido;** 1780–82; *National Gallery*, London

• **Mrs. Siddons as the Tragic Muse;** 1784; *The Huntington Art Gallery*, San Marino, California

Reynolds had a well-developed theory of art, which he expounded in his famous Discourses to the students at the Royal Academy. He emphasized the need to learn by copying the great masters, and he urged students to paint in the grand manner. He thought that art should aspire to convey a standard of harmony and ideal beauty that nature alone can never achieve.

WELL-PRESERVED PAINTING
This work is in exceptionally good condition, but many of Reynolds' paintings have deteriorated badly with age—the result of poor workmanship and inappropriate materials. Reynolds had been badly taught technically, and he was too often tempted by untried pigments that would give quick results.

Reynolds made an extensive study of the work of the old masters when he was in Italy. He became deaf in later life as a result of catching a severe cold when copying in the Vatican. His heroes were Michelangelo (p. 28) and Raphael (p. 32). His late works show the influence of Rubens (p. 40) and Rembrandt (p. 48)—he visited Flanders and Holland in 1781. He undoubtedly saw himself as one of the true successors of the established artists.

PASTORAL SETTING
The gentle landscape setting picks up a fashionable theme of the day and hints at the images of Arcadia that attracted many of the great artists of the 17th century (p. 42).

REFLECTIONS OF ANTIQUITY
The crossed legs show how Reynolds has subtly adapted the antique image of Mercury (see right). Master Thomas' pose is virtually a replica with an extended right arm.

Reynolds was extremely businesslike with an efficiently organized studio and good publicity. He was dedicated to his work and never married. At the height of his powers he received up to six sitters a day and recorded their visits and payments in his "Sitters' Book." He had a scale of fees according to the type and size of portrait.

Sir Joshua Reynolds; *Thomas Lister;* 1764; 91 x 55 in (231 x 139 cm); oil on canvas; Musée du Louvre, Paris

ROYAL ACADEMY

T he Royal Academy in London was founded in 1768, at a time when Britain had established itself as a major world political power with a growing empire. There was a conscious desire to establish a national school of art to encourage a wider interest and appreciation among the general public, as well as to train future generations of artists to a high standard of professionalism and good taste. Reynolds was the first president of the Academy, and he kept his authority for 20 years, during which time he delivered his *Discourses*, which have become the classic expression of the academic doctrine of the "grand manner". He relinquished his post only when blindness prevented him from painting in 1790.

LOUIS XV

King Louis XV (1710–74) inherited control of France at a time when it was the richest and most powerful country in Europe. But he preferred a life of pleasure to the pursuit of the reforms proposed by the radical thinkers of the Enlightenment. The arts and crafts prospered in his reign, notably through the influence of Mme. de Pompadour, the king's mistress. The artistic extravagance and the neglect of the affairs of state finally exacted a severe price: the bloody French Revolution of 1789 (p. 62) and the fall of the monarchy.

FRAGONARD (1732–1806)

Charming and witty, plump, dapper, always bright and cheerful, with fine rosy cheeks and sparkling eyes, Fragonard was so blessed with natural talent and independence of spirit that he was able to defy convention and make his mark in his own way. He was born in Grasse in the South of France, the son of a glove-maker, but his family moved to Paris when he was six years old. Fragonard first went to work in a lawyer's office, but he showed such talent for drawing that his employer suggested he should go to art school. After apprenticeships under Chardin and Boucher, he won the coveted Prix de Rome and studied at the French Academy in Rome. He might have become a successful Academic painter, but the official training and the wonders of antiquity bored him. When he was 35 years old, he decided to work as an independent artist producing work for the art dealers and rich collectors of the *ancien régime*, who wanted intimate work for their salons and boudoirs. He had enormous artistic and financial success, painting delightful airy scenes of gallantry and frivolity that embody the spirit of the Rococo. However, the Revolution of 1789 and the new taste for Neoclassicism changed the world in which he had flourished. He died impoverished, unnoticed, and out of fashion.

Jean-Honoré Fragonard

THE SWING

This charming painting is the finest example of Fragonard's work as an independent artist. The theme is typically playful and erotic: a beautiful young lady kicks off her shoe in gay abandon while her lover watches, concealed in the bushes beneath her.

The painting was commissioned by the libertine Baron de St. Julien. He initially gave the order to a painter of historical subjects, Doyen. Spelling out his requirements, the baron said, "I should like you to paint Madame [his mistress] seated on a swing being pushed by a bishop." Shocked by the request, Doyen refused the commission.

SUNLIGHT

Fragonard mastered the pleasing effect of dappled sunlight, which illuminates many of his works. The true heir to his seductive style, with its emphasis on youthful beauty and virtuoso handling of dappled light, is the French Impressionist painter Renoir.

Fragonard had a happy domestic situation. He married the daughter of a perfumier from Grasse, and they had several children. Her younger sister later joined the household, and under Fragonard's tuition became an accomplished artist.

FANCIFUL TREES

The fantastic trees owe more to the artist's memories of his childhood and his student days than they do to observation from nature. Fragonard was raised in the lush, flower-filled region of Grasse—the center of the perfume industry. As a student in Italy, he was more excited by the luxurious pleasure gardens at Tivoli, where he spent the summer of 1760, than he was by antique sculpture.

FINE DETAIL

Fragonard's technical versatility enabled him to master a variety of styles. His preference was for rapid, fluid brushwork, but here he has chosen to paint in unusually fine detail, perhaps influenced by the 17th-century Dutch masters, who were in fashion with French collectors.

One of Fragonard's most ambitious projects, entitled The Pursuit of Love, was a set of large decorative panels commissioned in 1770 by Mme. du Barry (Mme. de Pompadour's successor). But fashionable taste had moved away from the Rococo style to the sober neoclassical style, and the panels were returned to the artist in 1773 as unsuitable. Fragonard was deeply offended by the rejection and refused payment.

CHANGE OF HEART
On turning down the commission for this work, Doyen suggested to the baron that Fragonard would be a suitable painter. Fragonard accepted the work enthusiastically, but replaced the bishop with the girl's husband.

French high society thrived on intrigues and extramarital liaisons. Mme. de Pompadour, the king's mistress, was one of the most powerful political figures in the country, with an official position at Court.

Jean-Honoré Fragonard; *The Swing;* **c. 1768; 32 x 25½ in (81 x 65 cm); oil on canvas; Wallace Collection, London**

Fragonard is best known now for his mildly erotic subjects, but he was also an accomplished portrait painter and had a great facility for landscape. As a young man, his history and religious paintings met with official approval.

Husband
Fragonard has placed the girl's unsuspecting husband in deep shadow, whereas a shaft of bright sunlight illuminates the flushed face of the baron. Nevertheless, it is the husband who manipulates the swing, propelling it toward his rival.

FLYING SLIPPER
The slipper flying through the air is a brilliant touch, which adds a focus of visual attention and sums up the playfulness of the subject.

A LOVER'S SECRET
The stone statue of Cupid catches the sunlight and seems to have come alive. He raises a finger to his lips as if warning us to keep the secret of the baron hidden in the bushes. The cupid is based on Falconet's statue *L'Amour Menaçant,* which was commissioned by Mme. de Pompadour in 1756.

THREE GRACES
Around the base of the statue of Cupid the Three Graces appear as a classical relief. In Greek mythology, the Graces were attendants of Venus, the goddess of love. Fragonard half-hides them, as if to emphasize his lack of interest in the art of classical antiquity.

The once powerful French Academy was in decline in the mid-18th century, leaving the way open for independent artists like Fragonard to flourish. It was David (p. 62) who rejuvenated the Academy and restored its influence.

1760–1780

1762 Mozart tours Europe, aged six.

1766 Hydrogen discovered.

1768 London's Royal Academy founded.

1770 First public restaurant opens in Paris.

1771 *Encyclopedia Britannica* first published.

1773 Boston Tea Party.

1774 Louis XVI crowned King of France.

1776 American Declaration of Independence.

THE BARON
The Baron de St. Julien provided very specific details for the painting. Indicating his mistress, he said, "Place me in a position where I can observe the legs of that charming girl."

Playful Love
Fragonard liked to include hidden details that wittily develop the theme of love. The two embracing putti that ride a dolphin are easy to see, but the lap dog beneath them is less easy to find.

PINK DRESS
The luxuriant curves of the billowing dress, the delicate pastel colors, and the theme of youthful love are essential characteristics of the Rococo style, which deliberately appealed more to the eye than the intellect.

Although their painting styles and temperaments were completely different, David (p. 62) helped Fragonard when he fell on hard times after 1789. He used his powerful influence to secure Fragonard some administrative artistic appointments in the new Republic, which would pay a modest salary. Fragonard's son was a pupil of David.

❝ *Every audacity in Fragonard's art trembles half-hidden beneath the modesty of his bundling* **❞**
JULES AND EDMOND DE GONCOURT

GOYA (1746-1828)

Francisco José de Goya y Lucientes

THE ART OF GOYA is intimately bound up with the dramatic events that preoccupied his native Spain during his lifetime. His background was provincial, and he was no child prodigy. However, he was highly ambitious and sought to fulfill his goals by securing the patronage of the royal family in Madrid. By astuteness and diligence he succeeded, becoming not merely the first painter to the king (in 1799), but one of the most accomplished artists in a truly talented age. A liberal-minded and independent man, he welcomed the French Revolution of 1789 for its promise of political enlightenment; then he saw the dream collapse, his fellow countrymen butchered by Napoleonic troops. His own life saw many hardships, notably the affliction of deafness, and he died in exile. His genius lay in his ability to paint his own era in a way that was universal—with a voice that expressed a lasting belief in the human spirit.

Goya was born near Saragossa, the son of a master gilder. At the age of 14 he was apprenticed as a church decorator before attending the Madrid Academy. He was an undistinguished student but was much helped in his early years by an established painter, Francisco Bayeu (1734–95). He married Bayeu's sister, Josefa, in 1773.

When he painted The Family of Charles IV, *Goya was aged 54 and already deaf. He lost his hearing in 1792–73 after an illness, which was probably brought about by overwork and anxiety about the banishment of his liberal friends from Spain.*

THE FAMILY OF CHARLES IV

The king is surrounded by members of his family. They had been in power for just over a decade but were about to become the victims of events that they would be unable to control. Goya's portraits are always powerfully revealing of the frailties and doubts of his sitters, but they never criticize or pass judgement.

GOYA

Goya includes his own portrait in a shadowed corner, working at a canvas. There is no logical explanation for his presence or his position behind the carefully posed royal family, except that he was very much part of court life. (However, he did not share its views or identify with it.) Just before he started this painting, he had achieved his ambition to become first painter to the king.

PRINCE OF THE ASTURIAS

Ferdinand was the heir to the throne, but he was prepared to work against his parents, and in 1808 staged a *coup d'état*. After the French were driven out of Spain by the Duke of Wellington, he became king and ruled as a despot, banishing the liberals and eliminating freedom of speech.

Goya's work for the Court was primarily as a portrait painter and as a designer for the royal tapestry factory. But much of his most powerful work was of a private nature. Among these are his portraits of his friends, the print series The Disasters of War, *and the "black paintings" for his own house—*Quinta del Sordo, *"the house of the deaf man."*

Artistic Influences

Goya was deeply influenced by works that he saw in the Spanish Royal Collection, especially the paintings by Titian (p. 24), Rubens (p. 40), and Velásquez (p. 46). Like them, he responded to color and enjoyed rich, loose paint.

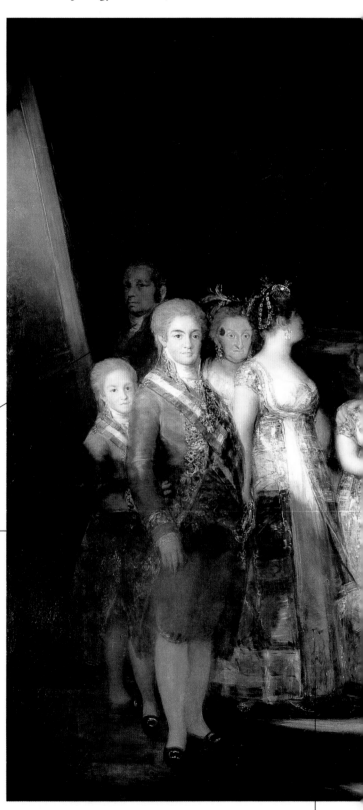

CHARLES IV

Charles IV (1748–1819) was not a direct descendent of his Hapsburg namesake, the Emperor Charles V (p. 34). The Hapsburg line died out in 1700, and the throne was inherited by the French royal family (Bourbon). Although born and raised in Spain, Charles' lineage was more French than Spanish. He was the cousin of Louis XVI, and he declared war on France when Louis was sent to the guillotine in 1793. The French army defeated the Spanish in 1808, and Napoleon installed his brother Joseph Bonaparte (1768–1844) as the King of Spain. Charles died in exile in Naples, in 1819.

BRIDE TO BE

All family members are identifiable except for the woman whose head is turned away so that her features cannot be seen. The figure was included to represent Ferdinand's bride, who had not yet been chosen.

FLATTERY OR CARICATURE?
It has been suggested that Goya deliberately caricatured the royal family—one critic memorably described the group as "the baker and his wife after they have won the lottery." However, the evidence is that the sitters were pleased with the portrait.

❝ *The sleep of reason produces terrible monsters* ❞
GOYA

Goya was born into the Age of Reason, and never lost his essential optimism about the human condition. Some of his best work is an observation of, and commentary on, the follies of ignorance and superstition and the way in which these are exploited by those in authority.

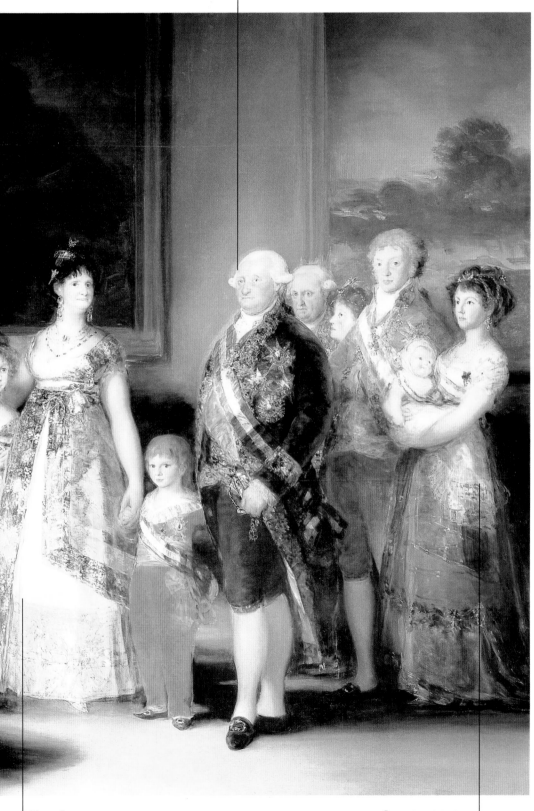

Charles IV
The king appears resplendent with his gleaming medals but, in reality, he was a weak monarch, dominated by his wife. He was eventually swept away by the political machinations of the Napoleonic Wars.

In 1824, Goya was forced to leave Spain by the repressive regime established by Ferdinand. He remained exiled in Bordeaux, France, until his death.

Francisco de Goya; *The Family of Charles IV*; 1800; 110¼ x 132¼ in (280 x 336 cm); oil on canvas; Museo del Prado, Madrid

1780–1800

1781 Kant: *Critique of Pure Reason.*

1783 Great Britain recognizes independence of United States.

1789 French Revolution. George Washington inaugurated as US President.

1791 Bill of Rights adopted in the US. Mozart: *The Magic Flute.*

1793 Louis XVI executed—Reign of Terror. Musée du Louvre opened.

1794 Whitney receives patent for cotton gin.

1799 Napoleon becomes First Consul. Infrared discovered.

MARIA LUISA
The queen controlled her husband but was herself manipulated by her lover, the politician Manuel Godoy, who was effectively the ruler of Spain.

SHIMMERING DISPLAY
Under the glittering array of lavish costumes, official honors, and jewelry, there is a structured color scheme: the women are dressed in white, gold, and silver; the men are accented in black, blue, and scarlet.

1810–1820

1810 Napoleon controls Continental Europe. Prussia abolishes serfdom.

1811 In England, Luddites revolt against use of machinery.

1812 Byron: *Childe Harold's Pilgrimage*. Napoleon's forces retreat from Moscow.

1814 Treaty of Ghent ends the War of 1812.

1815 Battle of Waterloo.

1818 First blood transfusion. Mary Shelley: *Frankenstein*. First steamship crossing of Atlantic.

1819 Electromagnetism discovered.

DAVID (1748–1825)

JACQUES-LOUIS DAVID lived through one of the most momentous political and social upheavals in European history and literally dedicated his art to the service of the French Revolution. The son of an iron merchant, he took a long time to establish himself as an artist and find his confidence, but he eventually emerged as the brilliantly gifted and passionate champion of a new serious style that we now call Neoclassicism. His first major works were for King Louis XVI, but, when the Revolution exploded in Paris in 1789, David became ardently committed to the new political cause with its rallying cry of "*Liberté, Egalité, Fraternité.*" With his fiery nature, he became deeply involved in party politics and, as a deputy, voted for the execution of the king. After the fall of Robespierre, David was imprisoned, and his release was secured only by the intercession of his royalist wife and his loyal pupils. In due course, the artist transferred his allegiance to Napoleon and painted works that were unashamedly propaganda pieces to glorify his hero. When Napoleon was defeated at Waterloo in 1815, David fled France. He lived in exile in Brussels, his artistic skills in decline, and died ten years later.

Jacques-Louis David

NAPOLEON IN HIS STUDY
This magnificent life-size portrait of David's political hero is overtly propagandist. The artist adapted the clear, detailed technique of the new Neoclassical style to convey an image of a handsome leader and a model of moral virtue devoted to the welfare of his people.

The reality behind the painting was somewhat different from the image conveyed. Napoleon was having difficulty sleeping—his Spanish campaign was ending in disaster, and he was obsessed with his doomed military campaign against Russia.

COMPOSITE UNIFORM
Napoleon's military dress is something of an artistic invention. Basically, it is the uniform of the famous Imperial Guard, but David has embellished the outfit with an infantry general's epaulettes from a uniform that Napoleon frequently wore on Sundays and special occasions.

CHARACTERISTIC POSE
Napoleon's right hand is tucked into his waistcoat in a characteristic gesture. The Emperor did not pose for this work; David painted it after existing portraits and studies.

Upon viewing the portrait, Napoleon is said to have commented, "You have understood me, David. By night I work for the welfare of my subjects, and by day for their glory."

WORKING WITHOUT SLEEP
The clock hands point to 13 minutes past four in the morning. The candles have burned low, and Napoleon rises heavy-eyed from his desk, where he has been working on state papers.

Medals
Napoleon wears two medals: the insignia of the Legion of Honor and the Iron Cross of Italy. He created both of these decorations himself. He made David a knight of the Legion of Honor in 1803.

CODE NAPOLEON

The document on the desk at which Napoleon has been working is the *Code Napoleon*, the codification of law that is the basis of the French legal system today. One of his greatest achievements was to establish an efficient system of civil administration throughout continental Europe.

Surprisingly, this painting was commissioned by a British nobleman, the Duke of Hamilton, who planned a series of portraits of European rulers. The duke also had a political agenda, which drew him close to Napoleon: as a Catholic and a nationalist, he dreamed that Napoleon might restore the Catholic Stuarts to the British throne.

ELABORATE CHAIR

David's work was fundamental in the creation of the French Empire style. The thronelike chair, designed by David, is a magnificent example of this style. The only hint of this is inscribed with the initial "N." The desk is in the same heavy and austere masculine style.

WRINKLED STOCKINGS

Napoleon's restlessness and insomnia were affecting his health and causing his legs to swell. The only hint of this is the wrinkled stockings. Like all great portraitists, David treads the tightrope that balances reality, idealization, and flattery.

Jacques-Louis David;
Napoleon in his Study; 1812;
80¼ x 49¼ in (204 x 125 cm);
oil on canvas; National
Gallery, Washington DC

THE LOUVRE MUSEUM

The French royal collections were not dispersed at the time of the Revolution but were reorganized and hung for public display. The Louvre, formerly the Royal Palace, was opened as the world's first national gallery in 1793, with David as its first director. Napoleon took a close interest in the new gallery, bringing to Paris a vast assembly of treasures seized from the countries he conquered. His dream was to create a central repository of the greatest masterpieces of European art. After Napoleon was defeated, the majority of the confiscated treasures were returned. Soon afterward, however, most European countries had inaugurated their own national galleries, inspired by the example of the Louvre.

❝ To give body and perfect form to your thought, this alone is what it is to be an artist ❞
DAVID

Signed Map

The rolled-up document on the floor beside the desk is a map of France, bearing the artist's name. The name is inscribed in Latin: *Lud./ocicus/ David Opus—*"This is the work of Louis David."

PLUTARCH'S LIVES

The book under the table is *Plutarch's Lives*, a great work written at the height of the Roman Empire. It contains learned biographies of military heroes such as Alexander the Great and Julius Caesar. David is paralleling Napoleon's achievements with those of the great leaders of antiquity.

WHITE QUILL

A white quill is balanced precariously on the edge of the desk, suggesting that Napoleon has just set it down. In his left hand he is still holding the imperial seal, which he would employ to authenticate important state documents.

David was happily married and the father of four children. He was 34 years old when he married 17-year-old Charlotte Pécoul, and he received a substantial dowry. However, his wife was a royalist, and his involvement in politics caused them to divorce in 1794. Charlotte remained personally loyal to David, and after his imprisonment she helped to secure his release. They later remarried.

DECORATIVE DETAILS

David borrowed details of the decor and accessories from information provided by acquaintances and from his own knowledge of the imperial furniture gleaned from previous audiences with the Emperor.

KEY WORKS

- **Oath of the Horatii**;
1784; *Musée du Louvre*, Paris
- **Death of Marat**; 1793; *Musée Royale des Beaux Arts*, Brussels
- **The Sabine Women**; 1799; *Musée du Louvre*, Paris
- **The Coronation of Napoleon and Josephine**; 1807; *Musée du Louvre*, Paris

The severe and serious Neoclassical style was a conscious reaction, both in subject matter and technique, against the light-hearted and delicately painted Rococo style, typified by the work of artists such as Fragonard (p. 58). In this work, David has adapted the Neoclassical style to modern portraiture. His hero is shown as a model of republican virtue, and the details show that he reveres the examples of military prowess and learning that the Roman Empire had established.

FRIEDRICH (1774–1840)

Caspar David Friedrich

THE BEST-KNOWN GERMAN ROMANTIC LANDSCAPE PAINTER, Friedrich was a melancholy and lonely man scarred by a tragic childhood. His life was not an easy one, bringing little recognition and no riches. He was born in Pomerania, on the Baltic coast, but spent most of his life in Dresden, which was one of the cultural centers of Europe. His father, a candlemaker, imposed a puritanical Protestant upbringing. After studying at the renowned Copenhagen Academy, Friedrich never again traveled outside Germany, and he refused an opportunity to visit Rome, thinking that it might corrupt the purity of his art. Although he made detailed studies from nature, his major works are drawn from his imagination. His paintings are rich in symbolism and intensely spiritual in character. In 1818, he married a girl much younger than himself and befriended younger artists. For a while his melancholy abated, but his last years were marred by ill health and poverty, and he died in obscurity.

THE STAGES OF LIFE

Although the picture is entirely imaginary, the setting is recognizable as the harbor in Greifswald, the town of Friedrich's birth. The imagery is symbolic, and the five silhouetted ships correspond to the five figures in the foreground. The ships are at different stages in their travels, just as each of the figures is at a different stage in life. It was painted in 1835, when Friedrich had suffered a stroke: death and the meaning of life were very much on his mind.

SYMBOLIC SHIPS •
The ships symbolize the voyage of life, and the central ship is nearing the end of its travels, just as Friedrich was approaching the end of his journey through life. The cruciform mast of the main ship is probably a deliberate reference to Christ's death on the cross, thus representing the artist's religious faith.

Friedrich's expression of Christian faith in terms of pure landscape was novel. One of his earliest landscapes in oil, **The Cross in the Mountains** *(1808), caused great controversy because it was painted as an altarpiece. Many critics considered such imagery sacrilegious.*

FOUR STAGES OF LIFE •
The figures represent the four stages of life: childhood, youth, maturity, and old age. The figure with his back turned symbolizes old age and is probably a representation of Friedrich himself.

Friedrich achieved some success between 1807 and 1812, when he received the patronage of the Prussian monarch. He also became involved in politics, supporting the pan-Germanic movement, which hoped for a unified German state.

Swedish Flag
The two children are shown playing with the Swedish flag. When the artist was born, Greifswald was a part of Sweden, but in 1815 it was absorbed into neighboring Prussia. The detail also signals Friedrich's deep affection for his own children.

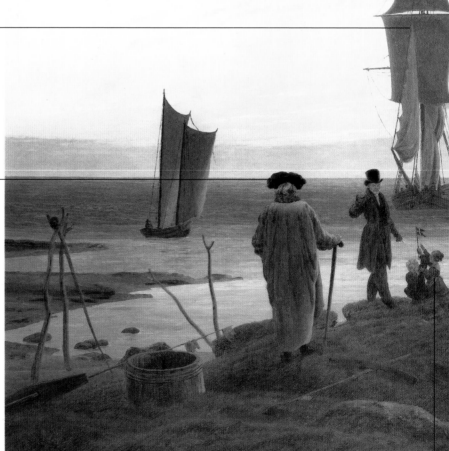

Caspar David Friedrich; *The Stages of Life*; c. 1835; 28½ x 37 in (72.5 x 94 cm); oil on canvas; Museum der Bildenden Künste, Leipzig

FAMILY PORTRAITS •
The two children playing on the shore represent Friedrich's own youngest children, Gustave Adolf and Agnes. The young woman is his eldest daughter, Emma, and the man in the top hat is probably his nephew.

Chalk Cliffs on Rugen

This painting is a reminder of the visit by Friedrich and his wife to a famous beauty spot near Greifswald on their honeymoon in 1818. The painting is almost certainly intended to be read symbolically: his wife Caroline seated on the left in a red dress represents charity; Friedrich, himself, on his knees in a blue coat represents faith; and his brother Christian, who gazes at the distant horizon, represents hope.

Caspar David Friedrich; *Chalk Cliffs on Rugen*; c. 1819; 35½ x 27½ in (90 x 70 cm); oil on canvas; Oskar Reinhart Collection, Winterthur

SPIRITUAL LIGHT
Friedrich was not interested in the magnificence of sunlight or the freshness of nature, as were other contemporary landscape painters (pp. 66–69). Rather, he chose moonlight, evening, and winter—times of transformation. Such moments evoke stillness, silence, and contemplation— and remind us of our mortality.

Although he made many sketches from nature, Friedrich's method of composition was unique. He stood silently in front of a bare canvas in an empty studio for long periods until the image came to him. He then recorded this image on the canvas.

DISTANT HORIZON
Many of Friedrich's paintings include seascapes in which the distant horizon represents the infinite and the unknown.

FINE OUTLINE
The meticulous detail of the ships is characteristic of the artist. His mastery of the use of fine outline and precise detail was learned at Copenhagen, as was his skill in balancing compositions. His work is always painted on a small scale in intense and minute detail, which demands that the viewer brings a similar intensity to the examination of the painting. He was trying to convey an experience that was both visually and spiritually intense.

Friedrich's childhood was scarred by death. His mother died when he was seven years old, and two sisters died before he was 18. His brother drowned trying to save Friedrich's life in a skating accident, and it has been suggested that Friedrich felt that only his own death could expiate the grief and guilt he carried as a result of the tragedy.

In 1816, Friedrich was awarded a small stipend from the Dresden Academy, and he was elected a member. This financial support enabled him to marry Caroline Bonner, a girl from Dresden, who was 22 years his junior.

SYMBOLS OF DEATH
The hauled-in nets and upturned boats lying in the foreground may have been included as symbols of death.

KEY WORKS

• **The Cross in the Mountains;** 1808; *Staatliche Kunstsammlungen*, Dresden

• **Monk by the Shore;** 1810; *National Gallery*, Berlin

• **Winter Landscape;** 1811; *National Gallery*, London

• **Wreck of the Hope;** 1824; *Kunsthalle*, Hamburg

❝ Close your bodily eye, so that you may see your picture first with your spiritual eye. Then bring to the light of day that which you have seen in the darkness so that it may react on others from the outside inward ❞
FRIEDRICH

1830–1840

1830 William IV crowned king of England. Revolution in Paris.

1831 Belgium gains independence. Cholera epidemic reaches Europe.

1832 Berlioz: *Symphonie Fantastique.*

1833 Colt invents the revolver. Chopin: *Twelve Etudes.*

1834 Victor Hugo: *The Hunchback of Notre Dame.*

1835 Morse demonstrates telegraph.

1837 Victoria crowned queen of the United Kingdom.

TURNER (1775–1851)

MOST FAMOUS OF ALL the landscape painters of the Romantic movement, Turner was born into a humble family in London, England—his father was a barber who liked to display his son's paintings in his shop window. He trained at the Royal Academy, and his precocious talent enabled him to become one of the youngest full members. He achieved early artistic success through his landscapes and seascapes built on the styles of the old masters, which greatly appealed to aristocratic collectors. Turner had a restless temperament: he traveled constantly, and his style of painting changed radically as he grew older. Always a loner, who had little time for anything other than his art and travels, he never married. Nevertheless, he was deeply excited by the turbulent political and social changes of his day, such as the Napoleonic Wars and the Industrial Revolution. But, above all, he was excited by nature: the thrill of overwhelming natural forces, delight in nature's delicate sweetness, and the crowning magnificence of sunlight.

*Joseph Mallord
William Turner*

Thin Paint
Turner has diluted his pigments with turpentine so that be can apply them in thin washes, almost like watercolor. He was a gifted and prolific watercolor artist, and here be brings his experience of that technique to oil painting. He was never afraid to experiment.

BRIGHT PALETTE
Turner suggests the glow of early morning sunlight by using a bright palette dominated by the complementary colors blue and yellow, which mutually enhance one another to create the vibrancy of sunlight.

*Many of Turner's late landscapes have a color scheme that is dominated by reds and yellows rather than the earth colors of his early work.
In 1819, he paid his first visit to Italy, and the impact of Mediterranean light had a profound influence on all his subsequent work, brightening and intensifying his colors and loosening his brushwork.*

WARM ACCENT
The cow standing in the water adds an essential accent of warm reddish brown, which sets off the coolness of the blues and yellows.

Turner had no pupils and no immediate followers of his late style. However, two young French artists later studied his work with interest—especially his use of color and handling of paint. They were Monet (p. 84) and Matisse (p. 98).

NORHAM CASTLE, SUNRISE
The view of Norham Castle is one that Turner reworked many times. This interpretation, painted when he was over 60 years old, is unfinished, and it was never exhibited. Turner produced many such works, either as experiments or as "lay ins" that he might later work up into a finished picture for exhibition.

CASTLE RUINS
The ruined castle dominates the River Tweed on the English-Scottish border. It had witnessed many important battles in the historic struggles between the two countries. It appealed vividly to Turner's love of history and the picturesque.

NEW COLORS
Scientific and technical advances produced new pigments and dyes during Turner's lifetime. Turner was able to use the new pigments to mix his own colors, and he was interested in the theoretical relationships between color and emotions.

Turner first visited Norham Castle in 1797, aged 22, when be made a topographical sketch. He returned to paint it again in 1801–02 and 1831. Turner loved wild countryside, rivers, and mountains.

J.M.W. Turner: *Norham Castle, Sunrise;* 1845; 36 x 48 in (91.5 x 122 cm); oil on canvas; Tate Gallery, London

1840 Queen Victoria marries Prince Albert.

1843 Ruskin: *Modern Painters*, Volume 1. First propeller-driven ship crosses the Atlantic.

1846 Irish Potato Famine. Smithsonian Institution founded in Washington, DC.

1848 Political revolutions across Europe—"The Year of Revolutions".

1849 California Gold Rush.

1850 California admitted to the Union as the 31st US state.

SNOWSTORM AT SEA

This painting is one of Turner's last masterpieces. Like *Norham Castle*, it reworks a theme that interested the artist from his earliest years: the life-threatening perils of the sea. It is supposedly the direct result of a sea voyage taken by Turner himself. When he exhibited the work at the Royal Academy it was greeted with incomprehension.

One critic wrote that the picture was painted with "soap suds and white wash"; another said he had chosen to paint with "cream or chocolate, yolk of egg, and currant jelly..." According to his friend Ruskin, Turner was deeply hurt by the criticism, saying, "I wonder what they think the sea is like? I wish they'd been in it."

ALMOST ABSTRACT

The painting appears to be almost abstract, but Turner claimed that it represented his own direct experience: "I did not paint it to be understood, but I wished to show what such a scene was like. I got the sailors to lash me to the mast to observe it."

Turner was influenced by the sea pictures of the Dutch masters, and the first picture he exhibited at the Royal Academy was a night scene depicting fishermen at sea. His first visit to mainland Europe was in 1802, at the age of 27. The Channel crossing was very stormy, and it is said that he was nearly drowned. He was excited by the experience and commemorated it in a large painting called Calais Pier. The painting represented his first radical departure from the classical tradition—it was widely condemned as "unfinished."

" *He paints with tinted steam* **"**
CONSTABLE ON TURNER

RAY OF HOPE

The ship's mast is silhouetted against a bright patch of sunlight, suggesting that the storm will abate and the danger is passing.

VORTEXLIKE COMPOSITION

Turner often used a swirling vortex to express the driving force of a storm. Here, at the center, it is possible to make out the form of a paddle steamer, the *Ariel*, lashed by the wind and waves.

J.M.W. Turner; *Snowstorm at Sea*; 1842; 36 x 48 in (91.5 x 122 cm); oil on canvas; Tate Gallery, London

Turner's love of the seagoing ships was born in his boyhood when he watched them on the nearby River Thames. In his last years he lived in a house overlooking the river, where he could watch the ships come and go.

Turner exhibited the painting with the following inscription: "Steamboat off a harbour's mouth making signals in shallow water, and going by the lead. The author was in this storm on the night the Ariel left Harwich."

EMOTION AND COLOR

Turner increasingly eliminated detail from his later works, and he explored the possibilities of using color to express mood. The Romantic spirit longed for the overwhelming experience—in life and love as well as in death. All the arts aimed to capture such moments of sublime excitement.

A major change in Turner's lifetime was the decline in importance of wooden-hulled sailing ships as they were superseded by iron-hulled coal-fired steamers. The first crossing of the Atlantic by a ship powered by sail and steam was in 1819. Britain was in the forefront of these changes.

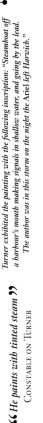

Dark Palette and Thick Paint

Turner has deliberately chosen a dark palette dominated by blacks, greens, and browns to express the angry mood of the storm. The thick paint imitates the foaming quality of the rough sea.

THE TURNER BEQUEST

Like many artists, Turner worried about his reputation after his death. He was extremely ambitious and competitive, and he amassed a considerable financial fortune. He was, however, concerned about the welfare of artists less fortunate than himself. In his will he left money to build almshouses for the benefit of "decayed male British artists." He left some pictures to the National Gallery and requested that others be sold. After his death the will was disputed and a settlement reached whereby the nation acquired all of his paintings and his relatives received all of his money. His project for an almshouse was simply abandoned. A new gallery to display his work was opened in 1987, over 100 years after his death.

CONSTABLE (1776–1837)

DETERMINED, DEDICATED, GIFTED, and with a deep and personal
response to nature, Constable created art that was constantly
misunderstood, and he was not a successful painter in his lifetime. He
was born into a prosperous family of mill owners and lived all his life
in a very small geographical area. He never traveled outside England
and never wanted to. He learned his
craft at the newly established Royal
Academy Schools in London and
studied the landscape artists of the
past, such as Rubens (p. 41), Claude,
and the Dutch masters. His ambition was to introduce a new
quality to landscape painting—to capture the reality of daylight
and the feel and smell of the dewy freshness of nature, both for
their own virtues and because he saw in them the moral presence
of God. His lifestyle and social views were very conservative:
he married late in life and fathered seven children, and he was
heartbroken when his wife died at the age of 40. Yet in artistic
matters he was a genuine revolutionary, daring to go where no
one had previously ventured and never compromising his art.

John Constable

CLOUDS IN THE SKY
Constable's sky and clouds are
faithfully observed, and at various
times he consulted meteorological
treatises. He believed that the pattern
of light and shade on the land should
appear to have been created by the
clouds in the sky, and that the Dutch
masters of landscape, whose work
he studied, had failed to achieve this.

FLATFORD MILL
In this early work,
Constable paints a view
of which he knew every
detail. As a child he
played here, just like the
boy he depicts. The red-
brick mill was inherited by
his father, who was one of
the most prosperous men
in the district. Constable
hoped the painting would
establish his reputation.

TURNING BARGES
Constable's viewpoint is a slope
up to a bridge over the river. The
horse is being unharnessed from
the barge, which will be pushed
under the bridge with poles.

John Constable; *Trees
at East Bergholt*; 1817; 21¼ x
15¼ in (55 x 38.5 cm); pencil
on paper; Victoria and Albert
Museum, London

Outdoor Sketches
*Constable was a slow worker and made many
sketches on the spot from nature, from which he
worked up his final exhibition pictures in his studio.
Flatford Mill is unusual in that the painting was
worked on out of doors as well as in the studio.*

*Constable fell in love with Maria
Bicknell, the granddaughter of a local
notable, who opposed the marriage. He
courted her for seven years. In 1816, his
father died, leaving him an allowance,
which finally made the marriage possible.*

CHANGES IN TASTE

England was still predominantly aristocratic and agricultural in 1817. Cultured
artistic taste was dominated by the classical ideal, and popular taste demanded
dramatic and theatrical effects. Constable's paintings fulfilled neither the popular
nor official artistic expectations. By the late 19th century, however, England had
changed to an urban and industrial society. Landscape painting and detailed realism
had achieved official approval, and popular taste took pleasure in Constable's work as
a nostalgic image of an idyllic lifestyle that city dwellers could only dream about.

John Constable; *Flatford
Mill*; c. 1816–17; 40 x 50 in
(101.5 x 127 cm); oil on
canvas; Tate Gallery, London

*Flatford Mill was painted when Constable was
preparing for marriage, and he had high hopes of
a successful career. After the early death of his wife,
he grew increasingly melancholy and solitary.*

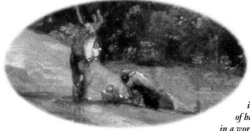

Changes
Initially, Constable included a horse instead of the reclining boy, and its towing gear is still shown on the ground to the right of the path. The details in the painting illustrate the artist's heartfelt vision of harmony between man and nature in a working agricultural landscape.

❝ I have seen him admire a fine tree with an ecstasy like that with which he could catch up a beautiful child into his arms ❞
C. R. LESLIE

Until late in the 19th century, landscape was considered an inferior subject for painting—decorative, but not worthy of the attention of a serious artist. Constable's revolutionary notion was to suggest that "God Almighty's daylight" was as moral and uplifting as any scene from the Bible or ancient history. Most critics and connoisseurs of his own time could not accept such a proposal.

CONSTABLE COUNTRY
The elm trees, the glory of Constable hedgerows, are no longer there, killed by Dutch elm disease in the 1970s. "Constable Country"—the Stour Valley in eastern England—is a place of pilgrimage because of the affection now shown for Constable's painting. Flatford Mill is a national monument.

INNOVATIVE TECHNIQUE
Constable animates his foliage and grasses by interweaving different greens and introducing touches of complementary red. The technique so impressed Delacroix (p. 72), who saw it in Constable's *Hay-Wain* in 1824, that he immediately repainted parts of one of his own paintings.

Constable devoted great attention to the picture in the summer of 1816, even suggesting to his future wife that they should delay their marriage so that he could finish his picture. She was not amused. The painting was exhibited at the Royal Academy in 1817, but it failed to find a buyer.

REAPER
A solitary reaper walks across the meadow in the middle distance. The summer of 1816 was particularly wet, and reaping was difficult. The water in the rivulet is further evidence of the wet summer.

1800–1810

1800 Washington, DC becomes US capital.

1802 Atomic theory introduced in chemistry.

1804 Napoleon becomes Emperor.

1805 Napoleon defeats Austrians and Russians at Austerlitz. Beethoven: *Fidelio*. Morphine discovered.

1808 French capture Rome and Madrid. Goethe: *Faust*. Beethoven: *Fifth Symphony*. Inquisition abolished.

1809 French capture Vienna. Napoleon divorces Josephine. Beethoven: *Emperor Concerto*.

STRANGE SIGNATURE
Constable has written his signature in the foreground as if he had scratched it into the earth with a stick. The gesture symbolizes his deep attachment to his native countryside.

SMALLEST DETAIL
Constable's early work is full of the most accurately observed detail, such as the flowers in the hedgerow, the swallows at the foot of the elm, and the cows in a distant field.

INGRES (1780-1867)

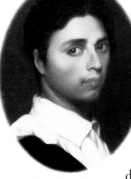

Jean-Auguste Ingres

BORN IN FRANCE during the last years of the *ancien régime*, Ingres witnessed the Revolution, the Terror, the rise and fall of Napoleon Bonaparte, the restoration of the monarchy, and Louis Napoleon's *coup d'état*. Yet in each era he strove to remain a pillar of the establishment, upholding secure traditional values. He was the son of a minor artist, and a devoted pupil of David (p. 62). He succeeded his teacher as the champion of Classicism, and his meticulous style reflected his character—honest, methodical, obsessive, and loyal. Yet he was also hypersensitive to criticism. His early work was generally not well received in Paris, so Ingres traveled to Italy and remained there until Parisian taste turned in his favor. In all, Ingres spent 25 years in Italy. He did not return permanently to Paris until 1841, when his inflexible determination brought the official success he longed for. He died rich, honored, and revered as a god by his many pupils.

THE BATHER OF VALPINCON

The simplicity of this work is deceptive. The relationship of each detail has been calculated with infinite care. The classical tradition considered mastery of the nude figure to be one of the greatest skills and a supreme means of spiritual expression. By studying casts from antique statues, artists strove to perfect nature and represent the ideal human form. Ingres' bather lends a modern interpretation to this tradition.

SUBTLE DISTORTIONS •
Beneath the apparently natural perfection of this nude form hide subtle and deliberate distortions: the back and neck are too long, and the shoulders slope with exaggerated grace. The artist did not seek to create the illusion of reality but a balanced harmony of form and color, order and pattern.

The painting is named after its first owners. The Valpincon family were close friends of Degas (p. 78), and this painting had an enormous influence on him. Whistler (p. 80) and Picasso (p. 102) were also influenced by Ingres' superb draftsmanship.

SHADES OF THE ORIENT •
Here, as in many of Ingres' works, drapery is used to suggest the sensuality and decadence of the Turkish harem. Although deeply influenced by Raphael (p. 32) and the classical ideal, Ingres was also fascinated by the mysticism of the Orient.

Flawless Surface
Ingres worked slowly and methodically to create such controlled masterpieces. His technique is meticulous, and he strove to achieve a flawless surface as smooth as a mirror.

EROTIC ALLUSIONS •
Many of Ingres' works contain a barely hidden sexuality. Here, the viewer's eye is drawn to the foot that gently rubs the other leg above a discarded slipper, the buttocks nestling on linen sheets, and the face concealed in shadow.

Jean-Auguste Ingres; *The Bather of Valpincon*; 1808; 57½ x 38 in (146 x 97 cm); oil on canvas; Musée du Louvre, Paris

INGRES IN ITALY

After winning the Prix de Rome in 1801, Ingres traveled to Italy, where his studies intensified his passion for the old masters. Rome was occupied by the French, and he gained a strong following among his compatriots. Disaster struck in 1814, however, when Napoleon abdicated, and the artist's supporters fled from Rome (it was also the year that Ingres' father died). Ingres stayed in Rome until 1824. After a decade in Paris, he returned to Italy and became a highly successful director of the French Academy in Rome.

« Ingres is the complete expression of an incomplete intelligence »
DELACROIX

• ARTIFICIAL GESTURE
The right hand is posed in a highly artificial gesture. It is based on an image found in a wall painting in the ancient Roman town of Herculaneum. The artist chose the gesture because of its symbolism— motherhood and modesty.

KEY WORKS

• **Emperor Napoleon**; 1806; *Musée de l'Armée*, Paris

• **Jupiter and Thetis**; 1811; *Musée Granet*, Aix-en-Provence

• **Apotheosis of Homer**; 1827; *Musée du Louvre*, Paris

• **Turkish Bath**; 1863; *Musée du Louvre*, Paris

Ingres disliked portraiture, preferring to make his reputation through traditional history painting. His ambition was to become the high priest of the academic tradition. He accepted this commission because he found the sitter so beautiful.

Exquisite Detail
Ingres' painstakingly meticulous technique enabled him to convey the most exquisite detail, as is clearly illustrated here in the variety of colors and textures in the jewels, tassels, and embroidery of the dress.

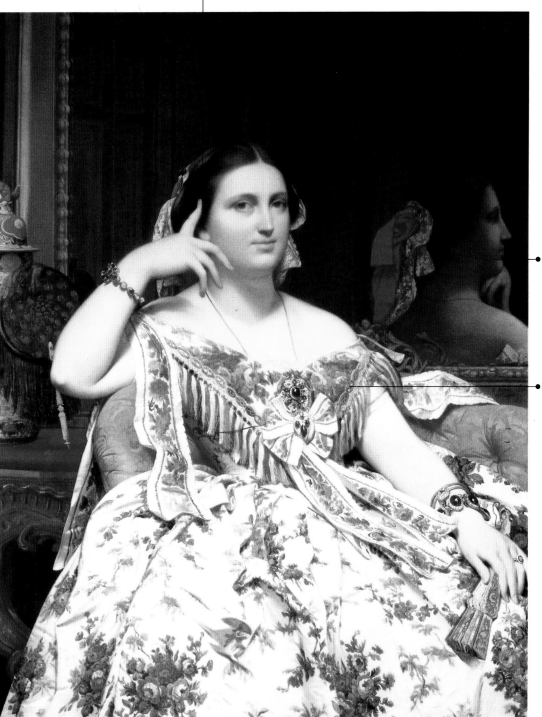

MADAME MOITESSIER

This portrait of the wife of a successful banker, Sigisbert Moitessier, is signed by Ingres with his age—76 years old. By this time his reputation was unassailable, and his busy studio was inundated with requests for portraits and with official commissions for allegorical works.

The commission of this portrait was interrupted by the death of Ingres' wife in 1849, which left the artist distraught and unable to paint for several months. Although it was an arranged marriage, Ingres and his wife were devoted to each other.

• IMPOSSIBLE IMAGE
The reflection in the mirror is impossible in reality. It is a theatrical device that Ingres used occasionally in order to portray his sitter's profile.

Ingres made studies from nude studio models for his portraits so that he could fully understand the form of the body beneath the clothing.

• SUMPTUOUS DRESS
Mme. Moitessier's status and wealth are indicated by her sumptuous chintz dress and by the jewelry adorning her wrists and neck. The buttoned sofa, Chinese vase, and gilt furniture indicate the lavishness of her lifestyle.

Jean-Auguste Ingres;
Madame Moitessier; **1856; 47 x 36 in (120 x 92 cm); oil on canvas; National Gallery, London**

1855–1860

1855 Florence Nightingale nurses in Crimea.

1856 Flaubert: *Madame Bovary.*

1857 Britain and France capture Canton. Baudelaire: *Les Fleurs du Mal.*

1858 Suez Canal Company founded. Ottawa becomes capital of Canada.

1859 Darwin: *Natural Selection.*

1860 Garibaldi seeks to unite Italy.

DELACROIX (1798-1863)

EUGÈNE **DELACROIX WAS THE LEADER** of the French Romantic movement in painting, and his life and character approached that of the hero of a romantic novel. He was aloof and aristocratic in temperament; witty, charming, and popular in society; and had an intensely passionate nature. He was raised by wealthy, elderly parents, but it is suspected that his natural father was the statesman Talleyrand, who stole his mother's affections and his father's post as Minister for Foreign Affairs. He had a good classical education, trained at the Ecole des Beaux Arts, and received his first state commissions at a very young age. But his interest was not in the classical and academic, as championed by his rival, Ingres (p. 70). His obsession was with moments of supreme emotion. He never married, but he was popular in society and had many love affairs. He was a close friend of some of the great figures of his day, such as Baudelaire and Hugo. But, in spite of his restless energy, his health was frail. In the 1830s, he turned away from society and worked on large official commissions. The labor he devoted to them exhausted him, and he died alone in Paris.

Eugène Delacroix

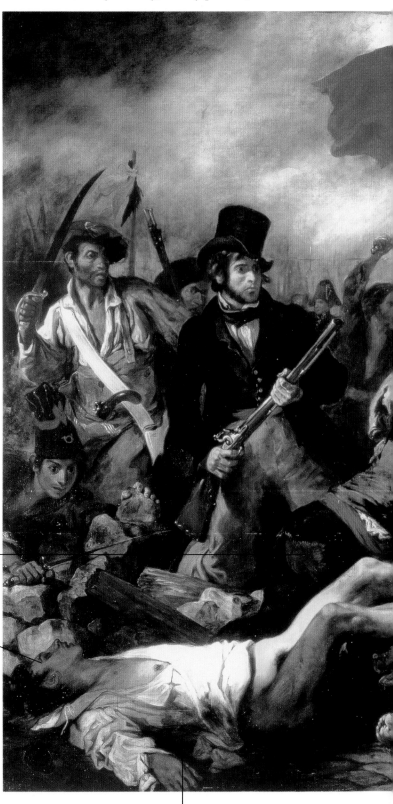

Eugène Delacroix; *Liberty Leading the People*; 1830; 102¼ x 128 in (260 x 325 cm); oil on canvas; Musée du Louvre, Paris

LIBERTY LEADING THE PEOPLE

This highly controversial painting commemorates the political uprising in Paris in July 1830, when Parisians took to the streets in revolt against the greedy and tyrannical regime of the king, Charles X.

Delacroix had high hopes for the critical reception of this work, but he was disappointed. The proletarian emphasis was considered so dangerous that the painting was removed from public view until 1855.

DYING PATRIOT
A mortally wounded citizen strains with his dying breath to take a last look at Liberty. His arched pose is a crucial element in the pyramidal composition. Significantly, the artist echoes the colors of the flag in the dying patriot's clothing.

HERO'S DEATH
Light shines on the dead patriot in the foreground. One of Delacroix's brothers fought with Napoleon and died at the Battle of Friedland.

CORPSE
At the Salon reception, one critic scoffed that this corpse looks as if it has been dead for eight days.

Caps for All Classes
All classes, except the dyed-in-the-wool monarchists, supported the revolt. Delacroix conveys this by the variety of hats that are worn by the streetfighters—top hats, berets, and cloth caps are all represented.

DELACROIX AND COLOR

Unlike Ingres (p. 70), Delacroix valued the use of bold color above meticulous draftsmanship, and he was to become increasingly innovative in his exploration of the expressive qualities of color. In particular, he investigated the effect of juxtaposing complementary colors to increase their individual richness and vibrancy. His visit to Morocco opened his eyes to new and exciting intensities of color and light. His insights into color theory are documented in his *Journals*.

Delacroix often used short, broken brushstrokes, anticipating artists such as Monet (p. 84).

Prominent Signature
The artist's signature is written boldly, in symbolic red, on the rubble of the barricades to the right of the young patriot.

"One must be bold to extremity; without daring, and even extreme daring, there is no beauty"
DELACROIX

KEY WORKS

- **Barque of Dante**; 1822; *Musée du Louvre*, Paris

- **Massacre at Chios**; 1823; *Musée du Louvre*, Paris

- **Death of Sardanapalus**; 1827; *Musée du Louvre*, Paris

- **Lion Hunt**; 1855; *Musée des Beaux Arts*, Bordeaux

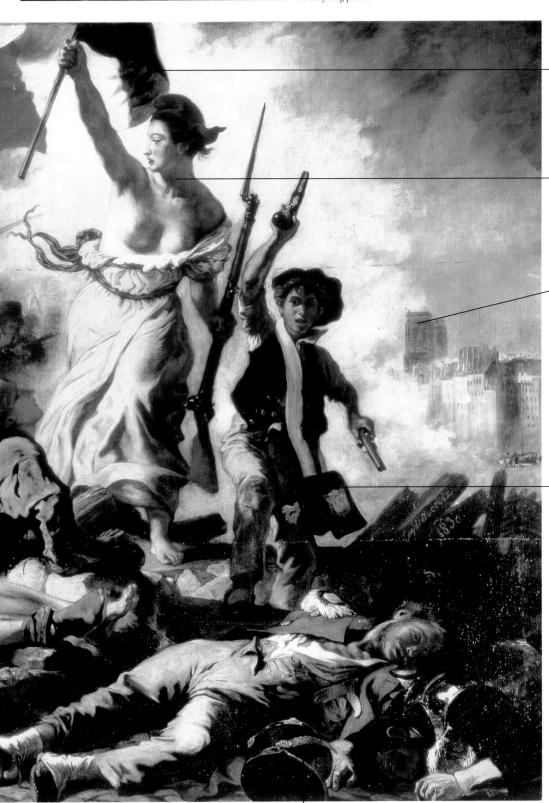

TRICOLOR FLAG
The Republican tricolor supplanted the royalist flag and was a rallying symbol for the Revolution. Delacroix was aware that it would bring to the public's mind the glories of the Napoleonic Empire, which had been the world of his youth.

LIBERTY
The central figure, bare breasted with a bayonetted musket in one hand and the tricolor in the other, is a symbolic representation of liberty. She wears a Phrygian cap, which was a symbol of liberty during the French Revolution. Women played a leading role in the street fighting of the 1830 Revolution.

NOTRE DAME
Emerging from the gunsmoke are the towers of Notre Dame. On one of the towers flies the tricolor. Delacroix was in Paris during the Three Day Revolution, but he did not play an active part.

In this painting, Delacroix balances realistic detail with a powerful abstracted composition—a pyramid rising up to the right hand of Liberty. The dynamic composition and energetic figures show the influence of Rubens (p. 40) and Géricault (1791–1824). Color is uncharacteristically subdued, but this serves to heighten the impact of the saturated colors of the flag.

YOUNG PATRIOT
The young patriot at the left hand of Liberty represents a popular hero named Arcole, who was killed in the fighting around the Hôtel de Ville. He also prefigures the character Gavroche in Hugo's *Les Misérables*.

After a visit to Morocco in 1832, Delacroix introduced exotic wild animals and Arab civilization as subject matter in many of his paintings. He found their living presence much more exciting than the dead history of the ancient world.

1820–1830

1820 George IV ascends British throne. Walter Scott: *Ivanhoe*.

1821 Napoleon dies.

1822 Greek War of Independence.

1824 Beethoven: *Ninth Symphony*.

1828 German Friedrich Wöhler founds organic chemistry. Dumas: *The Three Musketeers*.

1830 Mormon Society founded. Stendhal: *Le Rouge et Le Noir*. Sewing machine invented.

Delacroix was a rapid worker. He drew many preparatory sketches for his major works, both to establish the most suitable composition and to record details and poses that were to be included in the final painting.

FALLEN SOLDIER
Delacroix includes two soldiers as victims. Many soldiers refused to fire on their fellow citizens—some even joined the rebel ranks.

COURBET (1819-1877)

Gustave Courbet

THE FIRST SUCCESSFUL ANTI-ESTABLISHMENT ARTIST, Courbet thrived on his opposition to the powerful political and artistic regimes that dominated France during his lifetime. He was born in a remote part of provincial France, into a well-to-do farming family. He was unusually egocentric (even for an artist) and immensely ambitious. Without official training and largely self-taught, he made his name in Paris but remained staunchly loyal to his native territory and its people, making them both the subjects of many of his pictures. This enraged the official art establishment and the bourgeoisie who demanded "correct" subject matter such as history and portraits of themselves. Courbet was a champion of Realism—a new aesthetic claiming that art should be about ordinary facts without moral comment or idealization. His first success came in 1848—the "Year of Revolutions"—when a *coup d'état* established a new republic with strong liberal ideals. This was soon replaced by a corrupt regime led by Louis Napoleon, which in turn collapsed with the Franco-Prussian War of 1870. Courbet was indirectly involved with both events, and his career flourished and died with the French Second Empire.

> **"** *Show me an angel and I'll paint you one* **"**
> COURBET

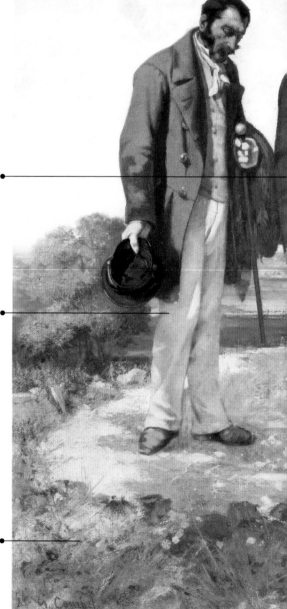

BONJOUR M. COURBET

This painting records a real-life incident: a visit by Courbet to Montpellier in 1854. Large in size and impressive in its factual detail, it illustrates the strengths and weaknesses of Realism. Although the artist may claim to do nothing more than record what he sees, of necessity the artistic process is one of constant selection and editing, and thus a personal commentary on reality.

Social Outrage
When the work was shown at the official Paris Salon of 1854 it caused an outrage, as this contemporary cartoon demonstrates. The subject of the painting was seen as a direct attack on the established social order. Courbet's accomplished but bold handling of paint, which deliberately avoided the finely detailed and highly polished technique that was officially approved, was attacked as crude and incompetent.

ALFRED BRUYAS
The well-dressed gentleman who meets Courbet is Alfred Bruyas. He formed a close friendship with Courbet, which was cemented by this picture. Melancholic and somewhat a dreamer, Bruyas was the son of a wealthy financier. Having dabbled with painting, he spent his inheritance on collecting art, much to his father's displeasure. He built up an important collection of Courbet's work.

SERVANT
Beside Bruyas is his servant, Calas, who humbly bows his head, while his dog, Breton, looks at the artist with interest. Courbet shows that all three of them regard this meeting as one of great significance.

The Salon was the annual official exhibition held at the Louvre— all the major established artists exhibited, and newcomers strove desperately to be included. A jury selected and rejected the exhibits. Only holders of a gold medal could exhibit automatically. Courbet had received a gold medal in the brief liberal atmosphere of 1848, so he had an automatic right to show his work.

THICK PAINT
In keeping with his forceful personality, Courbet rarely made preliminary drawings but painted directly onto the canvas using strong colors and luscious paint. He sometimes applied this with a palette knife rather than a brush.

THE FALL OF THE SECOND EMPIRE

When Napoleon III, the nephew of Napoleon I, became Emperor in 1852 he was determined to make Paris the center of Europe. Although he was initially successful in foreign affairs, he foolishly declared war on Bismarck's Prussia in 1870. France was forced to surrender after only a couple of months, and her economy was crippled by an indemnity of five billion francs demanded by the Germans. Courbet played an important role in the Paris Commune, which was established in the spring of 1871 in opposition to the new National Assembly and the terms of the peace treaty with Prussia. However, Assembly troops eventually crushed the Commune with great bloodshed; Courbet, lucky to escape with his life, was imprisoned for his part in the revolt.

Coach and Horses
The focus of Courbet's life was his studio in Paris. As if to emphasize the fact, he shows the carriage that had brought him—only as a visitor—to the South of France.

If Courbet's work had been smaller in scale it would have caused less offense. By painting large-scale work he was implicitly making the claim that his paintings should be considered "High Art" and that his scenes of everyday life had a right to be taken as seriously as conventionally approved subjects for public display, such as the birth of Venus or a portrait of Napoleon. Dutch 17th-century artists, such as Ter Borch (p. 50), had painted scenes of everyday life, but they were small-scale works and regarded as essentially decorative and private.

● **COURBET**
Courbet has shown himself to his best advantage. He was physically large, energetic, and attractive to women. He was proud of his profile and "Assyrian" beard.

KEY WORKS

• **The Peasants at Flagy;** c.1845; *Musée des Beaux Arts*, Besancon

• **Burial at Ornans;** 1849–50; *Musée du Louvre*, Paris

• **The Bathers;** 1853; *Musée Fabre*, Montpellier

• **The Painter's Studio;** 1854–55; *Musée d'Orsay*, Paris

• **The Sleepers;** 1866; *Musée du Petit Palais*, Paris

Gustave Courbet; *Bonjour M. Courbet*; 1854; 51 x 59 in (130 x 150 cm); oil on canvas; Musée Fabre, Montpellier

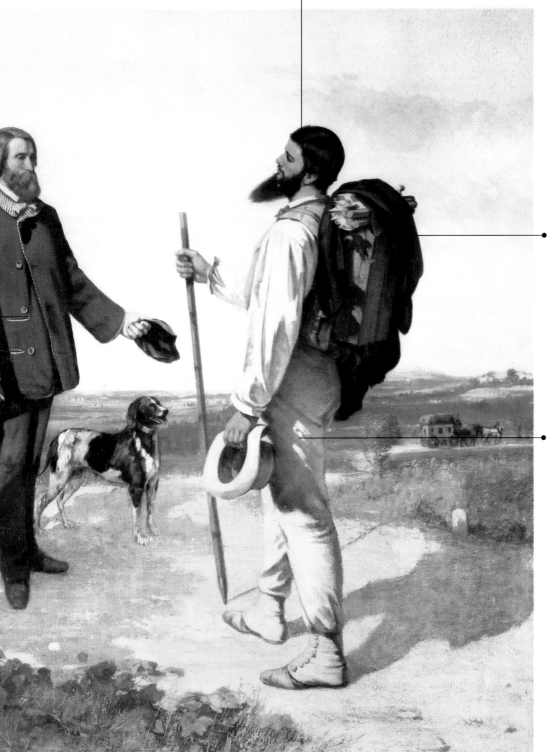

Although largely self-taught, Courbet had been a student at the independent Atelier Suisse and spent many hours studying in the Louvre. Artists who particularly impressed him were Caravaggio (p. 38), Hals, and Rembrandt (p. 48). All of them took a direct and "realistic" approach to their subjects. Like Courbet, Rembrandt and Hals are noted for the expressive and open way they handled paint.

● **INCORRECT DRESS**
Courbet shows himself dressed like a peasant, yet his head is held high, and he does not display humility. Correct etiquette demanded that an artist should be properly dressed with a coat and show due deference when meeting a respectable member of the bourgeoisie.

Courbet's lifestyle and attitude, through which he effectively declared that an artist was free to set his own rules, had a major influence on subsequent generations of avant-garde artists, notably Cézanne (p. 82) and Picasso (p. 102). Courbet painted alongside Whistler (p. 80) at Trouville and with Monet (p. 84) at Etretat.

● **PLACE IN THE SUN**
Courbet is standing in the sun, casting a strong shadow, whereas his hosts are standing in the shade of a tree. Whatever Courbet's intentions, it is difficult not to read this arrangement symbolically.

1850–1855

1850 Hawthorne: *The Scarlet Letter.*

1851 French *coup d'état* by Louis Napoleon. Melville: *Moby Dick.*

1852 Harriet Beecher Stowe: *Uncle Tom's Cabin.* Wells-Fargo Company founded.

1853 Crimean War. Verdi: *La Traviata.*

1854 US-Japan Treaty opens Japan to the West. Thoreau: *Walden.*

1855 Doctor Livingstone discovers Victoria Falls. Paris: World Fair. Whitman: *Leaves of Grass.*

MANET (1832-1883)

EDOUARD MANET NEVER ACHIEVED HIS AMBITION: to be officially honored as the true modern successor of the old masters. Coming from a well-to-do Parisian family, he was born to such a role. Good-looking, charming, strong, world-wise, and very gifted, he was always at ease in society. He studied with one of the most respected Parisian masters, Thomas Couture (1815–79), and he consciously sought to make his reputation at the official Parisian Salons. He longed for the approval of the conservative cultural and political establishment of the day, but his modern approach met with disapproval. In the end, the constant rejection and harsh criticism so wore him down that in 1871 he suffered a nervous breakdown. Yet Manet also had close friendships with avant-garde artists and writers, and he was fascinated by modern

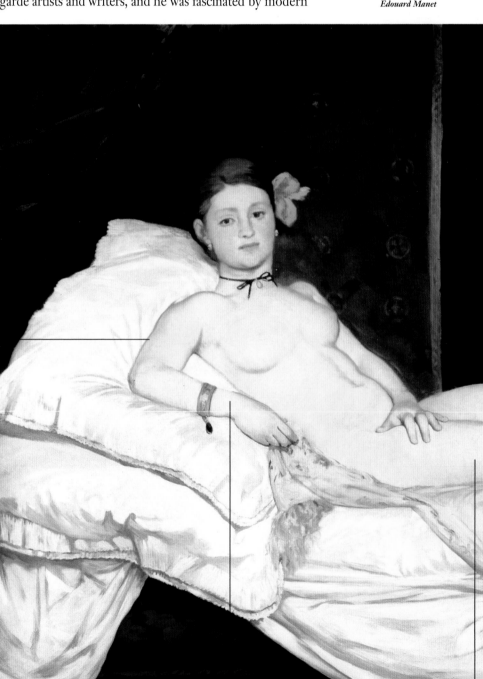

Edouard Manet

city and commercial life and enjoyed its benefits: café society, modern travel, and the goods and services that money could buy. Sadly, however, he also suffered the penalties, dying in agony from syphilis, aged 51.

OLYMPIA

This picture was shown at the official Paris Salon of 1865, two years after it was painted. Manet was nervous about how it would be received, since his famous painting *Déjeuner sur l'Herbe* had already caused a scandal. *Olympia* caused a storm of outraged protest. It was seen, not as a modern interpretation of a respected theme, but as a crude parody of sacred tradition. It was obvious to everyone that the reclining woman was not a goddess, but a prostitute.

STRONG OUTLINES
The candid style shows Manet at his best and suits the directness of the subject. He uses a bold composition with strong outlines to the forms. There is virtually no shadow or modeling with soft light. There is no fine detail, but the color harmonies are very subtle. Some critics saw this style as merely incompetent when compared with that of Ingres (p. 70), and it was described as being crude "like the image on a playing card."

Edouard Manet; *Olympia*; 1863; 51 x 75 in (130 x 190 cm); oil on canvas; Musée d'Orsay, Paris

AVANT-GARDE ART

Manet was a strong supporter of the young Impressionist painters (p. 84), but he never formally allied himself to their cause. For example, he did not take part in the ground-breaking first Impressionist Exhibition of 1874. Unlike the avant-garde Impressionists, he continued to believe in the practice of studio painting, with its traditional themes, preparatory drawing and sketches, and carefully planned large-scale final paintings. However, toward the end of his life, Manet did turn to painting directly from nature in the open air, influenced by the ideas of the Impressionists (p. 86).

VICTORINE MEURENT
Manet used mostly his family and friends to pose as models. Here he has employed a professional model, Victorine Meurent, aged 30. She became a painter herself but ended life as an alcoholic.

OLD MASTER THEME
The image of the reclining nude is one of the most revered in the old master tradition. Manet knew that his audience would understand his reference to Giorgione's *Sleeping Venus* (p. 30).

KEY WORKS

- **Music in the Tuileries;** 1860;
 National Gallery, London

- **The Fifer;** 1866;
 Musée d'Orsay, Paris

- **A Bar at the Folies Bergère;**
 1882; *Courtauld Institute*, London

Success finally came to Manet after 1871. He gained favorable notices at the Salon, and the dealer Durand Ruel bought 30 of his canvases. Just before he died he received the Legion d'Honneur.

❝ *Great colorists know how to create color with a black coat, a white cravat, and a gray background* **❞**
BAUDELAIRE

Manet considered Olympia to be his greatest work, and he never sold it. When he died it went to auction, but it did not find a buyer. In 1888, Sargent (p. 92) learned that Manet's widow was about to sell the painting to an American collector, and he warned Monet, who organized a public appeal to buy it for the Louvre.

● THE NEXT CLIENT
The servant brings in flowers—a gift from a previous admirer—but Olympia does not acknowledge her presence. She is ready and waiting for her next client: the spectator of the painting. She makes direct eye contact with the viewer, as does the cat, which is disturbed from sleep by our arrival.

Portrait of Zola

The writer Emile Zola (1840–1902) was a friend and supporter of Manet, and his novel *Nana* describes the rise and fall of a young woman like Olympia. On the board behind him are three key images: Manet's *Olympia*, a Japanese print, and Velásquez's *Bacchus*.

Edouard Manet; Portrait of Zola; 1867–68; 57¼ x 45 in (146.5 x 114 cm); oil on canvas; Musée d'Orsay, Paris

When he was 18 years old, Manet began a longstanding affair with his piano teacher Suzanne Leenhoff, and a son was born in 1852. In public, they pretended that the child was Suzanne's brother and that Manet was his godfather. They married in 1863, when Manet's father died and he inherited money.

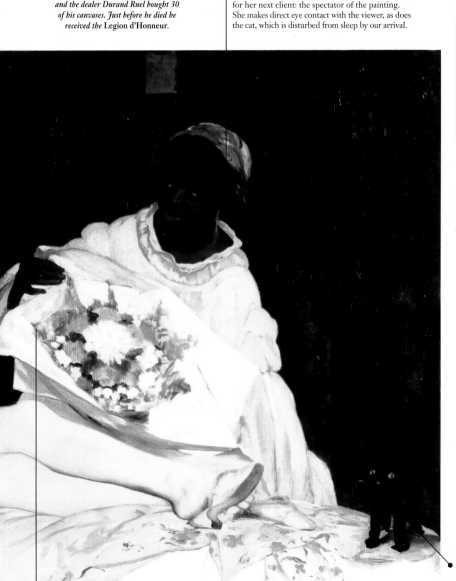

Modern Woman

Manet's creation is not the goddess Venus but a young woman in a recognizable role. Her slipper dangles impatiently on her foot. She is explicitly naked with pearls at her neck and ears, and an orchid is in her hair. Respectable married men of the day had frequent (if clandestine) recourse to prostitutes.

● BLACK
Black is one of the most difficult of pigments for an artist to exploit as it can easily overwhelm and kill all other colors and qualities. Manet is the great master of black: he was able to use it to bring a rich tonality and stylish elegance to his work. Manet, who dressed with great care, habitually wore the black frock coat and silk top hat that were fashionable in his day.

1865–1870

1865 Wagner: *Tristan und Isolde.*

1866 Prussia and Italy at war with Austria. Dostoevsky: *Crime and Punishment*. Dynamite invented.

1867 Karl Marx: *Das Kapital*. Reconstruction Acts passed in the US. Seward's Alaska Purchase.

1868 First Trade Union Congress. Louise M. Alcott: *Little Women.*

1869 Opening of Suez Canal. Postcards first introduced.

1870 Franco-Prussian War. Fall of French Second Empire.

● STILL LIFE DETAIL
Manet was a master of still life, which he often painted for his own pleasure. The bouquet of flowers symbolically suggests the sweet pleasures offered by Olympia.

Manet traveled widely, and after the critical rejection of Olympia he went to Spain. Like many artists of his generation, he was bowled over by the work of Velásquez (p. 46) and Goya (p. 60), both of whom had painted the theme of the reclining nude.

DEGAS (1834–1917)

EDGAR DEGAS SUCCESSFULLY BRIDGED the growing divide between the traditions of painting that sprang from the Renaissance and the aspiration of modern artists who wished to break with them. He never sought public recognition and was acutely shy—a solitary perfectionist and workaholic. He was born into a rich aristocratic family and, until he was in his 40s, was not obliged to sell his work in order to live. He entered the Ecole des Beaux Arts in 1855 and spent time in Italy making copies of the works of the great Renaissance masters, acquiring a technical skill that was equal to theirs. He was a founding member of the Impressionist circle, showing at their groundbreaking exhibitions and sharing the belief that art must address new modern subjects and not bury its head in the past. Fascinated by movement, space, temperament, and human relationships, Degas was one of the first artists to take an interest in photography: at the heart of his art is acute and silent observation. In his old age, the artist became increasing solitary as his failing eyesight brought a premature end to his painting.

Edgar Degas

THE BELLELLI FAMILY

In this early, life-size group portrait, Degas displays his lifelong fascination with human relationships and his profound sense of human character. In this case, it is the tense domestic situation of his Aunt Laure's family that serves as his subject.

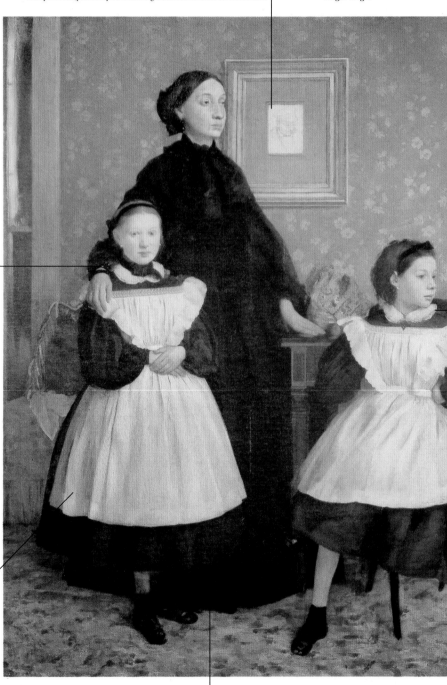

RENE HILAIRE DEGAS
The drawing on the wall is by Degas. It is a portrait from life of his grandfather—a successful banker who built up the family's prosperity. The portrait's proximity to Laure signals her fondness for her father.

PHYSICAL CONTACT
Apart from the aunt's hand, which is placed limply on her daughter's shoulder, Degas shows no physical contact between members of the family. The atmosphere is cold and austere.

Degas and his aunt were close and shared personal secrets. One such secret was that at the time this picture was painted she was pregnant with her third child. Thus the portrait has an inner theme—three generations of the family are shown, and the cycle of life, death, and regeneration continues.

Laure Bellelli
Laure Bellelli was the the sister of Degas's father. She stares off into the middle distance, significantly refusing to meet the glance of her husband, who is positioned on the opposite side of the painting. She found her husband disagreeable and considered that he had no proper employment.

EYE CONTACT
We are drawn into the unhappy family circle by the daughter, Giovanna, who is the only family member looking directly out of the painting.

Degas was intensely proud of his family and his aristocratic origins, despite his refusal to use his original family name de Gas because he deemed it pretentious. He shunned all publicity, and his studio was sacred. He never married but is rumored to have been the lover of the American painter Mary Cassatt (1844–1926).

AUNT IN MOURNING
Laure Bellelli is wearing a black dress because she is in mourning for her father (Degas's grandfather), who was recently deceased.

Although painted on a large scale, the work shows the influence of the 17th-century Dutch masters such as Ter Borch (p. 50)—the palette is subdued, and we are given a sense of being allowed to share intimate domestic secrets.

1860 Abraham Lincoln elected President. South Carolina secedes.

1861 Civil War begins. Italy proclaimed a united kingdom.

1862 Red Cross founded. Victor Hugo: *Les Misérables*.

1863 *Salon des Refusés* opened in Paris by Napoleon III. Battle of Gettysburg.

1864 Tolstoy: *War and Peace*. Pasteurization invented.

1865 Abraham Lincoln assassinated. End of Civil War and abolition of slavery.

Degas suffered an eye injury during the Siege of Paris in 1871, when he served in the artillery. As he grew older, his eyesight began to fail and he turned to pastel and wax, which allowed him to work directly with his fingers and so be less dependent on his previously acute visual observation. He stopped all painting in 1912.

BARON BELLELLI
Gennaro, Baron Bellelli, is shown turned toward his family, but he is seated in a corner with his back to the viewer and seems isolated from the other family members. He had been exiled from Naples because of his political activities.

Horse-racing Scenes
Degas developed his interest in controlled and elegant movement in his racing and ballet scenes. It was while he was residing with the Valpincon family in Normandy in 1860 that he first developed his interest in horses. The Valpincons owned one of Ingres' most famous paintings (p. 70), and they introduced Degas to Ingres.

Edgar Degas; *Horse Racing, Before the Start*; 1862; 19 x 24 in (48.5 x 61.5 cm); oil on canvas; Musée d'Orsay, Paris

Degas was brought up in Paris without any financial worries. His father came from Naples and was a successful banker; his mother came from New Orleans. However, when Degas' father died in 1874, it was discovered that the bank had incurred huge debts. Degas sacrificed his inheritance, his house, and his private art collection to save his brothers from financial ruin. From then on, he was obliged to earn a living as a professional artist.

KEY WORKS

• **Young Spartans;** 1860–62; *National Gallery*, London

• **The Dance Foyer at the Opera;** 1872; *Metropolitan Museum of Art*, New York

• **The Dance Class;** 1874; *Muséed'Orsay*, Paris

• **Woman Drying Herself;** 1903; *Art Institute*, Chicago

COUSINS
In the center of the painting is the Bellelli's second daughter, Giulia. In a 1858 letter to his friend Gustave Moreau (1826–98), Degas wrote fondly of his cousins: "The older one is a real beauty; the little one has the disposition of a devil and the kindness of a little angel. I am painting them in their black dresses and little white aprons, which make them look charming."

Degas greatly admired Ingres for his draftsmanship and superb technical skills. His teacher at the Ecole des Beaux Arts, Lamothe, had been a pupil of Ingres.

❝ *The artist does not draw what he sees, but what he has to make others see* **❞**
DEGAS

DEGAS AND MANET

Degas and Manet (p. 76) met in the Louvre in 1861, brought together by a mutual interest in the work of Velásquez (p. 46). Manet introduced Degas to the young Impressionists and persuaded him that art should address itself to modern subjects. Although neither artist was ever really an Impressionist painter, Manet was eventually persuaded to work outdoors by his sister-in-law Berthe Morisot (p. 86). Degas remained firmly studio-based, stating that artists should be kept indoors "with a whiff of grapeshot to stop them from painting landscapes from nature." The two men—who were from similar social backgrounds—shared mutual respect and influence. However, there also existed a rivalry between them because they both wished to be regarded as the modern successor to the Renaissance tradition.

PHYSICAL DIVIDE
Degas arranges his composition so that the table leg, fireplace, candle, and mirror form a vertical line separating the baron from his family. The females face toward the light that falls from the left, while he has his back to the light and his face in shadow. Degas leaves us in no doubt about the tension and separation in the family and where, in his view, the fault lies.

Edgar Degas; *The Bellelli Family*; 1858–60; 78¾ x 101½ in (200 x 258 cm); oil on canvas; Musée d'Orsay, Paris

BEHEADED DOG
The dog is cut off by the edge of the picture. Degas increasingly employed the device of placing people and objects half in and half out of the picture. It is an idea that was inspired by his interest in photography.

Degas was in Italy in the late 1850s, developing his draftsmanship by studying the great Renaissance painters. He stayed with the Bellelli family in Florence and, following the practice of the old masters, made a large number of preparatory studies for this group portrait.

WHISTLER (1834–1903)

A PIONEER OF A NEW TYPE OF ART and lifestyle, Whistler was truly international in outlook and in the scope of the artistic sources that influenced him. Born in the US, he spent much of his boyhood in St. Petersburg and Moscow, where his father was employed as an engineer supervising the construction of a railway. At the age of 21, after a brief and ill-fated spell at the West Point Military Academy, he went to Paris to develop a career as a painter and came into contact with avant-garde artists such as Courbet (p. 74), Manet (p. 76), and Degas (p. 78). However, it was London that became his permanent home. Small in stature and dressed as a dandy, Whistler moved in fashionable circles. He was a close friend of Oscar Wilde and was often at the center of controversy. His most famous dispute was the libel action he brought against the great art critic Ruskin (1819–1900) in 1877. Although he won the case, it ruined him financially. He retreated to Venice, where he recovered his reputation and financial losses with a series of brilliant etchings. By the 1890s he was back in London, much honored and painting successful society portraits. But he had lost the originality that had reached its high point in his paintings of the 1870s.

James Abbott McNeill Whistler

During the libel case, Whistler defined his artistic aims: "I have perhaps meant rather to indicate an artistic interest alone in my work.... It is an arrangement of line, form, and color, first, and I make use of any incident of it which shall bring about a symmetrical result."

THE FALLING ROCKET

This small painting of a firework exploding against the night sky provoked Ruskin's wrath and led to the celebrated court case. Behind the dispute lay a deeper question: should art have a moral purpose?

The painting was shown at the Grosvenor Gallery in 1877. It was seen by Ruskin, who wrote a scathing article saying that the painting was an insult, "flinging a pot of paint in the public's face." Whistler sued for libel, and the ensuing trial created a sensation. The jury agreed that Whistler had been libeled but awarded him just one farthing in damages (a farthing was the smallest coin in the realm). Whistler, who was obliged to pay his own court costs, was bankrupt.

JAPANESE INFLUENCE

The simple design and subject, and the flat pattern with no attempt to create an illusion of space, are ideas that Whistler discovered in Japanese art.

Satirical Cartoon

The British satirical magazine Punch published this cartoon in December 1878 after the trial. Whistler and Ruskin are shown standing before the Judge. The caption that appeared beneath the cartoon read, "Naughty critic, to use bad language! Silly painter, to go to the law about it!" The poisonous snakes are the legal costs Whistler had to pay, which made him bankrupt.

John Ruskin, who was the champion of Turner (p. 66) and the Pre-Raphaelites and the most influential English critic of the 19th century, firmly believed in the virtues of detailed and painstaking craftsmanship and the didactic moral purposes of art. Whistler's painting thus represented everything that he most disliked. However, the fact that Whistler won the case shows that Ruskin's definition of art was dying and a new modern aesthetic was developing to take its place.

• BRUSHWORK

The loose brushwork and subtle color harmonies are influenced by Velásquez (p. 46).

The full title of the painting is *Nocturne in Black and Gold: The Falling Rocket*. The idea of using musical titles for paintings, which was suggested by the poet and art critic Théophile Gautier (1811–72), suited Whistler's aims perfectly. He produced many "nocturnes" in the 1870s. They represent the summit of his artistic achievement.

INSPIRATION

The inspiration for the painting came from a visit to a fireworks show in Cremorne Gardens in Battersea. The outline of trees and a lake is just visible in the night atmosphere.

EDGE OF ABSTRACTION

The painting captures the drama and beauty of the fleeting instant in which a rocket explodes in the sky, scattering a shower of sparks into the night. The idea that art makes its principal impact with arrangements of color and form, and can have the same effect as music, has had a strong influence on 20th-century art (p. 98).

James Whistler: *Nocturne in Black and Gold: The Falling Rocket*; 1874; 23¾ x 18¾ in (60.5 x 46.5 cm); oil on canvas; Institute of Arts, Detroit

1875–1880

1876 Telephone invented. Twain: *The Adventures of Tom Sawyer*.

1877 Phonograph invented.

1878 Gilbert and Sullivan: *HMS Pinafore*. Microphone invented.

1879 Zulu War. The War of the Pacific.

1880 Gladstone becomes British Prime Minister. First workable electric lights.

In 1890, Whistler published a book called The Gentle Art of Making Enemies. *It was an anthology of his writings on art and a witty account of the trial in which he portrayed himself as mercilessly clever and unbeatable. The title sums up much of his attitude toward others. Vain, conceited, and opinionated, he was not always well-liked and often quarreled with his own supporters and patrons.*

● ORIENTAL SYMBOL

Whistler's unusual signature has similarities with the collector's seals found on Chinese art. He was an enthusiastic and early collector of Oriental blue and white porcelain.

THE PEACOCK ROOM

In 1876 Whistler was commissioned to produce a decorative design for a room that housed one of his great works: *La Princesse du Pays de la Porcelaine*. The room was at 49 Princes Gate in London, where the artist lived during the summer of 1876, working on the project with a mounting obsession. The Japanese-style design was based on peacock motifs, which were painted with a spectacular freedom. The room—a work of art in itself—was described in a pamphlet Whistler distributed at a press review as *Harmony in Blue and Gold: The Peacock Room*. Characteristically, Whistler argued over costs and the terms of the commission—he was subsequently forbidden to enter the house again.

Whistler never found painting easy, and he lamented his lack of disciplined training. In many ways his natural gifts lay in printmaking—a skill that be learned as a US navy cartographer in his youth. He helped bring back to etching qualities that had not been seen since Rembrandt's days (p. 48).

SPECTATORS

In the foreground, Whistler has given a suggestion of the other spectators. Despite the rapid brushstrokes, he actually worked slowly, often changing what he had done and relying very much on memory and feeling. Rather than build up thick layers of paint, he would wipe away his mistakes to leave only a thin film of transparent paint as the final image.

> *66 Art should stand alone and appeal to the artistic sense of eye or ear without confounding this with emotions entirely foreign to it, such as devotion, pity, love, patriotism and the like 99*
> WHISTLER

Whistler had neither the physique nor the temperament to make a soldier, and his days at the famous West Point Military Academy were few. He was expelled after failing an exam. Later he joked: "If silicon had been a gas, I would have been a major-general!"

Butterfly Signature

Although be has not used it here, Whistler often adapted his signature so that it assumed the shape of a butterfly. His restless temperament, love of show, and unusually wide search for inspiration among Western and Oriental art can be likened to the butterfly flitting from flower to flower.

KEY WORKS

- **At the Piano;** 1858–59; *Taft Museum*, Cincinnati, Ohio
- **La Princesse du Pays de la Porcelaine;** 1863; *Freer Gallery of Art*, Washington, DC
- **Arrangement in Grey and Black: The Artist's Mother;** 1871; *Musée d'Orsay*, Paris

CÉZANNE (1839–1906)

PAUL CÉZANNE REGARDED HIMSELF as a dismal failure and lived his last years as a recluse, his works unknown. His father, an ambitious businessman in Aix-en-Provence, terrified his son and cast a shadow over his whole life. Cézanne, always a loner, neurotic and melancholic, was saved by his artistic sensibility. His father eventually accepted that his son would never succeed in business and reluctantly agreed that he could go to Paris to study art, giving him a small allowance (and an inheritance when he died). Cézanne never had to sell his work to live—a rare privilege. His early efforts were as inept as his social behavior, and he was rejected as incompetent by the Ecole des Beaux Arts. Nevertheless, his subsequent lifelong struggle to find a coherent way of painting miraculously resulted in work that became a key influence on progressive 20th-century art, notably through his first one-man show in 1895 and the official retrospective exhibition of his work in 1907. Both caused huge excitement among avant-garde artists such as Matisse (p. 98) and Picasso (p. 102).

Paul Cézanne

❝ He is the parent of us all ❞
PICASSO

MONT ST. VICTOIRE

Mont St. Victoire, near Aix-en-Provence, is a subject that Cézanne revisited many times from the early 1880s until his death. In all these paintings he combines a remarkable faithfulness to what he observed with a deep awareness of his emotional responses—a skill that he achieved only after much hard work and rigid self-discipline (see below).

EMOTIONAL LANDSCAPE

Cézanne did not attempt to represent a superficial imitation of the landscape; rather, he intended to create work that would be both beautiful to look at and the artistic equivalent to what he himself had seen and felt in front of nature.

DISCIPLINED VISION

Around the fixed framework of the tree and certain key points such as the buildings, Cézanne appears to be measuring distances and angles, each mark corresponding to something seen in the landscape itself.

At the heart of Cézanne's painting was a determination to continue the highly disciplined French classical tradition, such as he admired in the work of Poussin (p. 42), but outdoors "from nature."

Paul Cézanne; *Mont St. Victoire;* 1885–87; 26 x 35 in (66 x 89 cm); oil on canvas; Courtauld Institute, London

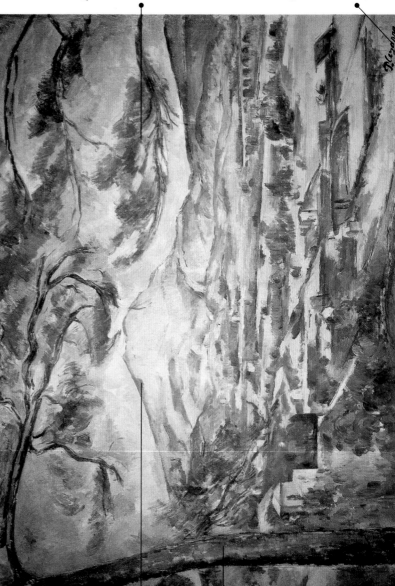

Underlying Emotion

Cézanne never allowed himself to become an impassive eye. In the sensitively modulated color and the gentle movement of the brushstrokes reveals a strong, though controlled, emotional response to his subject.

Cézanne did not innovate new subjects, and his standard themes are landscapes, portraits, still lifes, and nudes. His originality was in his way of seeing and painting them.

MOVEMENT

There seems to be a restless motion in the branches of the pine tree, and the mountain is fuller and larger than in real life. After the death of his father in 1886, Cézanne grew in artistic maturity and increasingly allowed his emotional response to assert itself.

Cézanne's landscapes often took him weeks or months to complete. The difficulty was that the detail was always changing as the light changed—and even as Cézanne moved his position. In other words, there never came a moment when he deemed the work to be finished. This is one of the reasons for his sense of failure and the reason why he rarely signed his work.

RARE SIGNATURE

This work was so admired by a young poet, Joachim Gasquet, that Cézanne gave him the painting, adding his signature as a sign of friendship.

1890–1895

1891 Mahler: *Symphony No. 1*. Rachmaninoff: *Piano concerto No. 1*.

1892 Ellis Island, New York, opens to receive immigrants.

1893 Dvořák: *New World Symphony*. Henry Ford's first car.

1894 Russia's Nicholas II begins the reign that will end the Russian monarchy. Rudyard Kipling: *Jungle Book*. Debussy: *Prélude à l'Après-midi d'un Faune*.

1895 First public film show in Paris. Marconi invents radio telegraph. X-rays are discovered.

Paul Cézanne; *A Modern Olympia*; c.1873; 117 x 141 in (46 x 55.5 cm); oil on canvas; **Musée d'Orsay, Paris**

PORTRAIT OF THE ARTIST

The seated figure is recognizably Cézanne, baldheaded and bearded. His self-perception was melancholy: though young, he portrays himself as middle-aged; his late work shows an affinity with old people and forgotten places.

Cézanne's last years were marked by loneliness and ill health. He received visits from the dealer Ambroise Vollard, who recognized the greatness in Cézanne's work and organized the 1895 retrospective. He also had occasional visits from young artists who had heard what Cézanne was doing. Already sick with diabetes, he died of pneumonia after being soaked in a downpour while painting outdoors.

KEY WORKS

- **View of Auvers**; c.1874; *Art Institute*, Chicago
- **Still Life**; 1883–87; *Fogg Art Museum*, Cambridge, MA
- **The Card Players**; 1892; *Musée d'Orsay*, Paris
- **Rocks at Fontainebleau**; 1898; *Metropolitan Museum*, New York
- **Bathers**; c.1900–06; *National Gallery*, London

A MODERN OLYMPIA

Cézanne was 33 years old when he painted this remarkable free-fantasy interpretation of Manet's *Olympia* (p. 76). He portrays himself seated in a brothel, where Olympia is stripped naked before his eyes. Cézanne met Manet but disliked both his painting and his elegant, man-about-town lifestyle. This painting is a conscious parody of Manet's work.

In Paris, Cézanne lived a Bohemian lifestyle and was resolutely uncommunicative and untidy. He studied at the independent Académie Suisse and frequented the artist's cafés where he met, among others, Monet (p. 84), Sisley, and Renoir.

FREESTYLE PAINTING

Although Cézanne had been thinking about the subject for years, the sketchy brushstrokes and bright, direct color indicate that the painting was executed rapidly. His early work reveals a fervent sexual imagination and an impetuosity that he later sought to control.

CURVACEOUS TABLE

Cézanne has added a still life on a table to Manet's scene. The curvaceous pink table seems to be participating in the atmosphere of charged sexuality.

Cézanne found relationships with other people extremely difficult. However, in 1870 he met Hortense Fiquet with whom he had a son, Paul, in 1872. It was a stable and successful relationship, but he concealed it from his father (his mother knew), and only when his father died in 1886 did he marry Hortense.

CÉZANNE AND PISSARRO

Cézanne's *Modern Olympia* was shown at the first Impressionist Exhibition of 1874 (p. 86), by which time his style had altered considerably. Under the influence of Camille Pissarro (1830–1903), whom Cézanne first met in 1861, he learned self-discipline, painting carefully composed landscapes in the open air with the small, accurate brushstrokes that characterized early Impressionism. However, Cézanne was never an Impressionist painter as such—he was more interested in the underlying structure of nature than fleeting impressions of light. He spent many long hours in the Louvre and aspired to "something solid and enduring, like the art in museums."

Still Life

The objects on the table receive more detailed attention than almost any other feature—an early indication that the still life would be one of Cézanne's major themes.

Cézanne was sent to a boarding school in Aix-en-Provence, where he formed a close friendship with the great writer Emile Zola, who later supported him both financially and spiritually. In 1886, however, Zola published a novel entitled L'Oeuvre, in which the central character is an unsympathetic painter. Taking it to be a reference to himself, Cézanne never spoke to Zola again.

MONET (1840-1926)

CLAUDE MONET WAS A FOUNDING MEMBER of the Impressionists, but like all of them he developed a very individual approach, both to style and subject matter. He was the son of a wealthy grocer from Le Havre in France. When he was 19 years old he moved to Paris, but he rejected the conventional training offered by the Ecole des Beaux Arts, choosing instead the more relaxed tuition offered by the private schools, which were also favored by other young avant-garde artists. His early years were hard and impoverished: his family cut him off financially, and his first wife Camille died tragically in 1879, leaving him with two children. In 1883, he settled in Giverny, near Paris, with Alice Hoschede, who left her husband to be with Monet. Gradually, his work gained recognition and sales, and by 1890 he was rich enough to buy the now-famous property and employ six gardeners. He lived his last years as a recluse, wounded by the death of Alice and his eldest son and by his rapidly failing eyesight.

Claude Monet

> *« My garden is my most beautiful masterpiece »*
> MONET

Alice Hoschede was the wife of a bankrupt department store owner. After Camille's death, she lived with Monet and eight children in a highly unconventional ménage, marrying only in 1892, when Ernest Hoschede died. Monet was a domestic tyrant who demanded constant attention and undisturbed silence. He became bad-tempered if his work was not going well.

PATH WITH ROSES, GIVERNY

Monet's garden at Giverny was a creative project that occupied half his life—in his later years, it became the principal subject of his painting. This work, portraying a path beneath a large rose arch, dates from 1920, when Monet was 80 years old. It shows the artist continuing to paint with extraordinary freedom in spite of his failing eyesight.

Japanese Influence
Monet passionately embraced the fashionable interest in Japanese art (p. 80), responding to the simple sophistication of the designs. The walls of his house were decorated with Japanese prints, and one of the most prominent features in his garden was a Japanese bridge.

KEY WORKS

• **Le Déjeuner sur l'Herbe;** 1866; *Musée d'Orsay*, Paris

• **Impression—Sunrise;** 1872; *Musée Marmottan*, Paris

• **The Waterlily Pond;** 1899; *National Gallery*, London

• **Houses of Parliament;** 1904; *Musée d'Orsay*, Paris

PAINTING BY INSTINCT
The thick paint and strange combinations of color are partly the result of Monet's failing eyesight. They express his emotional struggle to come to terms with his possible blindness. The subject was very familiar to him—as, of course, was the act of painting—and he had an accurate memory for colors. He asked his stepdaughter, Blanche, for each color by its name before he applied it to the canvas.

Claude Monet; *Path with Roses, Giverny;* c.1920; 32 x 39¼ in (81 x 100 cm); oil on canvas; **Musée Marmottan, Paris**

Color Contrasts
Monet had a sound knowledge of the theories of color perception, which he applied to all his work. In this painting, for example, he deliberately uses the opposition of primary colors, such as blue and yellow, to produce an optical vibrancy. Similarly, he exploits the opposition of warm and cool colors.

OPEN-AIR PAINTING

In his early work, Monet was committed to *plein-air* painting: starting and finishing a picture outside in front of the subject. This often presented huge difficulties: on a wet and windy day he had to weigh his easel down with large stones and mix his paints under his raincoat. When the light changed he was forced to adapt his painting or begin another. Monet's garden at Giverny provided him with an environment where he could paint outdoors under more controllable and comfortable circumstances.

Monet first suffered the effects of double cataracts in 1908. In 1922, he had to stop work altogether. The following year, he underwent an operation that partially restored his sight—although his perception was veiled and colors were distorted. His eyesight failed entirely shortly before he died.

● **MATCHING TEXTURES**
As well as having a lifelong interest in light and the challenge of recording the effects of light in paint, Monet became increasingly fascinated by textures. He explored different ways of matching the textures in nature with the textures produced by oil paint. Here, dappled sunlight, and the interplay of foliage and light, is a main interest.

The French prime minister Clemenceau (1841–1929), who was a friend of Monet, was determined to preserve for the nation a complete series of works by the artist. He proposed that Monet should undertake a work that would serve as a memorial to those who died in World War I, which would hang permanently in the Orangerie of the Tuileries in Paris. Monet took a close interest in the progress of the war: the gunfire on the front could be heard at Giverny.

● **ROSE TRELLIS**
The large rose trellis, which stands adjacent to Monet's house at Giverny, is one of the most prominent features of this part of the garden. Although Monet eventually built three studios in the garden, this work was probably painted entirely out of doors in front of the trellis.

The garden next to the house is relatively formal in character, and the theme of the planting is on the interplay of color and texture. The lily-pond garden, designed to emphasize curving shapes, is a deliberate contrast. It is less formal, with plants selected for their qualities of soft foliage and subtle shades. The light, which is reflected off the water, is softer. In Monet's day, a railway line divided the two gardens.

1915–1920

1915 Albert Einstein propounds his Theory of Relativity. *Lusitania* sunk off coast of Ireland.

1916 Battles of Verdun and the Somme. Jazz sweeps the US.

1917 Russian Revolution. US declares war on Germany. Freud: *Introduction to Psychoanalysis*.

1918 Treaty of Versailles and end of World War I.

1919 Founding of the Bauhaus. First nonstop transatlantic flight.

1920 League of Nations established. F. Scott Fitzgerald: *This Side of Paradise*.

MORISOT (1841-1895)

BERTHE MORISOT WAS BORN IN FRANCE at a time when there were no opportunities for a woman to become a respectable professional artist. The Ecole des Beaux Arts, in Paris, did not admit female students until two years after her death. But fortune favored her and allowed her natural talents to find an opening. She was the youngest daughter of a wealthy middle-class family, and her father, a civil servant, had studied architecture and painting as a young man. He often entertained well-known artists, and in 1860 Morisot was introduced to Corot (1796–1875), one of the leading painters of the day, who took her under his wing and gave her and her sister Edma (also a gifted painter) practical instruction. In 1868 she met Manet (p. 76), who greatly influenced her work and her life—she eventually married his brother. She found her spiritual and artistic home with the Impressionist circle and became one of its leading figures, helping to organize their pioneering exhibitions and bringing together like-minded painters, writers, and musicians. She shared their interest in informal, modern subject matter and loose, open brushwork, but her style was firmly stamped with her own strong personality.

Berthe Morisot

EUGENE MANET AND HIS DAUGHTER IN THE GARDEN AT BOUGIVAL

Morisot's works are, in total, an autobiographical diary. In this intimate family scene, the artist's daughter plays with a favorite toy—a model village—watched over by her father. The family had moved to a rented house at Bougival, which was a fashionable bathing spot on the river near Paris, in the late spring of 1881.

Berthe Morisot and Eugène Manet met on vacation in Normandy in 1873 and were married the following year. It was a marriage based on respect and convenience rather than deep passion, but it allowed Morisot the freedom to continue with her painting. Eugène died in 1892.

EUGENE MANET
Morisot was married to Eugène Manet, brother of the great French artist Edouard Manet (p. 76). Relatively little is known about Eugène. He was an amateur painter and a writer and, in later life, he held a number of government posts.

Morisot first met Edouard Manet in 1867 when a fellow artist, Henri Fantin-Latour, introduced them in the Louvre, where she was making a copy of a work by Rubens (p. 40). The Manet and Morisot families became close and visited each other regularly. Both sisters were deeply attracted to Manet (who was married), and he introduced Edma to her future husband. Berthe features in a number of works by Manet—notably in his famous On the Balcony of 1868.

HANDS IN POCKETS
In society, Eugène did not share his brother's easy charm and confidence. He had suffered more than his brother at the hands of their autocratic father. He was shy and solemn by nature, but he adored his family. However, he did not enjoy sitting for portraits and looks ill at ease in this painting. With his hands hidden away in his pockets, his posture is rather stiff.

1870–1875

1870 The Siege of Paris.

1871 France cedes Alsace Lorraine to Germany after defeat in the Franco-Prussian War. Darwin: *The Descent of Man.*

1872 Yellowstone National Park established. First Arbor Day.

1873 Cable cars first used in San Francisco. Lawn tennis invented. First typewriters produced commercially.

1874 Disraeli becomes British Prime Minister. Johann Strauss II: *Die Fledermaus.*

1875 Bizet: *Carmen.* Mark Twain: *Tom Sawyer.*

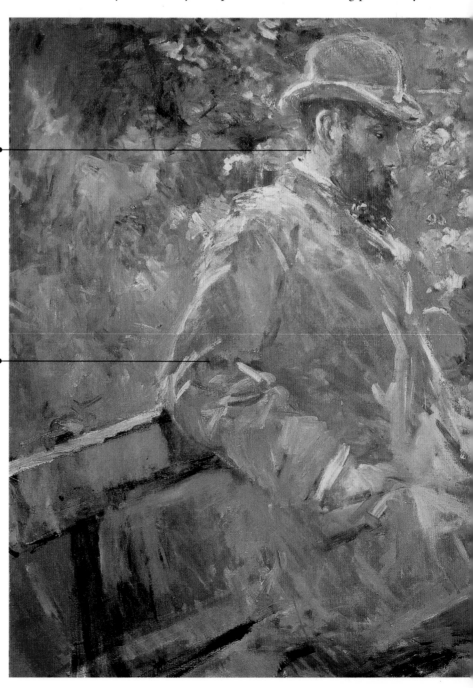

Berthe Morisot; *Eugène Manet and his Daughter in the Garden at Bougival*; 1881; 28½ x 36¼ in (73 x 92 cm); oil on canvas; private collection

Loose Style
The very sketchy style of painting is characteristic of Morisot's work, and of all the Impressionists it was she who adhered most closely to the notion of a free and spontaneous style to reflect the informality of her subjects. The same quality is found in her watercolors and pencil sketches.

Berthe's Sister
This tender image portrays Berthe's younger sister Edma at the cradle of her second child, who was born in 1871. Edma abandoned a promising career as a painter to look after her family. She married a naval officer in 1869.

Berthe Morisot;
The Cradle; 1872–74;
22 x 18 in (56 x 46 cm);
oil on canvas; Musée
d'Orsay, Paris

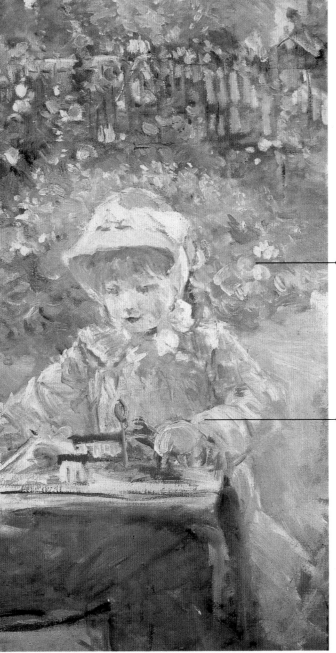

❝ *Men incline to believe that they fill all one's life, but as for me, I think that no matter how much affection a woman has for her husband it is not easy to break with a life of work* **❞**
BERTHE MORISOT

● **DAPPLED LIGHT**
Like many Impressionist works, this scene was painted outdoors—the gentle dappled light that pervades the scene shows the influence of Renoir.

Morisot knew Renoir well, and they shared similar interests—for example, both were influenced by 18th-century French painters such as Fragonard (p. 58). Renoir also spent the summer of 1881 in Bougival, working on his famous painting, **The Luncheon of the Boating Party.**

● **DAUGHTER**
The artist's only child, Julie, was born on November 14, 1878. Morisot was an attentive mother, and Julie was a bright and happy child. She features in many of her mother's paintings. She also posed with her still-elegant mother for a double portrait by Renoir in 1894.

KEY WORKS

• **The Harbor at Lorient**; 1869; *National Gallery*, Washington, DC

• **Portrait of the Artist's Mother and Sister**; 1869–70; *National Gallery*, Washington, DC

• **In a Park**; c.1873; *Musée du Petit Palais*, Paris

• **The Cherry Picker**; c.1891; *Private Collection*, Paris

THE IMPRESSIONISTS

Morisot exhibited *The Cradle* at the famous first Impressionist exhibition of 1874. The independent exhibition, which was organized in revolt against academic teaching and conventions, included works by Pisarro, Renoir, Degas (p. 78), Cézanne (p. 82), and Monet (p. 84). Frequently working outdoors, the Impressionists were not interested in historical subjects but aimed to capture an "impression" of a moment from contemporary life. Morisot received some favorable reviews: the art critic Castagnary said, "You cannot find more graceful images handled more deliberately than *The Cradle*… the execution is in complete accord with the idea to be expressed."

GAUGUIN (1848-1903)

Paul Gauguin

PAUL GAUGUIN LED ONE OF THE MOST EXTRAORDINARY lives of any artist. He was born in Paris, but, when his father died in 1849, the family moved to Peru to live with a great-uncle. They returned to France when Gauguin was seven years old, and, in 1865, he joined the merchant navy. From 1872 he worked successfully as a stock broker, grew rich, married, and had five children. However, his passion was for painting, and he met the Impressionists, bought their work, and showed his own paintings in their last four exhibitions. In 1882 the stock market crashed, and Gauguin decided he could support his family by painting. He had little success, and in 1886 he abandoned his family and devoted himself to a solitary bohemian lifestyle. He went to Brittany and abroad to Panama and Martinique. In 1888 he visited van Gogh, with disastrous consequences (p. 90). He later abandoned the Impressionist style of painting and used areas of pure color for expressive purposes. A man of deep emotions, he was always searching for answers to his spiritual needs, and he used painting as a means of resolving these inner questions. In the last decade of his life he hoped to find the answers on the "paradise" island of Tahiti.

NEVERMORE
Painted in Tahiti, this late work is a modern interpretation of a the time-honored subject: the reclining nude (p. 30). The simple, outlined image, decorative motifs, and flat areas of intense color are typical of Gauguin. He is less interested in painting external reality than his inner vision.

The Raven
The bird and the word "Nevermore" bring to mind the poem *The Raven* by Edgar Allen Poe. The poet had a cult following in Parisian artistic circles, and, in 1875, Manet had illustrated Mallarmé's translation of Poe's poem. In the poem, the author's imagination is haunted by a menacing raven, who utters only one sound, "nevermore."

The first owner of the painting was the progressive English composer Frederick Delius. Gauguin was pleased it had gone to someone who would be sympathetic to his aims and ideals.

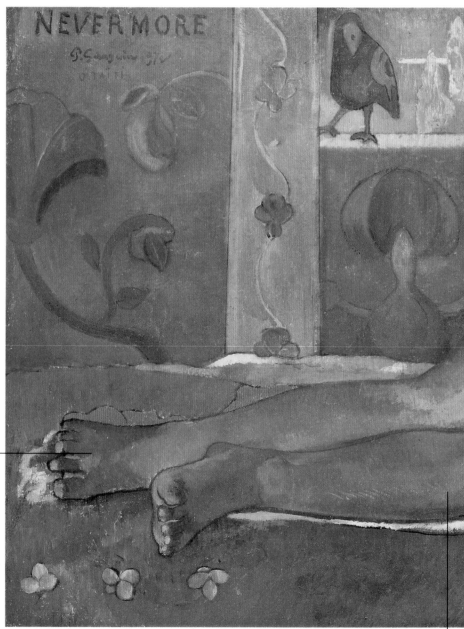

1895–1900

1895 Oscar Wilde: *The Importance of Being Earnest.*

1896 Chekov: *The Seagull.* Puccini: *La Bohème.* First Nobel Prize awarded.

1897 Hawaiian Islands annexed to the US.

1898 H.G. Wells: *The War of the Worlds.* Zeppelin builds first airship. Paris Metro opens.

1899 Boer War. Elgar: *Enigma Variations.*

1900 Quantum Theory propounded by Max Planck. Brownie box camera introduced.

THICK PAINT
Unusually, this painting has a thick paint surface. The artist's Tahitian works are normally painted thinly on sacking because his poverty forced him to economize on materials. X-ray photographs show that this work was painted over another image.

Gauguin's life ended as curiously as it began. In 1901, he visited the Marquesas Islands near Tahiti, but the authorities regarded him as a subversive. He was arrested and sentenced to prison for "defamation" of the authorities. He is buried in the Islands.

LONG-LEGGED BEAUTY
Gauguin lived with a teenage Tahitian girl, and he described the Tahitian women as possessing "something mysterious and penetrating…. They move with all the suppleness and grace of sleek animals, giving off that smell which is a mixture of animal odor and scents of sandalwood and gardenia."

TAHITI

Gauguin first went to Tahiti in 1891, seeking a tropical paradise far removed from the corruption and artificiality in modern society. However, although fascinated by the culture and spiritual beliefs of the Tahitians, he saw they were increasingly westernized and witnessed the erosion of their culture by missionaries. He also encountered snobbery among the colonial residents, worse than in Paris. He was granted repatriation to France in 1893 but returned to Tahiti in July 1895, infected with syphilis.

Gauguin made a collection of postcards of art that interested him—from Egypt, Cambodia, Japan, Central and South America, and medieval Europe. Pinned up in his hut, however, was a postcard of Manet's Olympia *(p. 76).*

❝ *In painting as in music one should look for suggestion rather than description* **❞**
GAUGUIN

KEY WORKS

- **Vision after the Sermon;** 1888; *National Gallery*, Edinburgh

- **Tahitian Landscape;** 1893; *Hermitage*, St. Petersburg

- **Contes Barbares;** 1902; *Folkwang Museum*, Essen

Mystery
Gauguin has sought to fill the picture with mystery. He wrote, "I wished to suggest a certain long-lost barbarian luxury." The girl seems lost in her own reveries (she is not asleep), and her eyes turn toward the bird in the background, which could exist in reality or only in the girl's imagination.

CONTRASTS
Gauguin uses subtle contrast to heighten emotion. The clothed figures in conversation in the background contrast with the nude girl lost in her private thoughts in the foreground. The curves of her body contrast with the geometric horizontals and verticals behind her.

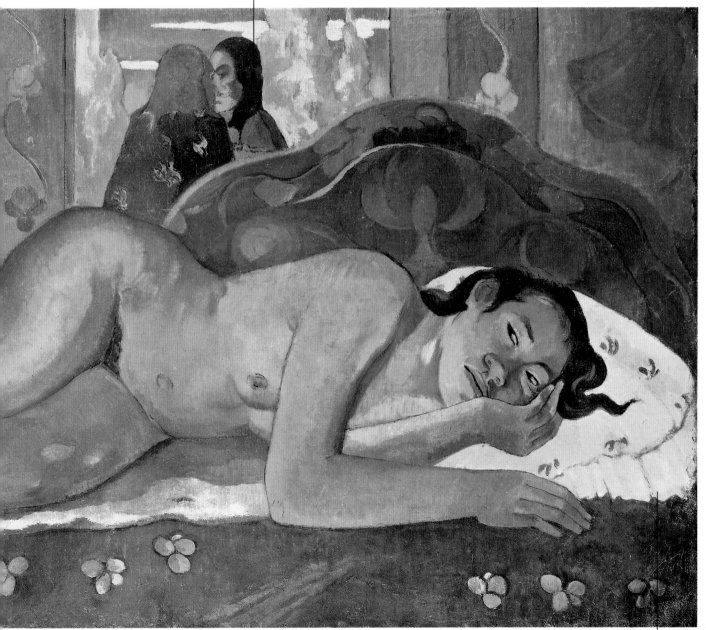

Paul Gauguin;
Nevermore; 1897; 23½ x 46 in (59.5 x 117 cm); oil on canvas; Courtauld Institute, London

When he returned to Paris in 1893, Gauguin received some critical acclaim for his Tahitian paintings, and after 1901 he gained a regular income from the dealer Amboise Vollard. He also experimented boldly with wood carvings, pottery, and sculpture.

SYMBOLIC COLOR
Gauguin's colors are intentionally antinaturalistic. He wanted to create a style that would express deep emotions and feeling in a modern way. His symbolic use of color had an enormous influence on the subsequent generation of artists, such as the German Expressionists and Matisse (p. 98).

VAN GOGH (1853–1890)

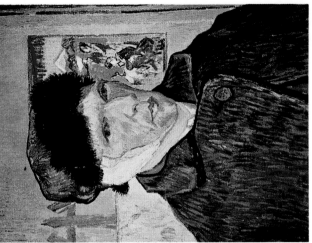

Vincent van Gogh

❝ I am risking my life for my work, and half my reason has gone ❞
VINCENT VAN GOGH
(IN HIS LAST LETTER TO THEO)

BORN IN HOLLAND, the son of an evangelical pastor, Vincent van Gogh was a sensitive, intelligent, and passionate man. However, his life history was one of continual rejection. His early employment with his uncle's art-dealing firm included a period in London, where an unsuccessful love affair led to his dismissal. He then decided to enter the Church, but this new career was again abruptly terminated when his overly zealous care for the poor displeased his superiors. In despair, van Gogh turned to painting, seeking an outlet for his powerful emotional and spiritual drive. He worked for ten years with astonishing intensity and originality, pioneering an expressive use of color and line that would later inspire the Fauvists and Expressionists. However, he sold only one painting in his lifetime. With his spiritual anguish and depression becoming increasingly acute, most of the artist's last years were spent in mental institutions, where he continued to paint. Finally, he moved to Auvers-sur-Oise in northern France to be near his devoted brother, Theo. After a final burst of creativity, when he completed 70 canvases in as many days, he shot himself in the stomach. He died from the wound two days later.

THE YELLOW CHAIR
The simple subject can be read as a portrait of the artist at a decisive moment in his life. The mood is optimistic—van Gogh was convinced that his dearest ambitions were on the verge of being realized.

Van Gogh moved from Paris to Arles in 1888, hoping to found an artists' colony of kindred spirits who would also find harmony and inspiration through light and color and by adopting a simple lifestyle dedicated to creativity. His dream seemed to be within his grasp when fellow artist Gauguin (p. 88) agreed to join him. However, the two artists' (equally difficult) temperaments clashed, with disastrous consequences.

● COMPLEMENTARY COLORS
Van Gogh has outlined the yellow chair with its complementary blue, which enhances the yellow glow and makes it jump forward from the canvas.

Van Gogh lived in London for a time and was influenced by the novels of Dickens. Dickens often describes inanimate objects with language that endows them with the characteristics of living beings. Similarly, van Gogh was able to "animate" objects through the expressive treatment of line and color.

Self-portrait with Bandaged Ear
Van Gogh's thin and anxious face is in direct contrast to the expansive and optimistic image of the yellow chair. His fiery relationship with Gauguin reached the crisis point in December 1888. After a ferocious argument, van Gogh attacked Gauguin and mutilated himself. He cut off part of his left ear and presented it to a prostitute.

Vincent van Gogh; *Self-portrait with Bandaged Ear;* **1889; 23½ x 19¾ in (60 x 49 cm); oil on canvas; Courtauld Institute, London**

● YELLOW CHAIR
Van Gogh believed that mundane objects could be transformed by color to become symbols of a greater truth. The plain wooden chair glows symbolically with brilliant yellow—the color of the Sun—representing the hope and optimism that the artist felt at this period of his life.

SPROUTING BULBS
Van Gogh has included sprouting bulbs as symbols of new life. They represent the new beginning that he hoped to make with Gauguin.

● BOLD SIGNATURE
The signature is prominent and personal, indicating van Gogh's childlike confidence.

VAN GOGH'S PIPE

The artist's pipe and tobacco placed on the rush seat, the thick, personal brushmarks, and the sheer oddity of the tilting perspective make this much more than an image of a chair. It can be seen as a self-portrait—a symbolic evocation of the artist himself. In an unfinished companion painting, van Gogh depicted an elaborate armchair for Gauguin, which emphasizes the polarity in the artists' characters.

Van Gogh did not attempt to reproduce realistic colors but used color to create moods. In one of his letters he wrote: "Instead of trying to reproduce what I see before me, I use color in a completely arbitrary way to express myself powerfully."

BOLD OUTLINE

The bold outline and simple imagery show the influence of the Japanese prints that van Gogh collected. He also admired, and tried to emulate, the frugal lifestyle that Japanese artists were reported to lead. A Japanese print appears in the background of his *Self-portrait with a Bandaged Ear* (above).

Had he lived, van Gogh would undoubtedly have received the critical recognition and commercial prosperity that was denied him in his short life. Shortly before his suicide, his work was the subject of an enthusiastic review by the critic Albert Aurier.

VINCENT AND THEO

Throughout his life, Vincent was supported and encouraged by his younger brother, Theo. More than six hundred letters were exchanged between the two brothers, and it is through them that we know more about the details of van Gogh's life, emotions, reactions, and artistic theories than any other artist. It was Theo who first suggested that Vincent should become a painter. He sent his brother money for paints and canvases, and he sent photographs and prints on which they exchanged aesthetic judgements. Vincent died in his brother's arms on July 29, 1890. Theo died six months later.

TILTING PERSPECTIVE

There is an unusually high viewpoint for the chair, which makes it appear closer to the viewer and more inviting. Van Gogh makes no attempt to render the perspective of the tiles in a "realistic" manner.

After his initial mental breakdown in 1888, van Gogh was taken to the mental asylum at Arles and later admitted himself into an asylum at St. Rémy. He had periods of depression and lethargy, followed by bouts of intense activity. The cause of his illness is unknown, but it may have have been a form of epilepsy.

During a stay in Paris with Theo in 1886, Vincent came into contact with young, avant-garde artists including Toulouse-Lautrec, Pissarro, Degas (p. 78), Seurat, and Gauguin. Seurat and the Impressionists had a strong influence, but van Gogh's style always remained highly individual—he never belonged to any artistic movement.

KEY WORKS

- **The Potato Eaters**; 1885; *Van Gogh Museum*, Amsterdam
- **Sunflowers**; 1888; *National Gallery*, London
- **The Bedroom at Arles**; 1889; *Musée d'Orsay*, Paris
- **Starry Night**; 1889; *Museum of Modern Art*, New York

Impasto Brushstrokes

Van Gogh had great admiration for Rembrandt's work (p. 48). Like Rembrandt, he frequently used thick (*impasto*) brushstrokes and worked extremely rapidly on his paintings, desperate to capture the immediacy of his perception and emotion. Both artists painted many self-portraits that chart their emotional struggles.

1885–1890

1886 Canadian Pacific Railway completed.

1887 The Golden Jubilee of Britain's Queen Victoria. Conan Doyle: first Sherlock Holmes detective story.

1888 Kodak box camera introduced. Rimsky-Korsakov: *Scheherazade*.

1889 Eiffel Tower constructed.

1890 Ibsen: *Hedda Gabbler*. First steel-skeleton building constructed in New York.

Vincent painted this work, along with a companion painting Gauguin's Chair, while the two artists were living in his beloved "Yellow House" at Arles. He later described the "high yellow note" he struck in the summer of 1888—it was then that he painted his famous series of joyful sunflower paintings.

TERRACOTTA TILES

Van Gogh's thick, emphatic strokes recreate the physical presence and color of terracotta tiles. He loved simple, utilitarian objects, which he associated with his own self-professed "peasant" lifestyle.

Vincent van Gogh: *The Yellow Chair*; 1888; 35½ x 28½ in (90.5 x 72 cm); oil on canvas; Tate Gallery, London

SARGENT
(1856-1925)

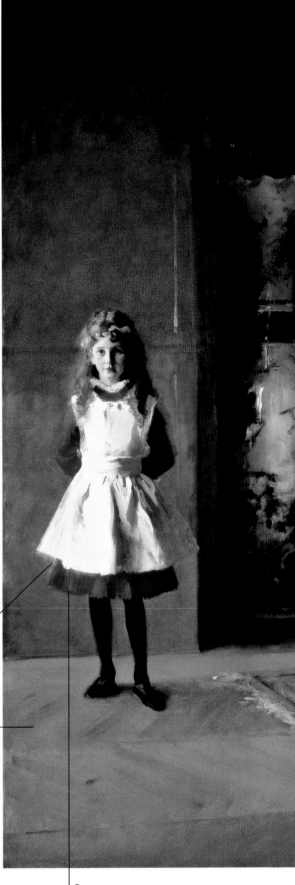

John Singer Sargent

SARGENT COULD HAVE been invented by the American writer Henry James (1843–1916) as a character in one of his novels. His well-to-do parents came from Philadephia (his father was a physician), but they spent their lives touring Europe, and it was as a traveler that Sargent grew up and was educated. He was born in Italy, and his mother encouraged him to paint the places they visited. He was determined to make painting his career (although his father would have preferred the navy), and in 1874 he was sent to study with the renowned portrait painter Carolus-Duran (1838–1917) in Paris. He showed immense talent, and by the age of 23 he had set up his own studio in Paris. In 1884 he moved to London (on the recommendation of Henry James) and quickly became the favorite portrait painter of the British and American *nouveaux riches* and the aristocracy. He portrayed them with ease and flattery as they lived in the privileged "golden age" that was to end with the advent of World War I.

> **"** *Sargent showed his sitters to be rich, and looking at his portraits they understood at last how rich they really were* **"**
> OSBERT SITWELL

THE DAUGHTERS OF EDWARD D. BOIT
Under the conventional surface of this charming group portrait is a fresh and modern approach—a hallmark of Sargent's finest portraiture. The four young sisters are placed off-center and are posed in a way that is consciously modern, conveying an air of spontaneity to the image and introducing a sense of mystery to their relationship. The four sisters seem to have been interrupted in the middle of some joint activity and have a curious, almost guilty, appearance.

BOIT FAMILY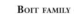
From left to right the four sisters are Mary-Louisa, Florence, Jane, and Julia. Edward Boit was a friend of Sargent. He was a painter and a leading figure in the American expatriate communities in Paris and Rome.

Dramatic Light
Sargent's fluid technique enabled him to explore subtle and dramatic sources of light. Here it falls from the left, creating deep, rich pools of shadow, accents of bright light on the pinafores, and subtle reflections on the glazed Chinese vases and mirror.

BALANCING OF TONES ●
One of the principal lessons of Sargent's teacher Carolus-Duran was the careful balancing of exactly observed tones. He advised his pupils to apply the middle tones first (here, for example, it is the floor and foreground that define these tones). Once the middle tones are established, the pupil was advised to build up and down from there to the highlights and shadows. This painting shows how brilliantly Sargent applied this lesson.

FASHION FOR PORTRAITURE

In Sargent's working lifetime, portraiture by British artists such as Reynolds (p. 56), Gainsborough, and Lawrence became the most sought-after and expensive paintings in the international art market. Such works were eagerly purchased by the American *nouveaux riches*. The British aristocracy was happy to sell its heirlooms for vast prices through dealers such as Joseph Duveen. This fashionable art market assisted Sargent, who, in spite of his American citizenship, was seen as the natural successor to these great portraitists.

Sargent had little formal education, but travel gave him a lively cultural grounding, and he learned several languages. He was also an enthusiastic pianist, and his work plays with tonalities and textures in much the same way as music.

● **LONELY CHILDHOOD**
Sargent shows a natural affinity with the young girls and the age of childhood. He was a shy and lonely man who never married (although his name was linked with some of his glamorous sitters). He had a lonely childhood and spent much of his time with his sisters Emily and Violet.

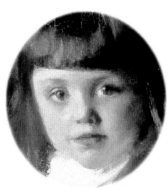

Characteristic Expression
Although brilliantly gifted in his ability to capture a likeness and a characteristic expression, Sargent grew bored of society portraiture and preferred making small sketches of landscapes and his friends.

● **INFLUENCE OF VELÁSQUEZ**
The rich colors and fluid brushwork reveal the influence of Velásquez (p. 46), who was very much a "rediscovery" for artists in the late 19th century. Carolus-Duran used to intone Velásquez's name to his pupils as he paced around his studio, and Sargent made copies of Velásquez's paintings during a visit to Spain in 1879.

Although he spent most of his life in Europe, Sargent was proud of his American origins (he declined a knighthood from Edward VII because it would involve giving up his American citizenship). His most cherished project was the murals for public buildings in Boston.

● **BRILLIANT HIGHLIGHTS**
The observation of light is a constant theme in Sargent's work. It is an interest he shared with the Impressionists—Monet (p. 84) and Sargent became good friends.

● **Madame X**; 1884; *Metropolitan Museum of Art*, New York

● **Carnation, Lily, Lily, Rose**; 1885–86: *Tate Gallery*, London

● **Lady Agnew**; c. 1892–93; *National Gallery*, Edinburgh

● **Gassed**; 1918–19; *Imperial War Museum*, London

1880–1885

1880 Edison receives patent for incandescent lamp. Cholera vaccine discovered.

1881 Henry James: *The Portrait of a Lady*. Camera roll film patented. President Garfield assassinated.

1882 Robert Louis Stevenson: *Treasure Island*. Tchaikovsky: *1812 Overture*. Machine gun patented.

1883 First skyscraper (Chicago).

1884 Mark Twain: *Huckleberry Finn*. Steam turbine invented.

1885 Brahms: *Symphony No 4*.

John Singer Sargent;
The Daughters of Edward D. Boit; 1882; 87 x 87 in (221 x 221 cm); oil on canvas; Museum of Fine Arts, Boston

● **CONFIDENT TECHNIQUE**
When painting a portrait, Sargent was very active, pacing around his canvas and muttering thoughtfully to himself. Finally, he would run at his canvas, his brush laden with paint, and place an accurate brushstroke.

This painting was well received when shown at the Paris Salon in 1883, and Henry James wrote an enthusiastic review for the American magazine Harpers Bazaar. *But, a year later, Sargent's portrait of Mme. Gautreau created a scandal at the Salon because it was considered too unconventional and daring. As a result, he left Paris and established himself in London, taking over the studio of the bankrupt Whistler (p. 80).*

KLIMT
(1862–1918)

A**N ENORMOUS BEAR** of a man, Klimt had a voracious visual and sexual appetite. His life was centered on his native Vienna and bridged two worlds: on the one hand was the brilliant world ruled by the Emperor Franz Josef, which would finally crumble in World War I with the collapse of the Austro-Hungarian Empire; on the other hand was the modern world with its new sciences, new art forms, and new priorities for human relations, where Sigmund Freud (1856–1939) was the outstanding intellect. Vienna was the melting pot for these different worlds, and for both of them the relationships between men and women were an obsession. Klimt trained at the School of Applied Arts, where his prodigious talent brought him early success, and he seemed destined to become a pillar of the art establishment. But his temperament was basically bohemian so, in 1897, he and other artist friends formed a breakaway group, called the Secession, that aimed to put Vienna on the international stage artistically and counteract the provincial attitudes of the conservative academics.

Gustav Klimt

❝ *Enough of censorship…*
I want to break free ❞
KLIMT

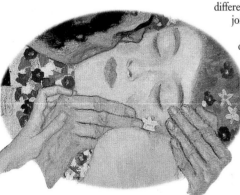

Expressive Hands
The touch of the hands and the gestures in the fingers are particularly expressive. Klimt was fascinated by hands, and they are often an important element in his work. Faces are characteristically hidden or impassive.

SECESSION

K limt earned a commission at the age of 17 to help design a pageant for the celebrations of the silver wedding of Emperor Franz-Josef and consequently was seen as a potential leader of conventional taste. In 1897, however, he won a commission to decorate the Great Hall of Vienna University, and his work for this project provoked outrage and was condemned as pornographic by many critics. As a result, he and a group of friends set up a new organization—the Secession—determined to pursue avant-garde ideas.

SYMBOLIC GARMENTS ●
The man and the woman wear highly decorated gold gowns that define their individuality, but there is a golden "envelope" that surrounds them both and goes beyond the description of their gowns. This "envelope" symbolically unites the sexes.

THE KISS
One of Klimt's culminating explorations on the theme of human desire, *The Kiss* shows man and woman separate but united, experiencing different sensations but sharing joy while joined to the Earth and blossoming nature. The typically sumptuous decoration is used for its aesthetic power and its symbolic force.

GOLD BACKGROUND ●
Klimt, whose father was a gold engraver by trade, trained as a craftsman learning fresco and mosaic techniques as well as oil painting. His training was thus rather different from that of the conventional academic painter.

Klimt was a tireless worker. He rose early and worked in his studio all day. Although he was a man of few words, he frequented his favorite cafés, which were a vital part of the highly strung and emotional fin-de-siècle *Vienna.*

FLORAL MOSAIC
The carpet of flowers and the use of gold is highly reminiscent of the mosaic decorations found in Byzantine churches. Klimt was influenced by the mosaics he saw in Ravenna in Italy, which he visited twice in 1903.

Klimt always wanted to create a union between the fine arts of painting and sculpture and the applied arts of design and decoration. The Secession focused increasingly on pure painting, and so Klimt broke away from the movement.

Gustav Klimt; *The Kiss*;
1907–08; 71 x 71 in
(180 x 180 cm); oil on canvas;
Österreichische Galerie, Vienna

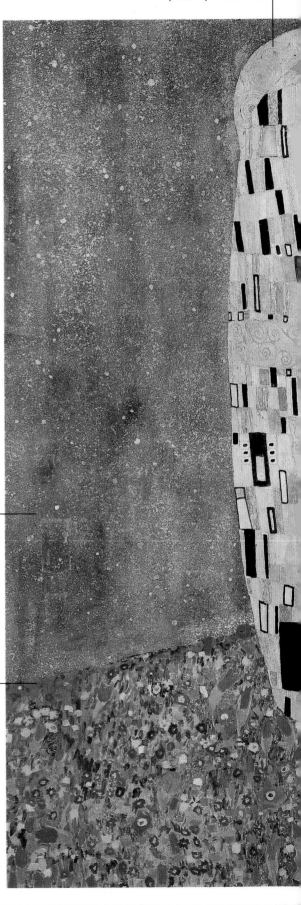

Klimt never married, but he had many affairs and fathered at least four illegitimate children. He had a longstanding relationship with Emile Floge that lasted for 27 years. She was a beautiful woman who owned a fashion shop in Vienna. She features in several of Klimt's works.

● Adele Bloch-Bauer

The woman's features are highly reminiscent of Adele Bloch-Bauer, who was the wife of a rich Viennese merchant and allegedly one of Klimt's lovers. She appears in several of the artist's paintings in various guises.

Klimt's work explores the relationship between the human psyche and sexuality, and it examines themes of birth, life, and death. Women are portrayed at different times as temptresses, providers of emotional and erotic joy, and as childbearers.

Key Works

• **Judith and Holofernes**; 1907; *Österreichische Galerie*, Vienna

• **Hope II**; 1907–08; *Museum of Modern Art*, New York

• **The Maiden**; c.1913; *Narodni Galerie*, Prague

• **Avenue in the Park of Schloss Kammer**; 1912; *Österreichische Galerie*, Vienna

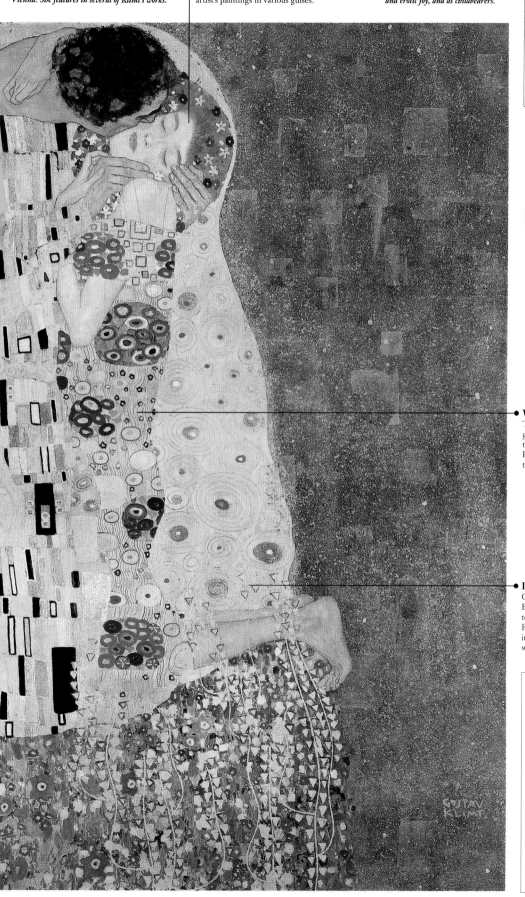

Male Principle

The man's gown is decorated with geometric "masculine" shapes in black and white, but within it are curved and flowing patterns, which reflect those in the woman's gown and symbolize the female "anima" within the male essence.

● Woman's gown

The colorful flowers on the woman's gown unite her visually and symbolically with the carpet of flowers on which she kneels. Her gown also contains geometric elements that symbolize her union with the male.

There is no evidence that Klimt read Freud's work, but the great psychiatrist's ideas were circulated (accurately or otherwise) in the coffee houses of Vienna. Freud was the originator of psychoanalysis, which is based on free association of ideas and analysis of dreams.

● Decorative influences

Greatly influenced by his fascination with Byzantine and early Italian art, Klimt also took decorative ideas from the art of ancient Egypt and Greece. Contemporary influences included popular Japanese prints and the works of Monet (p. 84) and Whistler (p. 81).

1900–1910

1900 Freud: *The Interpretation of Dreams.*

1901 Queen Victoria dies. Marconi transmits transatlantic telegraphic message.

1903 Wright brothers make first powered airplane flight. Western Pacific Railroad Company founded.

1904 First US Olympic Games held in St. Louis.

1908 Mahler: *Eighth Symphony.*

1909 Model T Ford introduced. Blériot flies across English Channel.

KANDINSKY (1866-1944)

WASSILY KANDINSKY WAS AMONG THE FIRST to establish a truly abstract art in which color and form take on a life of their own. Born in Moscow into a wealthy family, his early education was in legal studies. When he was 30 years old, he went to Munich to study art. Although reserved and persnickety by nature, he was a great organizer: in 1911, he founded the Blue Rider Group of avant-garde painters. After the outbreak of World War I, he returned to Russia to try to organize artistic life in the new state, but the aspiration perished and he returned to Germany to become an inspired teacher at the Bauhaus. When the Nazis closed the Bauhaus he moved to France, where he continued to develop his highly personal style of abstract painting. Capable of sophisticated conceptual thought, he developed his ideas in theoretical writings as well as paintings. The connections between art and music were a prime concern because he had an unusual sensitivity to sound, being literally able to "hear" colors—a quality known as "synesthesia."

Wassily Kandinsky

Kandinsky was a friend of the Austrian composer Arnold Schönberg (1874–1951), who developed the revolutionary twelve-tone technique.

COMPOSITION #8

Painted at the height of his powers, Kandinsky regarded this as one of his most important works— a successful expression of his theories about the emotional properties of shape, line, and color. At the time of its completion, he was teaching at the Bauhaus and working on his book *Point and Line to Plane*, which was published in 1926.

Looking at a painting such as this requires an approach fundamentally different from that of traditional figurative art. A good starting point is to stand close so that the colors and forms fill the field of vision. Relaxing the eye and mind allows what is seen to reach the part of the brain that responds to music. Analysis and attempts to read it as a design destroy its impact.

CIRCLES •
The painting explores numerous aspects of Kandinsky's theories. In 1926, the artist wrote: "Angular lines are youthful…curved lines are mature…the point (small circle)…is a small world cut off more or less equally on all sides."

ABSTRACT ART •
One of the questions facing the first abstract painters was whether the elimination of any recognizable subject matter would simply leave an arrangement of color and form that was merely decorative with no spiritual depth. Kandinsky established that this was not so and that abstract art could fulfill the aim of all high art since the Renaissance: to uplift and touch the human soul.

❝ *Color is the keyboard, the eyes are the hammers, the soul is the piano with many strings. The artist is the hand that plays, touching one key or another, to cause vibrations in the soul* **❞**
KANDINSKY

1920–1925

1920 Republic of Ireland separates from UK. Prohibition introduced into US. Holst: *The Planets.*

1921 Inflation in Germany. Pirandello: *Six Characters in Search of an Author.* Splitting of the atom. First Miss America crowned.

1922 Mussolini forms Fascist government in Italy. Tutankhamen's Tomb discovered.

1923 First Winter Olympics held in Chamonix, France.

1925 Hitler: *Mein Kampf.* Television invented. Charleston dance in fashion.

YELLOW •
According to Kandinsky's theories, yellow "possesses a certain capacity to ascend higher and higher and attain heights unbearable to the eye and spirit." Blue "descends into infinite depths." Light blue "develops the sound of the flute."

Wassily Kandinsky; *Composition #8;* **1923; 55 x 79 in (140 x 201 cm); oil on canvas; Guggenheim Museum, New York**

ABSTRACT ART

Kandinsky is credited with creating the first abstract painting, but the interest in a new art free from natural representation (yet with the the power to stir the soul in a similar way to music) was shared by other distinguished artists such as Delaunay (1885–1941) in France, Malevich in Russia (1878–1935), and Mondrian (1872–1944) in the Netherlands. In terms of its ambition and serious purpose, abstract art replaced the role previously played by history painting.

Kandinsky developed an interest in theosophy, which proposes that there are certain fundamental truths inherent in all the world's religions. His very early work was figurative and drew on folk art, and his earliest abstract works were loosely painted and concerned only with color. He said that a turning point in his life came when he saw one of Monet's paintings of haystacks. At first, not recognizing the subject, he saw it only in terms of form and color—as a true abstract painting.

After an unsuccessful marriage with his cousin, Kandinsky had a close relationship with the painter Gabriele Munter, which was highly creative for them both. In 1917, following his return to Russia, he married Nina Anreeswky.

● COLOR AND SPIRITUALITY
According to Kandinsky, "Green is well balanced and corresponds to the attenuated sounds of the violin," red "can give the impression of a strong drum beat," while blue can be seen "in the depth of the organ."

The Guggenheim
Solomon Guggenheim was Swiss by origin, and his family had amassed a fortune in the US from mining. He became an art collector—first of old masters, but later of experimental European art. *Composition #8* was the first of more than 150 works by Kandinsky that he purchased. He founded a museum in New York, now called the Guggenheim, to house these works; it was designed by Frank Lloyd Wright.

Triangle and Circle
Kandinsky believed that abstract art could be as profound as the greatest figurative painting. He wrote: "The impact of the acute angle of a triangle on a circle produces an effect no less powerful than the finger of God touching the finger of Adam in Michelangelo."

Concerning the Spiritual in Art, a key early theoretical work by Kandinsky published in 1912, explored the emotional and spiritual impact of color and was one of the most influential pioneering works on abstract art.

● LINES AND ANGLES
According to Kandinsky, horizontal lines are (or sound) "cold and flat," whereas verticals are "warm and high." Acute angles are "warm, sharp, active, and yellow," and right angles are "cold, controlled, and red."

KEY WORKS

• **Landscape with Church II;** 1910; *Stedelijk Museum*, Eindhoven

• **Improvisation 31;** 1913; *National Gallery*, London

• **Accent in Pink;** 1926; *Musée National d'Art Moderne*, Paris

• **Thirteen Rectangles;** 1930; *Musée National d'Art Moderne*, Paris

MATISSE
(1869-1954)

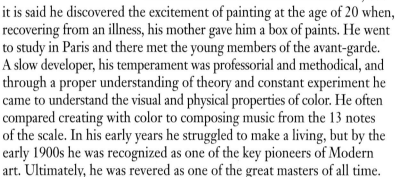

Henri Matisse

ONE OF THE MOST INNOVATIVE and influential artists of the 20th century, Matisse earned the name "King of Color" for the boldness of his visual experiments and for the way he liberated the expressive use of color to reflect modern sensibility. He was born in northern France, the son of a corn merchant, and inherited a shrewd business acumen. At first he studied law, but it is said he discovered the excitement of painting at the age of 20 when, recovering from an illness, his mother gave him a box of paints. He went to study in Paris and there met the young members of the avant-garde. A slow developer, his temperament was professorial and methodical, and through a proper understanding of theory and constant experiment he came to understand the visual and physical properties of color. He often compared creating with color to composing music from the 13 notes of the scale. In his early years he struggled to make a living, but by the early 1900s he was recognized as one of the key pioneers of Modern art. Ultimately, he was revered as one of the great masters of all time.

COLOR RELATIONSHIPS
Matisse uses color harmonies (such as mauve and green) and color contrasts (such as blue and orange). These, with the upward movements of the shapes, give a cheerful and uplifting mood. The colors are also evocative of the sea, sky, fruits, pine trees, foliage, sand, and sunlight of the South of France.

❝ *My painting is finished when I rejoin the first emotion that sparked it* ❞
MATISSE

Paper Cutout
The work is made out of individual pieces of paper, which Matisse had painted with the precise colors he wanted. These pieces were then arranged on a white background of paper. In front of the actual work it is possible to see pin holes and places where papers has been torn or the scissors have slipped.

THE SNAIL
The artist's underlying interest lay in color relationships that expressed his inner feelings. Created toward the end of his life, this work communicates Matisse's unquenchable *joie de vivre*. It radiates the brilliant color and light of the Mediterranean, which was a constant source of inspiration and joy.

Matisse first discovered the power of Mediterranean light in 1898, shortly after his marriage to Amélie Parayre, when he spent some time working in Corsica. The experience influenced his whole life and shaped the development of his work.

SPIRAL SHAPE
There is no literal depiction of a snail, but the central shapes above the blue are arranged to form a spiral representing the snail's shell.

*Like most pioneers of modern art, Matisse was deeply influenced by Cézanne's use of form and color. With his wife's dowry he bought a small painting, **Bathers**, by Cézanne, which he constantly referred to.*

VIBRANT COLOR
The intensity of the color relationships expresses Matisse's lifelong intellectual and emotional excitement at the boldness and success of his experiments. *The Snail* is the final act of an artistic journey that started half a century earlier.

Henri Matisse; *The Snail*; 1953; 113 x 113½ in (287 x 288 cm); gouache on paper; Tate Gallery, London

NOTES OF A PAINTER
Matisse believed that the painter's best spokesman was his own work, but in 1908, while living in rooms in the Hôtel Biron in Paris, he wrote *Notes of a Painter*, one of the most influential artist's statements of the century. The article, published in *La Grande Revue*, encapsulates the principles that shaped Matisse's work until the day he died. A key passage states: "The chief function of color should be to serve expression as well as possible. I put down my tones without a preconceived plan.... To paint an autumn landscape I will...be inspired only by the sensations that the season arouses in me: the icy purity of the sour blue sky expresses the season just as well as the nuances of foliage."

From 1920, Matisse spent most of his time in or near Nice, usually staying in hotels. Initially, his marriage was happy (he had three children), but he and his wife grew apart, separating in 1939. In his old age, he was looked after and inspired by a young Russian, Lydia Delectorskaya.

● **BLACK CONTRAST**
The black shape is an essential piece of the overall design and mood. Take it away (cover it with your hand), and the intensity of color and strength of the design disappear.

Behind the apparent simplicity of Matisse's creation lay endless hours of work and rework. He aimed always to achieve that final pure distillation of expression and visual balance in which nothing could be added or subtracted.

KEY WORKS

• **The Open Window at Collioure**; 1905; *Private Collection*, New York

• **The Dance**; 1909–10; *The Hermitage*, St. Petersburg

• **Bathers by a River**; 1916–17; *Art Institute*, Chicago

• **Jazz**; 1943; *Victoria and Albert Museum*, London

Matisse's boldest early color experiments were painted in Collioure, near the Spanish border, in the summer of 1905. When shown in Paris, their vivid colors and free manner caused outrage. One critic described the paintings as fauves ("wild beasts") compared to conventional work.

● **NEW COLORS**
19th-century scientific developments produced many bright new pigments and dyes. Matisse's generation was among the first to have such colors available as artist's materials, pre-mixed and relatively cheap. These innovations made his first bold color experiments possible.

Matisse was gifted as a sculptor as well as a painter. He once said that cutting into his pieces of colored paper with scissors was like being a sculptor cutting into a block of color.

● **WHITE SPACES**
In many of Matisse's works he leaves bare patches of white canvas, often at the edges of flat areas of color, in order to allow colors to "breathe" and reach their full visual potential.

● **GLOWING FRAME**
The central design is surrounded by a continuous band of glowing orange. It frames the work and refers back to one of Matisse's earliest subjects: a view through a window onto a sunlit landscape.

Serious illness and repeated surgery in 1941 left Matisse weakened and often bedridden in his last years. Paper cutouts enabled him to work on a large scale from bed, directing assistants to move the pieces of paper.

1950–1960

1952 Elizabeth II crowned Queen of England. Eisenhower elected President. Beckett: *Waiting for Godot.*

1956 Soviet invasion of Hungary. Craze for rock'n'roll.

1957 European Common Market founded. First satellite launched by USSR. Kerouac: *On the Road.*

1959 De Gaulle becomes President of Fifth Republic of France. Castro becomes President of Cuba.

1960 Kennedy elected President.

H. Matisse 53

KLEE (1879–1940)

PAUL KLEE WAS ONE OF THE MOST ORIGINAL ARTISTS of the Modern movement, and his work often captures that small-scale innocence and freshness that is usually found only in the work of children. He was born near Bern, Switzerland. Music played a large part in his life—both his parents were professional musicians, he was an accomplished violinist, and he married a piano teacher. But he always wanted to be a painter, and so he went to Munich to study art. He soon became interested in the work and ideas of the avant-garde artists and was especially fascinated by investigations into the relationships between music, color, mysticism, and primitive art. A defining moment in his life was a visit to Tunisia in 1914, where he was thrilled by the vividness of the light and color and by the mixture of shapes, cultures, fantasies, and fairy tales of the Arab world. In 1920, he was invited to join the Bauhaus (see below) as one of the founders of the program that would revolutionize art teaching and design. Klee was a gifted teacher and his time there was extremely happy; however, by the early 1930s the Fascist regime had moved to suppress the type of art and free thinking that Klee championed. In 1933 he returned to Switzerland, and his later years were overshadowed by a rare and painful wasting disease and the knowledge of his impending death.

Paul Klee

❝ *The creation of a work of art [must be] accompanied by the distortion of natural form…for therein is nature reborn* ❞
KLEE

MONUMENTS AT G

Klee visited Egypt from December 24, 1928 to January 10, 1929, visiting Cairo, Luxor, Aswan, and the pyramids at Giza. This painting was made after he had returned to Germany. The work plays with simple images and memories that had impressed Klee and which remained with him, much as a particular melody may haunt the musical imagination.

Klee and his wife Lily had a five-year courtship, which was conducted mostly by correspondence. Lily's father disapproved of artists.

BANDS

The thin bands evoke the monotony of the desert that stretches from horizon to horizon and the strips of cultivation that border the River Nile.

At the Bauhaus, Klee formed a particularly close friendship with Kandinsky (p. 96). Of particular interest were Kandinsky's theories concerning abstract art and the relationships between color and music.

MUSICAL COLOR

Like the acute angles representing the pyramids themselves, the brighter yellow color represents "high notes" in the painting. According to Kandinsky's color theories, yellow has the capacity to elevate the spirit of the viewer.

Klee was extremely neat and well ordered in his own personal affairs. He kept a complete record of all his works—totaling over 9,000—in a catalog. He had a complex classification system that recorded his works by medium as well as by value. He also kept meticulous accounts of household expenditure.

He was equally thrifty as a craftsman, often making his own tools and materials—even his own glue.

RHYTHMIC COLORS

Down the entire length of the left-hand side of the painting Klee has meticulously repeated three bands of color in earthy brown, green, and red. In this way he has created a steady visual pulse, similar to a monotonous drumbeat in music. This underlying order accentuates the discordant effect of the brighter colors and jarring angles.

Klee was a lover of Mozart, and this work has some of the qualities of his chamber music. There is a strong underlying structure that is at the same time innovative and flexible. Both of them enjoy juxtaposing different textures and sound colors, and both understand the haunting power of a simple and delicate refrain and its subtle repetition.

Klee's neat and tidy temperament found the confusion of Egypt bewildering. He disliked the dirt, sickness and poverty, and the lack of purpose and responsibility. On the other hand, he was fascinated by the clash of cultures from Africa, Europe, and the Orient. He kept a diary and wrote to Lily, recording his impressions of the journey.

PYRAMIDS AT GIZA

The triangular shapes are clearly a reference to the famous pyramids at Giza, which are close to Cairo and which Klee visited by catching an electric tram. The other shapes may reflect other features such as sand dunes or irrigation canals.

Klee left the Bauhaus in 1931 to move to a new post at the less controversial Düsseldorf Academy. The Bauhaus was closed by the Nazis in 1933—the year in which Klee returned to his native Switzerland. Seventeen of his works were shown at the notorious Entartet Kunst Exhibition of 1937, in which the German dictator Adolf Hitler attempted to expose the supposed degeneracy of Modern art. Hitler's ploy backfired, however, and the exhibition attracted widespread and admiring interest.

Paul Klee: Monuments at G;
1929; 27⅜ x 19¼ in (69.5 x 50 cm);
gypsum and watercolor on canvas;
Metropolitan Museum of Art,
New York

One of Klee's major contributions at the Bauhaus was to develop a curriculum that examined the raw material and fundamental processes of picture making. Revolutionary in its day, his ideas have now been adopted as the standard methods for art schools.

THE BAUHAUS

Founded in 1919 by the architect Walter Gropius (1883–1969), the Bauhaus became the most influential art school of the 20th century. Central to the school's teaching was the study of form and design, modern materials, the role of the machine, and the relationship of the fine arts to machine production. The school attracted many talented pioneers such as Kandinsky and Klee, and painters, architects, designers, and craftsmen worked closely together. They established many of the cornerstones of modern industrial design, such as furniture made from tubular steel. The Bauhaus believed that social and moral improvements could be encouraged by good art and design, but such attitudes created enemies, and it was finally closed by the Nazis in 1933.

The curious hieroglyphics along the bottom of the painting suggest the presence of palm trees or other vegetation growing in the fields. It is typical of Klee's work to tease the imagination with the gentlest suggestion of a "real" object—coaxing the release of the viewer's own memories rather than dictating a definitive image.

PALM TREES

KEY WORKS

- **Fugue in Red;** 1921; *Felix Klee Collection,* Bern
- **The Golden Fish;** 1925–26; *Kunsthalle,* Hamburg
- **Diana in the Autumn Wind;** 1934; *Kunstmuseum,* Bern
- **Death and Fire;** 1940; *Kunstmuseum,* Bern

Klee had formed good friendships with young members of the German avant-garde before World War I. Two of them, Auguste Macke and Franz Marc, were killed in the conflict. Klee was deeply depressed by their deaths, which affected him for the rest of his life. He served briefly in the German army (although born in Switzerland, he was a German national), but did not see any fighting.

Inventive Techniques

Klee enjoyed experimenting with different techniques, paper textures, and unusual materials, which he often combined with great inventiveness and delicacy. Here he primed canvas with gesso (gypsum), then painted with watercolor and made scratch marks in the surface.

In a sense, nonrepresentational art frees the viewer to interpret a painting in many different ways. This work, for example, might be seen as a bird's-eye view, looking down on an imaginary Egypt, or else as a perspective view from the "trees" in the foreground, past the pyramids in the middle distance, and on to the vast desert beyond. Again, it might be viewed as an assembly of different motifs rather like much Egyptian art. Each interpretation is equally valid.

OBSCURE MONUMENTS

Apart from the pyramids themselves, other, more obscure "monuments" are suggested. Although we can only guess which monuments inspired the artist to place each motif, some clues are provided by the diary entries made on the visit. His guidebook described a famous view from the top of the Pyramid of Cheops (which Klee may well have seen) contrasting the overwhelming desolate sands and the "barren cliffs" with the "luxurious blue-green vegetation" along the River Nile.

NOTATION

The dark horizontal lines that separate the bands may be viewed as a great stave upon which the visual symbols can be read like musical notes and ornaments—the visual tones and cadences playing upon the eye as musical notation plays on the ear of a musician.

101 • KLEE

PICASSO (1881-1973)

THE DOMINANT ARTISTIC PERSONALITY of the 20th century Picasso is one of the creative geniuses of all time. He was born in Málaga into an artistic family (his father was an art teacher), and his extraordinary ability was apparent at an early age. Traditional skills in drawing and painting came so easily to him that he had to find new modes of expression appropriate to modern sensibility, and through his experiments—notably with Cubism—he rewrote the language of art. Picasso settled in Paris in 1904 and made France the center of his activities. His was a restless personality, obsessed with making things (painting for him was just one means of making), and his many love affairs are legendary. He relished intense experiences, and his life knew great extremes: love and hate, poverty and riches, rejection and adulation. These contrasts are expressed in his art, which is, in effect, a detailed autobiography.

Pablo Picasso

SEATED HARLEQUIN
Picasso painted this picture when he was happily married and his first child, Paolo, was two years old. His work of this period shows a return to order and tradition, reflecting his own emotional security and the influence of classical Italian art.

In 1917, Picasso went to Rome (his first visit to Italy) to design costumes and scenery. It was through his work with Diaghilev's Ballet Russes that he met his future wife Olga Koklova.

ARTIST FRIEND
The portrait shows Picasso's Catalan friend, the painter Jacinto Salvoldo, wearing a costume that Jean Cocteau had left behind in Picasso's studio. Picasso, who had many artist friends, wished to be recognized as leader of the avant-garde.

Three-dimensional Modeling
The face is well-modeled using light and shade. Picasso was a gifted sculptor, and a feature of many of his paintings is a sense that he is thinking in three dimensions.

1925–1930

1926 Scopes monkey trial.

1927 Collapse of German economy. Marcel Proust: *A la Recherche du Temps Perdu.* First "talkie," *The Jazz Singer,* starring Al Jolson. Lindbergh's nonstop transatlantic flight.

1928 Penicillin discovered. Hoover is elected president. Ravel: *Bolero.*

1929 Wall Street Crash. First Academy awards presented. Museum of Modern Art opens in New York.

UNFINISHED?
The work appears to be unfinished, but this may be a deliberate effect. Picasso has given enough information to allow our eye and mind to complete the image. Inviting the participation of the spectator in this way is typical of Picasso.

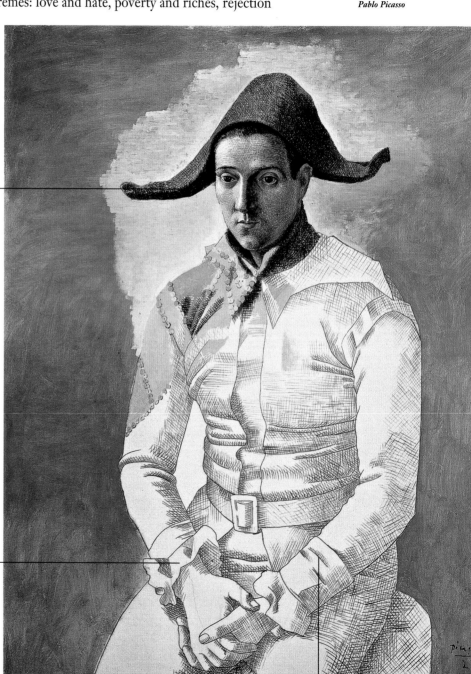

The meticulous observation and technique of Seated Harlequin are worthy of a Renaissance master or Ingres (p. 70). Much of Picasso's work at this time is a deliberate reworking of tradition.

HARLEQUIN
Picasso frequently used the image of the harlequin to refer to himself and his own activities as an artist. He saw both painter and harlequin as solitary, melancholy public entertainers.

Pablo Picasso; *Seated Harlequin;* **1923; 51 x 38 in (130 x 97 cm); oil on canvas; Musée National d'Art Moderne, Paris**

1929: A TURNING POINT

A key year politically and artistically, 1929 was the year of the Wall Street Crash, which led directly to the Depression. The high-spirited years of the Jazz Age were over, and the countdowns to the Spanish Civil War and World War II were starting. In November, the Museum of Modern Art opened in New York—the first such museum in the world—with an exhibition that included works by Cézanne (p. 82) and Van Gogh (p. 90). The first step had been taken to institutionalize avant-garde art and give it official approval.

Cracked Paint
In places, particularly in the areas representing flesh, the paint surface is cracking. This is evidence of the haste with which Picasso created the image. These cracks have now become part of the image and add to its expressive force.

Picasso's love life became legendary, and all of the women who shared his private life influenced the style and appearance of his art. His last years were spent with Jacqueline Roque, whom he married in 1961. He never returned to Spain after 1937 because of his opposition to Franco's dictatorial regime.

SURREALISM
Picasso first painted violent female images in 1925 when his marriage first ran into trouble, and in so doing opened up a new area of expression that painting had not yet touched.

LARGE NUDE IN A RED ARMCHAIR
By 1929 Picasso's domestic and emotional life had changed dramatically. His marriage had broken down irretrievably, and he had started a secret liaison with Marie-Thérèse Walter, a beautiful Scandinavian woman many years his junior.

CUBIST TECHNIQUES
The fragmented and flattened imagery comes out of Picasso's earlier experiments with Cubism. Here he develops Cubist techniques to express intense inner emotion and conflict.

The Surrealists, who founded their movement in 1925, were impressed by this type of work by Picasso. They sought to use painting to unlock and reveal inner states of mind. They were greatly influenced by Freud's theories and his emphasis on sexuality and death. This work explores both of these driving forces in a highly personal and impressive manner.

COLOR
Picasso used color very directly and for expressive purposes. For him, painting was rarely an end in itself but a means to something else—for example, to investigate form or explore a deeply felt emotion. In this painting, he uses extreme distortion and crude color to express an inner torment.

❝ *Why do you try to understand art? Do you try to understand the song of a bird?* ❞
PICASSO

The human figure always remained central to Picasso's art, and he was never tempted by abstract art. Such was his mastery of technique and the diversity of his imagination that he had the unique ability to switch between traditional imagery and styles and new ways of expression. He would choose whichever was more appropriate for the work he was creating. Like his Spanish predecessors Velásquez (p. 46) and Goya (p. 60), he had the ability to express emotions and concerns that were simultaneously highly personal and universal in their meaning.

Pablo Picasso; *Large Nude in a Red Chair*; 1929; 77 x 51 in (195 x 129 cm); oil on canvas; Musée Picasso, Paris

KEY WORKS
• **Les Demoiselles d'Avignon;** 1907; *Museum of Modern Art,* New York

• **Ma Jolie;** 1911–12; *Museum of Modern Art,* New York

• **The Three Dancers;** 1925; *Tate Gallery,* London

• **Guernica;** 1937; *Museo del Prado,* Madrid

EVIDENCE OF HASTE
In the white cloth covering the seat and arm of the chair, the muddied paint shows Picasso changing his mind and, in his hurry, running the black and white paint together.

Although he was a pioneer of the Modern movement, Picasso respected the past; as a young man spent long hours studying in the Louvre. The styles that he developed were not so much a rejection of past values as an expression of his desire to revive the fresh vision and vitality that characterized the work of the early Renaissance.

HOPPER (1882-1967)

THE TYPICALLY LONELY IMAGES of Hopper's paintings reflect both the artist's pessimistic personality and the times in which he grew to maturity. He was born in a small town in New York State, the son of a shopkeeper who imposed a strict Baptist upbringing. Unusually tall, the young Hopper had a solitary, bookish childhood, and throughout his life he retained a hatred of small talk, often choosing to be alone and silent and rarely discussing his art. When he was 18 years old, he went to the New York School of Art to learn how to become a magazine illustrator. In his mid-20s, he twice visited Paris, where he took an interest in the relatively old-fashioned Impressionists. However, he did not become a full-time artist until 1924 (aged 42)—the same year that he married Jo Nivison, a vivacious actress turned painter. The couple lived in New York and had a summer house in Cape Cod. Hopper despised abstract art and remained outside the modern mainstream. The abstract painters, however, admired the strong geometry of Hopper's work, which had an unmistakably modern feel. By the late 1930s, he had gained success in his own right.

Edward Hopper

NIGHTHAWKS

Many of Hopper's most haunting works feature isolated people in anonymous spaces, such as restaurants, offices, and hotel rooms. It is never clear why they are there or what their relationship is. The principal mood is one of transience—people passing through, somehow not belonging to, the setting in which they are depicted.

« Great art is the outward expression of an inner life in the artist »
HOPPER

SUBTLE DISTORTIONS •
Careful analysis of many of Hopper's works reveals that the spaces he creates are subtle alterations of reality. However, the change is often so slight that it is felt instinctively rather than perceived visually. This sense of something being wrong helps to heighten the feeling of unease engendered by Hopper's pictures.

None of Hopper's pictures tells a story. Each one is like a single frame from a movie, suggesting that at any moment the scene will move on and the meaning will become clear. As an ardent movie-goer in the great age of the black-and-white film, Hopper was undoubtedly influenced by cinema techniques, which relied heavily on angles, contrasts of light and shade, and memorable compositions to compensate for the lack of color.

BOLD DESIGN •
Hopper had an instinct for strong, simple design—a skill that made him sought after as a commercial artist (advertisers and magazine editors have a liking for bold, direct images). Hopper sets off his distinctive, strong designs against an uneasy mood of unexplained tension.

Even when successful, Hopper preferred threadbare clothes, secondhand cars, and cheap restaurants. In 1942, he and his wife undertook a three-month car journey from New York to the West Coast and back. This painting could well be inspired by something seen or experienced on that journey.

1940–1945

1940 Battle of Britain. Roosevelt elected President for third term. Walt Disney's *Fantasia*.

1941 Japanese bomb Pearl Harbor. Germany invades Soviet Union. Orson Welles: *Citizen Kane*.

1943 Germans defeated at Stalingrad. Penicillin produced commercially.

1944 D-day landings in Normandy. Bartok: *Violin Concerto*.

1945 Atomic bomb exploded. Germany and Japan surrender.

EMPTY STREET •
Speaking about this painting, Hopper said: "I simplified the scene a great deal and made the restaurant a lot bigger. Unconsciously, probably, I was painting the loneliness of a large city."

Hopper professed to have no interest in modern styles of painting and consciously detached himself from the concerns of contemporary artists. In 1960, he protested vigorously to the Museum of Modern Art in New York against the inclusion of Abstract art in their collection.

Edward Hopper;
Nighthawks; 1942; 30 x 56½ in (76 x 144 cm); oil on canvas; Art Institute, Chicago

ISOLATED CORNER •
Hopper often selects odd viewpoints that separate a corner of a room or an angle of a street, simultaneously isolating the figures and giving the viewer the sense of being an outsider excluded from the world depicted in the scene.

Couple at the Bar
The relationship of the man and woman standing at the bar is provocatively ambiguous. Their hands almost touch, or are about to touch, but it is unclear whether any such contact should be seen as deliberate or accidental.

Hopper's study of light was, in part, inspired by his knowledge of Impressionist paintings (p. 86). He visited Paris in 1906–07 and again in 1909–10. One of the attractions of Cape Cod (where he and his wife had a summer house) was the clarity and brilliance of the seaside light.

ARTIFICIAL LIGHT
Hopper was always fascinated by the effects of light. Here, he is attracted by the harsh artificial light filling the interior of the café and flooding out with a ghostly greenness into the empty street.

THE ARMORY SHOW

Until 1913, the year of the famous Armory Show in New York, the American public had little firsthand experience of the radical achievements of European art—from Symbolism and Impressionism (p. 86) to Cubism (p. 102). (Two-thirds of the show was devoted to contemporary American artists, who were still wedded to Realism.) Although the impact of the new European art took time to develop, it was, nonetheless, a turning point. Hopper was included in the show and made one of his first sales.

SOLITARY STRANGER
His face hidden, an anonymous man sits alone at the bar. Hopper almost certainly sketched him from life, and his observation of the way light falls on his face and shoulders is masterly.

Although they stayed together, Hopper's relationship with his wife was sometimes turbulent. Their personalities were very different, and in her diary Jo refers to arguments and the difficulty she experienced in communicating with her husband.

OBSERVATIONS OF REALITY
Hopper's influential teacher at the New York School of Art, Robert Henri, encouraged him to take everyday life as a subject and to study painters with a similar interest, such as Velásquez (p. 46), Manet (p. 76), and Degas (p. 78).

Sculpture

In 1909, Modigliani began to make sculptures. He was especially influenced by the pure and simplified forms of Brancusi and by the tribal sculptures of Africa. The elongated head and nose in this work look as though they could be carved in stone and reflect the work that Modigliani produced as a sculptor.

Modigliani lived in conditions of acute poverty, lacking the money to buy materials to paint. He was not alone in this—the small scale and thinly painted quality of many early works by pioneering modern artists reflect this economic reality.

ALMOND EYES

The almond-shaped eyes, set above a long nose and bow-shaped mouth, are hallmarks of Modigliani's art. In this portrait, the pale blue eyes, which are like windows cut into the face to reveal the sky beyond, intensify the disturbingly blank facial expression.

DEVOTED MISTRESS

A shy and retiring art student, Jeanne Hébuterne was devoted to Modigliani and bore with fortitude his many public humiliations, infidelities, and physical attacks. The day after the artist died, Jeanne committed suicide by throwing herself out of an upstairs window. They are buried side by side in the Cemetery of Père Lachaise in Paris, the resting place of many artists.

MODIGLIANI (1884–1920)

AMEDEO MODIGLIANI'S LIFE reads like the popular misconception of the unreliable, drug-addicted, but brilliantly gifted Bohemian artist that is usually found only in fiction. He was born in Italy into a Sephardic Jewish family. His liberal-minded and unconventional mother adored him and introduced him to art and poetry. His father, a businessman, went bankrupt shortly after he was born and was often absent from home. Modigliani was a sickly but beautiful child, and he grew up spoiled and wayward. His ambition was to be a portraitist, and, at the age of 22, he went to Paris with a small allowance. He consciously pursued a decadent lifestyle, frequenting bars and brothels, and became dependent on alcohol and drugs. At the same time, however, he developed an artistic style that was a highly original synthesis of traditional art and the ideas of the avant-garde, which were so potent in Paris between 1900 and 1914. Like many of his generation, he played the role of the outsider and often showed a callous disregard for his friends and mistresses. Such a lifestyle brought its own inevitable conclusion. In the bitter winter of 1920 he contracted pneumonia and tubercular meningitis and died in poverty. He was just 35 years old.

Amedeo Modigliani

Jeanne Hébuterne
Characteristic of Modigliani's late Expressionist style, this highly individual and moving portrait was completed shortly before the artist's death. It shows his lover, Jeanne Hébuterne, whom he first met in July 1917. She is heavily pregnant with their second child.

Like many of his generation, Picasso (p. 102) included, Modigliani painted and sculpted out of a sense of inner necessity, rather than for recognition or commercial success. They worked with the dedication of scientists in a laboratory rather than the canniness of entrepreneurs seeking to exploit a new idea or fashion. There were a few dealers in Paris who wanted to help these young and unproven avant-garde artists. Modigliani was backed by a Polish poet-cum-dealer, Leopold Zborowski. His first one-man show was closed after one day because the police judged the nudes to be obscene.

INDIVIDUAL STYLE

The stylized pose with sloping shoulders, long neck, and head tilted to one side are key features of Modigliani's style, bringing to mind Botticelli (p. 22) as much as Matisse. Uniquely, he achieved a successful synthesis between the art of the Renaissance and the 20th-century avant-garde.

KEY WORKS

- **Seated Nude;** 1916; *Courtauld Institute,* London
- **Reclining Nude;** 1917; *Staatsgalerie,* Stuttgart
- **Girl in White Chemise;** 1918; *Private Collection*
- **Jeanne Hébuterne in Profile;** 1918; *Private Collection*

SIMPLIFIED FORM AND LINE
Modigliani shared the ideas and aspirations of many of the leading avant-garde artists and painted portraits of many of them, including Picasso (p. 102), Cocteau, Gris, and Soutine. The simplification of form and line that is evident in his work reveals the influence of Matisse (p.98).

Modigliani's mother introduced him to the work of symbolist poets, such as Baudelaire and Rimbaud, and through his aunt he discovered Nietzsche's ideas of the artist as an exile from conventional society. Externally, Modigliani expressed his flirtation with decadence by wearing a chestnut corduroy suit and large felt hat.

Amedeo Modigliani: *Jeanne Hébuterne;* 1919–20; 51 x 32 in (130 x 81 cm); oil on canvas; private collection

1910–1915

1910 Independent South African Republic is established. Father's day first celebrated in the US.

1911 Turkish-Italian War. Chinese Republic proclaimed.

1912 Lenin becomes editor of *Pravda.* Scott reaches South Pole. Sinking of the *Titanic.*

1913 Balkan War. D.H. Lawrence: *Sons and Lovers.* Thomas Mann: *Death in Venice.* First Charlie Chaplin film. Stravinsky: *Le Sacre du Printemps.*

1914 Panama Canal opens. World War I begins in Europe.

"You must have that holy cult, the cult of everything that can exalt and excite the intelligence! Try to provoke and to perpetuate these fertile stimulants, for they alone can lift the intelligence up to its highest creative levels"
MODIGLIANI

SECOND PREGNANCY
Modigliani and Jeanne conceived two children. The first was born in October 1918 in the South of France. This portrait was painted in Paris when Jeanne was carrying their second child. She died before the child was born, seven months pregnant. The first child was adopted by Modigliani's family in Italy.

Before his relationship with Jeanne Hébuterne, Modigliani had a stormy, and sometimes violent, relationship with a South African journalist and poet named Beatrice Hastings. Like many of his lovers, she was attracted by his romantic Bohemian appearance and vulnerability.

Modigliani's lifestyle and art expressed a desire to escape from reality, rather than confront it— as did Picasso (p. 102), for example. He also fantasized about his family, encouraging speculation that his distant ancestors were once bankers to the popes and his mother was descended from the philosopher Spinoza.

EXPRESSIVE POSE
Before painting a portrait, Modigliani made many drawings so that he could get to know his sitter and work out a suitable pose. Then he would paint the portrait rapidly, usually completing it at one sitting. For him, painting was an intensely emotional activity, in which he cried out and sighed with the effort of concentration and frustration. He also drank heavily in the process—it is said that his best work was produced when he was in a drunken rage.

Like most of the early avant-garde artists, Modigliani had a deep respect for the old masters. He first studied in Florence and Venice, where he took an interest in the paintings of Bellini (p. 20), Botticelli (p. 22), and Titian (p. 34). He also admired Sargent's portraits (p. 92).

CUBIST SPACE
The simple but fragmentary background reveals his debt to, and admiration for, Cézanne (p. 82) and an awareness of the cubist work of Picasso (p. 102) and Braque. Modigliani first saw Cézanne's work at the now-famous retrospective Exhibition in Paris in 1907.

At the turn of the century, Paris was a fertile melting pot out of which new art, architecture, writing, and music developed. Munch, Whistler (p. 80), van Gogh (p. 90), Cézanne (p. 82), and Picasso (p. 102) are a few of the artists attracted to the Bohemian lifestyle.

LA VIE BOHEME

From the middle of the 19th century, many young artists and writers from provincial France and overseas were attracted to Paris by the prospect of fame, fortune, and the dream of a supposedly carefree Bohemian lifestyle that was devoted to art, conversation, aesthetic enjoyment, women, and the conviviality of café life. The idea was popularized by a novel written by Henri Murger (1822–61) called *Scenes de la Vie Bohème* (1847–49), which was the basis for Puccini's opera *La Bohème* (1896). Even if the reality of this life differed from the dream, it nonetheless attracted many talented and energetic spirits to Paris.

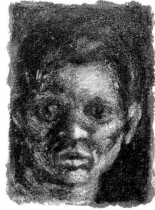

Jackson Pollock

POLLOCK (1912-1956)

WITH JACKSON POLLOCK, modern American art was seen to have established an independent identity, and within a short space of time American artists led the international avant-garde. He was born in Cody, Wyoming, one of five brothers. His father was unsuccessful and tried various careers, and as a result the family was frequently on the move in the western US. Pollock adopted the deep-drinking, monosyllabic, macho image of the American cowboy, but in reality he was sensitive, artistic, erudite, and hungry for greatness. He followed his brother to New York in 1930 and enrolled at the Art Student's League. The Depression years were very hard, and he succumbed to severe alcoholism, which, in spite of years of psychoanalytic treatment, remained with him throughout his life. His celebrated dripped-paint technique developed in 1947 shortly after his marriage, and soon afterward he became a celebrity figure, seen as typifying the outlandish behavior of the modern artist. In 1956, deeply depressed, separated from his wife, and dependent on alcohol, he was killed in a car crash.

KEY WORKS

• **Guardians of the Secret;** 1943; *Museum of Modern Art*, San Francisco

• **Autumn Rhythm No.3;** 1950; *Metropolitan Museum*, New York

• **Lavender Mist No.1;** 1950; *National Gallery*, Washington, DC

BLUE POLES
This huge painting is one of Pollock's last works and arguably his masterpiece. It is unusually rich in color and densely painted. At one stage, Pollock nearly abandoned the painting, thinking he could not find a way to make it "work."

Pollock and his wife Lee Krasner (1908–1984), who was also a painter, had a house in East Hampton near New York. Blue Poles was started in the studio there. Pollock was finding work difficult, and the strong, varied color left the painting without any natural harmony or rhythm. Finally, in frustration, he imposed on it the eight blue "poles," which pulled the work together and gave it focus.

LUMBER POLES
The poles were imposed by using pieces of lumber, 2 x 4 inches (5 x 10 centimeters) thick, which were dipped in blue paint and then pressed onto the surface of the painted canvas to leave an impression. The skeins of paint over the poles show that Pollock continued to work on the canvas subsequently.

Jackson Pollock; *Blue Poles*; 1952; 83 x 192 in (210 x 487 cm); variety of paints on canvas; National Gallery, Canberra

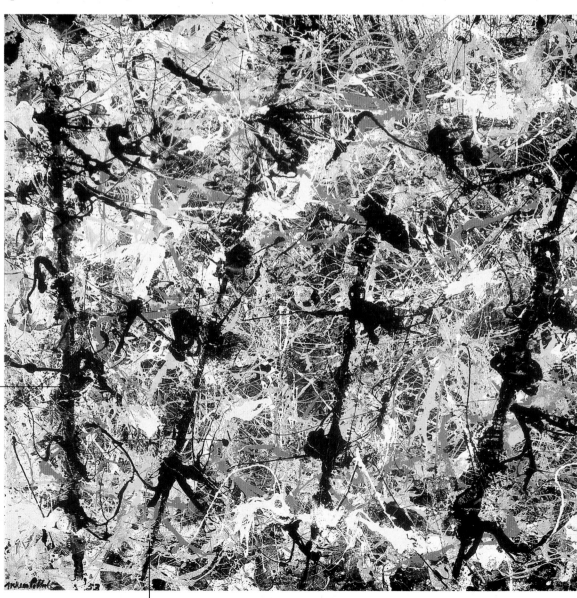

Pollock's influential teacher at the Art Students League was Thomas Hart Benton (1889–1975). He introduced Pollock to the giants of European art; Pollock was particularly responsive to the work of Michelangelo (p. 28), Rubens (p. 40), and Rembrandt (p. 48).

MIND AND BODY
The flowing lines demonstrate how Pollock used his whole being, using wide gestures with his arms, moving with his entire body, and mentally becoming completely lost in what he was doing.

Blue Poles is one of Pollock's largest works. He was most at home with large-scale work because it gave the maximum scope for expression and movement.

1945–1950

1945 World War II ends.

1946 United Nations founded. Nuremburg Trials.

1947 India gains independence. Dead Sea Scrolls discovered. Albert Camus: *The Plague.* The *Diary of Anne Frank* is published.

1948 Jewish state created. Truman elected President.

1949 Communist Republic of China proclaimed. NATO formed. George Orwell: *Nineteen Eighty-Four.*

1950 Korean War begins. Sartre: *La Mort dans l'Ame.* McCarthy's anticommunist witch-hunt.

Layered Pattern
Pollock used industrial and enamel paints, which dried relatively quickly. They enabled him to build up his image layer upon layer into a densely woven pattern.

EXHIBITION AND ACCLAIM

Pollock first received critical notice in 1942, when his work was included in a mixed show in New York alongside works by Picasso (p. 102) and Braque. The noted patron and art dealer Peggy Guggenheim (1898–1979) showed his work at her pioneering Art of this Century Gallery, linking him to the European artists who were working in exile in New York. Pollock showed *Blue Poles* at the Sidney Janis Gallery in New York in 1952 to widespread critical acclaim, but few works sold. He finally received $4,000 for it in 1954. The Australian government bought it for a record price of $2,000,000 in 1972, causing outrage among the electorate.

❝ When I am in my painting I am not aware of what I'm doing...because the painting has a life of its own ❞
JACKSON POLLOCK

Pollock was attracted to Kandinsky (p. 97) and Picasso (p. 102), in whose work he saw the play of rhythms that was so important to his own painting. He was also inspired by the murals of the Mexican artists Orozco (1883–1949) and Siqueiros (1896–1974) because of their large-scale and innovative use of sprayed and spattered industrial paints.

● FLAT CANVAS
Pollock painted works such as this by laying his canvas flat on the floor and either standing on it or approaching it from all four sides in turn.

During the Depression of the 1930s, Pollock worked as a janitor and received help from the government-funded WPA program, which commissioned art for public places.

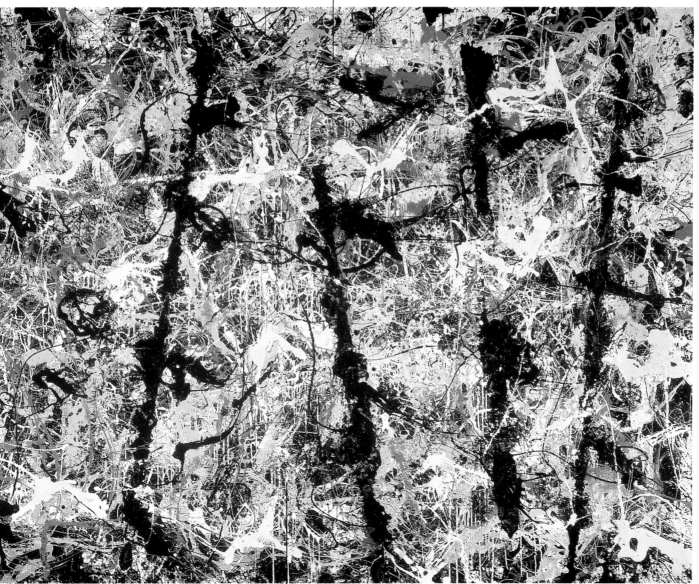

In his fight against alcoholism, Pollock chose Jungian analysis. Accessing the subconscious and freeing the unpredictable inner being was central to his art: "Action-painting," as Pollock's dynamic style came to be known, relied on the artist's creative impulses, and there was no preconceived idea of form.

● DRIPPED PAINT
Pollock did not apply paint conventionally but dripped it onto the canvas from sticks or hardened brushes. He also used basting syringes used in cooking, which he filled with paint and squirted onto the canvas in a controlled manner.

The final decisions about his work were particularly difficult for Pollock: for example, where to cut the edges and which side should be the top. He hated signing his work because it implied an act of finality.

INDEX

ACKNOWLEDGMENTS

Author's acknowledgments

"To all the artists whose work is included in this book—wherever they now may be—my endless thanks for enriching my own life and experience, and for having the vision, courage, and tenacity to make the world a better, more interesting, more beautiful, and more humane place for the rest of us."
(Robert Cumming)

A book such as this is a collaborative venture, with a professional team who discusses, designs, edits, and promotes. To everyone I have worked with at Dorling Kindersley my sincere thanks, especially to Damien Moore and Claire Pegrum with whom I have worked most closely, and who helped me see and understand things in the paintings and about the artists I had not appreciated before.

Dorling Kindersley would like to thank :
Jo Marceau for proofreading.
Will Hoone for additional picture research.
Hilary Bird for indexing.